Photoshop
for 3d artists | v1

Enhance your 3D renders!
Previz, texturing and post-production

Photoshop
for 3d artists | **v1**
Enhance your 3D renders!
Previz, texturing and post-production

 3dtotal
PUBLISHING

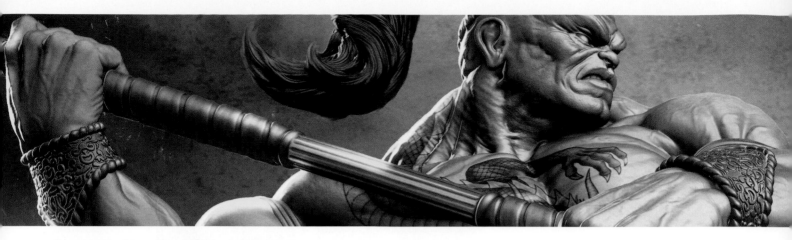

Compiled by the 3DTotal Team

| Tom Greenway | Simon Morse | Jo Hargreaves | Chris Perrins | Richard Tilbury |

Photoshop for 3D Artists: V1 Enhance your 3D renders! Previz, texturing and post-production

3DTotal Publishing

1 Shaw Street, Worcester, WR1 3QQ, United Kingdom

Correspondence: publishing@3dtotal.com

Website: www.3dtotal.com

First published in the United Kingdom, 2011, by 3DTotal Publishing
Softcover
ISBN: 978-0-955-1530-3-7

Printing & Binding

Everbest Printing (China)
www.everbest.com

Visit www.3dtotal.com for a complete list of available book titles.

DEC 0 9 2011

Contents

Photoshop
for 3d artists | v1
Enhance your 3D renders!
Previz, texturing and post-production

Introduction

Since my introduction to 3D software sometime in the last century, technology and practices have changed quite a bit. The calibre of CG has evolved dramatically across film, television and video games, moving ever closer towards photo realism. The arrival of new software, upgrades and overhauled interfaces mean that each year we are faced with a continually changing environment in which to meet our artistic endeavours.

Having worked across both 2D and 3D, I have had the experience of using software affiliated with both disciplines, but it is perhaps Photoshop that has remained the stable backbone of much of what I do. Despite the traditional upgrade each year, the interface and toolsets remain much as they did when I first used it. This sense of familiarity is always a welcome break from the elaborate tools and modifier panels typical in 3D packages and although being very sophisticated, Photoshop remains remarkably intuitive and concise. It is perhaps for this reason that it has become so widely used as both a painting package and as a texturing tool. Almost every games company and post-production studio will utilize Photoshop to some degree and as someone who once worked as a texture artist, this was

© Richard Tilbury

my principal software. When I was asked to write this introduction, I began to consider the extent of its value within a 3D pipeline and how it has always occupied a supporting role.

From matte painting through to texturing environments, characters and props, Photoshop has proved an invaluable part of how we view CG in all fields. It has also been adopted by many as a post-production tool and a way of compositing and refining renders. There was a time when many 3D artists would rarely venture into Photoshop to finish or enhance their renders, and special effects were added in video post etc. To do otherwise was almost looked upon as cheating.

Nowadays the story is somewhat different, with almost everyone tweaking and compositing passes in Photoshop to some degree. There are instances where some artists will export flat shaded geometry and reserve the entire texturing process for Photoshop, as Aleksandar Jovanovic demonstrates later in this book with his Alchemist's Chamber. In The Breakdown Gallery chapter we also get a glimpse of this in Neil Maccormack's contributing image, which has been partially textured this way but also incorporates atmospheric effects, lighting and smoke. Of course these practices are severely restricted where animation is concerned, but in

© Richard Tilbury

the case of production art, concept art and stills, it has proved an economical and effective way of achieving the desired results.

With the ever-growing complexity and scope of CG within the film industry, and the expansion of the games sector, artists are being put under increasing pressure to meet deadlines and complete work. Techniques used to save time and assist in this process are a welcome addition to anyone's repertoire and Photoshop is a tool that comfortably fulfils such a role.

Throughout these pages we shall be shown an array of techniques used to aid 3D practices and streamline an artist's workflow. From using custom brushes to develop a tangible design through to post-production, each author will share their experience and knowledge, revealing their industry-proven methods.

Richard Tilbury
2D/3D artist, 3DTotal

Free Resources

Some of our contributing tutorial artists have kindly supplied, where appropriate and possible, free resources for you to download so that you can follow along with their teachings. You will find free custom brushes donated by Richard Tilbury and Branko Bistrovic. On top of these, 3DTotal have also provided the 3D base images to accompany the "3D as a Painting Tool" chapter and 36 high resolution textures with accompanying Bump and Specular maps from the Total Texture DVD Collection.

Download your free resources

All you need to do to access these free resources is to visit the new 3DTotal micro site at: www.3dtotal.com/p3dresources. Go to the "Free Resources" section, and there you will find information about how to download the files. Simply look out for the "Free Resources" logo, which appears on articles within this book that have files for you to download.
www.3dtotal.com/p3dresources

Previsualization

With the boundaries between 2D and 3D becoming increasingly blurred in a lot of CG it is perhaps appropriate that we consider their growing interdependence. The relationship between the two has become more poignant over recent years and the overlap has extended to ZBrush, which now includes 2.5D brushes for sketching purposes. To mirror this, concept artists commonly use rudimentary 3D and packages such as Google SketchUp to block-in compositional elements and establish perspective. Similarly 3D artists use the versatility and power of Photoshop's custom brushes to create thumbnail sketches and silhouettes to block-in key shapes and volumes that help determine an underlying design. As art director Branko Bistrovic highlights: *"2D skills are a valuable asset to any 3D aspiring modeler, but with the help of 2D specialized software like Photoshop, a digital 3D artist whose traditional artistic skills may not be quite up to par can still make some exceptional concepts which, if done properly, can be a great starting point for 3D modeling"*.

Over the following pages three authors will reveal a snapshot of their techniques and show how a rudimentary grasp of Photoshop and its brushes can provide a practical starting point for 3D design.

Spaceship Concepts
By Mike Hill

Introduction

This article is designed to show the general workflow for developing ideas and designs for a spaceship. In a normal commercial project the contextual requirements would be the starting points for a design. In this case I was given completely free reign, with no requirements other than to make a "cool" spaceship. With this in mind, I just tried to explore lots of different shapes and design options.

I start by first going completely crazy with thumbnail sketches (**Fig.01**). This stage can happen in a sketchbook or directly in Photoshop, but in the end it always goes into Photoshop anyway so if you have sketched it on paper it should be scanned in.

In these early stages there are a few techniques that can be very useful in Photoshop to help

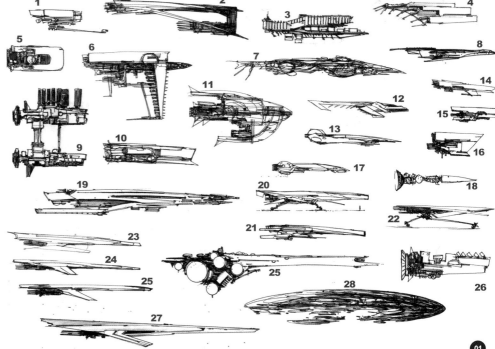

01

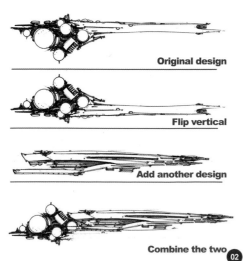

Original design

Flip vertical

Add another design

Combine the two 02

you to create interesting concepts that you may not have thought of. For example, taking elements from photos, then cropping and reshaping them is a great way to obtain original and interesting features.

Another great way to explore your concepts in Photoshop is to flip the contents of your layers on their horizontal and vertical orientations. Again, this can sometimes open up a fresh idea that you may not have intended. The Flip tool is one that is used regularly to generate new and original concepts, but it can also be used together with our cropped and adjusted

designs. You can see all of these techniques and how they can be used to create a previously un-thought of concept in **Fig.02**.

This is perhaps something that 3D artists may be familiar with, as the same principle applies to 3D techniques. Many of you will take some basic geometry and play with modifiers such as Stretch, Taper, Bend, Twist and Spherize to generate something original (**Fig.03**). It is the same principle in Photoshop.

Again you can do the same in 3D as you would in Photoshop. You can put some of the

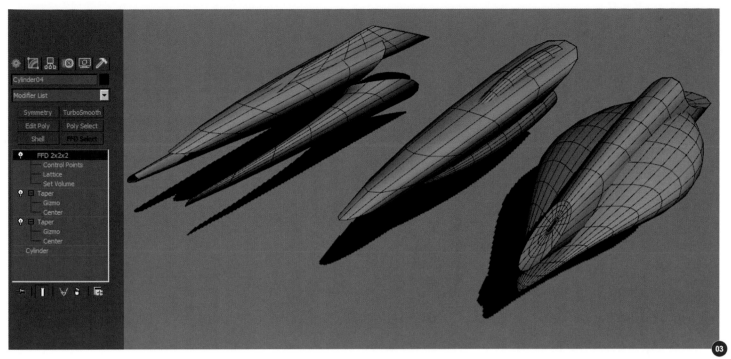

03

geometry together into certain configurations, and you will find that all sorts of ideas can take shape very quickly!

In **Fig.04** you will see that by only using cylinders and spheres you can generate ideas such as these in a matter of minutes. With time and experimentation, interesting shapes can come about really quickly!

If you go back now to the thumbnails that I have been playing with in Photoshop you can look at the designs and check to see if they fulfil basic design requirements. Firstly, does the design stand out as recognizable on the very first viewing? This should be clear even on the thumbnail. Is the design clear and understandable, even from a distance? Consistent forms: does the design have a consistency in the language of the shapes, or if it doesn't have consistency, does the contrast between the language of the shapes contribute to the design or make it look silly?

With these specifications in mind I find designs 20, 25 and 27 the most interesting visually! This is a very quick and easy process that can be done in Photoshop without even touching any 3D programs.

You can approach the next stage in several different ways. In this instance I have utilized

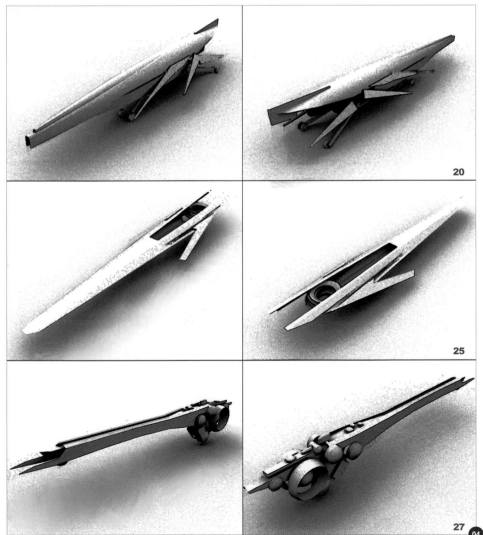

20

25

27

04

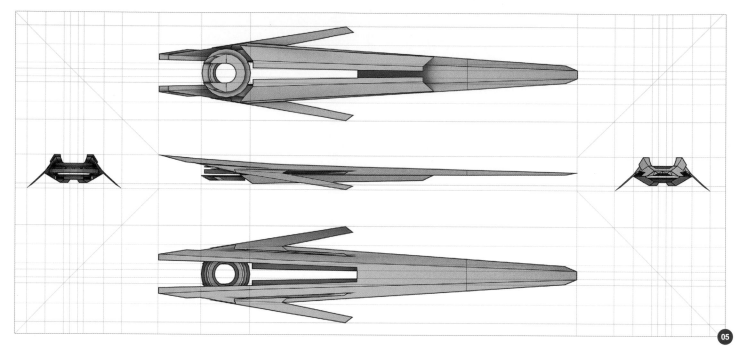

05

3D. This is in order to show that it is not just 2D artists who can be involved with the design process.

The thumbnail stage shows important design elements. It's a great way of creating concepts quickly and, all in all, is a great starting point. However it does have a downfall: it cannot show depth or volume! So a few very rough 3D block-outs of our favorite designs allow us to compensate for this and see the potential of the 2D designs in 3D space.

There are several reasons why this is a really beneficial method of working. Firstly, the designer gets the opportunity to understand the proportions from all angles. Sometimes a profile view can look great in 2D, but won't make sense when viewed from a variety of angles. By doing a 3D mock-up version, it allows the designer to connect all the elements of the concept together into a cohesive design.

From the block-outs I feel that design 27 is the most interesting visually. I take the basic Ambient Occlusion render and then focus on getting together a selection of reference materials. Collecting references is very important when getting a feel for the aesthetic of the design and providing a direction for development. 3DTotal have a great texture and reference library, which can be found at: **http:// freetextures.3dtotal.com**.

The references are there to give ideas for materials, construction methods, technology and colors! Basically all the little bits and pieces that will make a design come together. These references can be used in Photoshop at the concept stage, as they can be cropped, warped and adjusted to help develop ideas.

Orthographic projections can then be taken of the design to give the modeler a rough, but accurate, base for a model (**Fig.05**)! This step allows the concept artist to guarantee that the modeling stage will have solid foundations,

which is very important as every concept artist wants to see his concept developed to its full potential.

Finally, using a mixture of hand-painting and photo overlays, I attempt to breathe a little life into the design (**Fig.06**). The concept is generally kept rough as good modelers can often bring their own interpretations to a design, which are more informed when working with a developed model. At the end of this process you will have a great base to work from (**Fig.07**)!

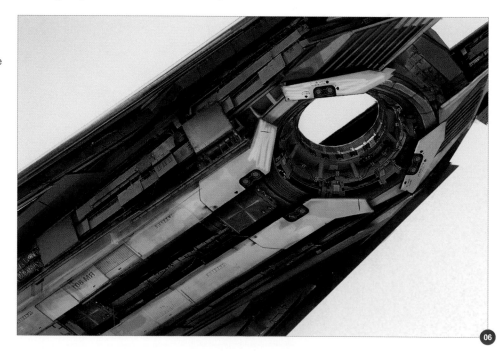

06

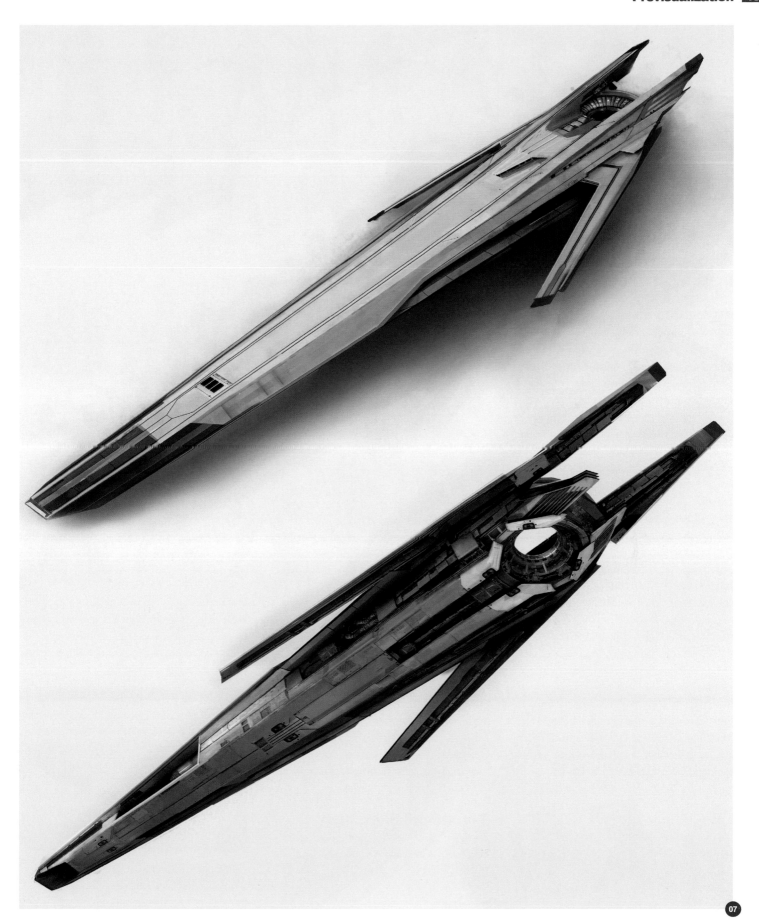

Spaceship Concepts

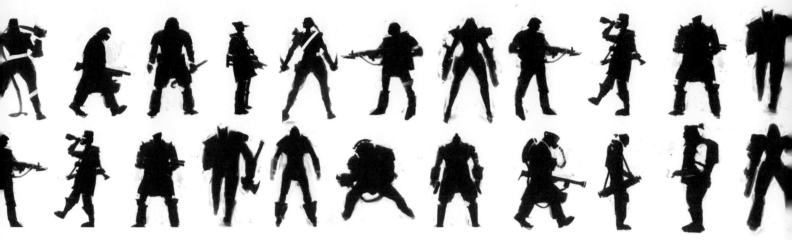

Silhouettes
By Darren Yeow

Introduction

Creating artwork is a wonderful gift. It's a pleasure that I cherish and indulge in on a daily basis, because it is both my favorite pastime and because it is also my profession. However, speak to any artist and I'm sure they'll vouch for the fact that it is also an activity that can drive many of us to the heights of frustration. This is especially true if we don't have battle-tested procedures and processes that we can rely on when inspiration is not enough.

This article delves into the very heart of the creative process by looking at that initial flowing of ideas onto paper, when we feel our ideas are strongest. It also gives insight into workflows you can rely on when your art director returns to you and says, "Give me something more!"

Before You Get Started

If you know me, then you'll know what I am going to tell you to start with – research! Whether you know the subject matter intimately or not, you need to fill your consciousness with new information on a consistent basis in order to provide fresh ideas/reminders for your images. If you don't then you'll risk growing stale and creating highly derivative art.

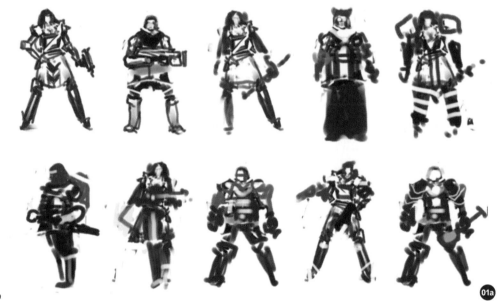

If you don't have the internet then it means a little more leg work. Going to your local library, picking up a magazine or watching a movie and stockpiling your mental arsenal from there can also be a good start.

Whichever resources you choose, just make sure you use them as inspiration only. Don't plagiarize the work. That would be unscrupulous and does not help your skill level to grow; indeed, it is more likely to lower your confidence in your own abilities.

Thumbnail Sketching

So you're given your brief and the synapses start firing off instantly. A myriad of images start flashing through your mind.

01b Now what?

The best thing to do is to start getting your ideas into visual form. The first few will probably be really bad; just accept it and have the confidence to know that the more little sketches you do, the better they will be.

> **Quick Tip:** It is important to understand that how your sketches look right now is of little importance at this early stage; they are representational shorthand ideas for yourself that will lead to more developed ideas down the track. It helps to imagine yourself as a documentary agent, trying to capture the images that are flashing before your mind's eye.

Quick Initial Sketches – To start off, I create a relatively small canvas on my screen in Photoshop – roughly 400 pixels by 400 pixels

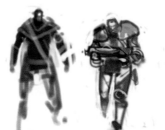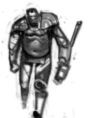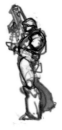

02

at 72 dpi (**Fig.01a – b**). This is fairly small and nowhere near print quality, but because this is the digital medium it doesn't really matter as I am able to upscale at any time.

Another practicality is that a small canvas does not chew memory; brush strokes can be as free and quick as you like, with no danger of lag. I also like to start off at a small scale so as to resist the temptation of jumping into the details immediately.

As the name suggests, thumbnail sketches are very small scribbles, designed to be fast. They're for putting down what you feel and emptying your mind of your current thoughts so that they may be replaced by more ideas. By jotting down these ideas in quick succession you are aiding the velocity of the process.

If you are wondering what sort of sketching you should use to document your ideas, or how much is too much or too little, then you're most likely not alone. The answer is that you should use as much information as you need, but as little as possible. If you feel you can sketch a character using just plain old line work, then so be it. If you need to put in some value to bring out the form, then do that. There is no single answer for everyone, and so you should document your ideas using what you feel comfortable with.

Don't be afraid to go crazy at this stage. Every thought is valid – in fact, some thumbs will simply be filler used to dirty up the page. I don't know about you, but I find that a blank sheet

staring me in the face is intimidating. Once the page has been violated with scribbles, it is no longer as imposing to draw on and a mental barrier is broken, allowing your sketches to flow more freely.

Trying Out Different Types of Sketches – As you can see from **Fig.02**, I am not coy about creating "dirty" marks on the page – in fact it can go some way to breaking that computer-illustrated look that many beginners seem to fall into.

I tend to work with very simple brushes, or brushes that come standard with Photoshop – mostly a combination of soft airbrushes and harder edged airbrushes with reduced spacing so as to mimic continuous tone. I tend to use these by laying large areas of tone onto the canvas before cutting back into the shapes with white.

In order to facilitate this quick process I mainly use my stylus, the spacebar to grab the canvas, and the Alt key to color-pick the tones I want from previously laid down strokes. When you get used to it, this is a very quick method of working and allows you to put your ideas down very quickly.

You may also notice in the illustration (**Fig.02**) that there are some images that look very similar to each other. Herein lies another of digital media's advantages: the ability to create variations using the Marquee tool, and creating a new layer using the existing illustrated layer as the source. This will then allow you to illustrate over the image, creating a variation to go with the original.

So far we've been thinking of the sketches as a personal tool; an external representation of internal ideas that we have attempted to organize into a structured pattern for our own personal use. We have part of the design in our minds and this can often cause us to stop short of creating sketches that mean anything to anyone but ourselves.

However, most often the art we do isn't just for fun, it's because someone is paying us to deliver. These people need to understand what we are thinking at every step of the process to reduce the likelihood of going in the wrong direction down the line – it saves them time (and money), and it saves you the frustration of having to do a major re-work.

This is an important consideration to keep in mind because, as commercial artists, we never operate in a vacuum. Our work is generally part of a greater whole. In short, we need to share our ideas effectively with other people, and most often with people who are not artists.

Cleaning Up – I have chosen to clean up this design because I feel the character has poise, balance and potential (**Fig.03**). It is also the least developed and therefore demonstrates the process between an abstract image of large shapes and how you would begin to gradually add in the design elements.

In this case, I also increase the resolution to 1221 pixels by 657 pixels to ease the adding of

03

details. If you generally print your work, stick to at least A4 as this will allow you sufficient room for detail.

Silhouettes

Silhouettes are simply another form of visual shorthand and a tool that can be used as a fore-runner to a fully fledged design.

Silhouette Design – As you can see from **Fig.04a – b**, creating a silhouette involves designing the character from the outside inwards. You are determining the features that directly influence the exterior of the character, leaving your imagination to fill in the details.

In the example you can again see the use of duplicates, allowing me to fill a page quickly using the copy-paste method. This will free up your time to work on making sure that each silhouette receives your attention.

Adhering to the principles of creating silhouettes is important for a number of reasons:

- It removes the temptation to spend too long on the minutiae – not being able to putter away endlessly on infinitely small details expedites the process and forces you to think of thc big picturc
- It enhances the amount of thought given to an object's recognizability from a distance, so a character is easily recognized from far away
- It lets you concentrate on one aspect of design at a time – you don't need to worry about anything else other than the overall shape of the silhouette, the emotional response from the viewer and whether that response is the desired effect based on the design requirements.

Once the external shape of the character is established, it's time to fill in the internal details. This involves the reconciliation of external

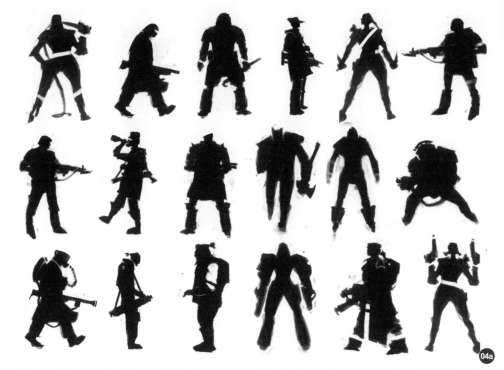

04a

shapes with associated internal objects, that also serve a functional purpose for the character in question. There's no real "right" way to go about this, but a good rule I try to follow is to concentrate on the larger shapes before going into the minute details.

Silhouette Detailing – So here is an example of how a character's silhouette is taken from an abstract silhouette to a fairly well fleshed-out concept (**Fig.05**).

I chose this particular pose because I like its dynamic nature. I felt it had lots of possibilities and so I increased the resolution and began by working in the large shapes using the same brush that I began with.

When I was happy with the overall shapes, I began using a soft edged airbrush in order to give the shapes form and roundness. Picking out your light source will answer many questions regarding form, so always keep this in mind early on in the rendering process.

Duplication – You can see from **Fig.06** that the base image is the same; however, because I have duplicated the image twice, I negate the need to think of new poses, and the proportions of the figure have already been taken into account with the first character on the left. This means that for the two characters on the right, there is less to think about, and more effort can be put into things such as the accessories.

As you can imagine, the advantages are huge and very economical if you want to create a large number of variations based on a single silhouette or body type. All that is required is the duplication of the image layer and some painting over the top of it.

The advantages are huge, and very economical if you want to create a large number of variations based on a single silhouette or body type. All that is required is the duplication of the image layer you want to work with and simply painting over the top of it.

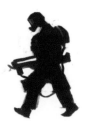

04b

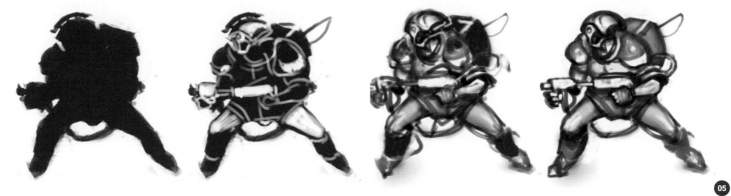

Custom Brushes

These days, custom brushes seem to be a staple of most digital artists' tool boxes and make the task of repeating elements a breeze.

However, this tutorial isn't going to cover custom brushes.

Yes, I know – huge riots, controversy and all that – but the truth is, I just don't use custom brushes for idea generation. There are some artists who swear by them because of "happy accidents", just as there are some, such as myself, who would rather make every stroke deliberate. Neither workflow is right nor wrong; it is a personal choice. If you feel comfortable using something and you can deliver the results, your methods work for you!

That being said, because I see such an over-reliance on custom brushes by many novice artists, I'd like to explicitly remind people reading this that a custom brush is nothing but a tool. Like all tools, there are moments when they should be used and moments when they should not be used. Custom brushes should never be used to replace the basics of art making and, ideally, you should be able to illustrate your thumbnails and silhouettes

without them. Once you can do this then using custom brushes may speed up your work, but as always: basic art skills first, flash-tastic technology second.

I'm not trying to discourage the use of custom brushes. In fact I encourage you to try them, along with other methods, as you might just find they gel with your working process.

Rules and Guidelines

When it comes to art, many feel that rules may inhibit artistic expression. If you want to be a commercial artist, you'll need to kick that idea right out of your head. Creating art in a commercial environment has plenty of constraints which can be bent at times, but certainly not broken, especially if you're not the art director.

These are a few that pop up frequently, so try to keep them in mind when you do your work:

- **Function before form**: It is of absolutely no value to your employer or client if you create art that is flash over substance. The functional value of the costume needs to be there; once it suits the purpose it was built for, then you can make it look cool. One big

example is articulation; I see a lot of artists creating hulking power suits that look cool but are completely impractical.
- **Rely on pre-existing memes to present your ideas**: Rely, to an extent, on what has come before in the design world. Red means stop or danger, green means go, etc. Leverage these memes and archetypes to give credibility to your designs
- **Don't "ape" other people's artwork**: Don't steal, copy or plagiarize other people's designs.

Mindset

I've always insisted that what goes on in the head of the art maker is equally, if not more important, than what happens on paper/canvas. Here are some of my thoughts on what you should try to keep in mind while you are exploring your ideas:

- You are creating many tiny, inconsequential pieces of art: the more you create, the higher the likelihood that within those drawings you will have the elements of the final design
- You are unbiased towards any one design because Murphy's Law will almost always guarantee that the design that least excites you will be chosen by the art director
- Every single sketch, thumbnail, silhouette or scribble is valuable – don't erase them
- Any idea is a good idea; each sketch holds a key that could open another door and may eventually lead to the final design.

I hope you've enjoyed my tutorial and hopefully picked up one or two pointers. You should have everything that you need now to create some basic silhouette concepts that can be turned into great 3D models!

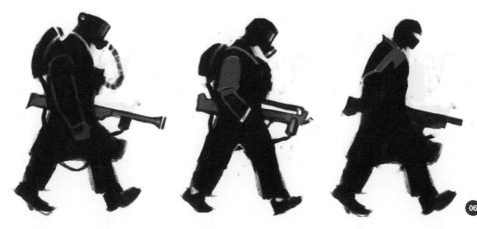

Photoshop Concepts
By Branko Bistrovic

Introduction

It goes without saying that traditional 2D skills are a valuable asset to any 3D aspiring modeler. But with the help of 2D specialized software like Photoshop, a digital 3D artist whose traditional artistic skills may not be quite up to par can still make some exceptional concepts which, if done properly, can be a great starting point for 3D modeling. I'm going to walk you through a set of concept ideas, built buy a set of varying brushes, in the hope that even if you aren't the hottest industrial designer, nor have the skills to make and render perfect circles by hand, you can nonetheless still generate usable 2D images as a reference for your 3D projects.

It should be noted that this method will show you one of many ways you can quickly generate ideas to build from. There are others, and some might work better for you than this one. Take what you can from this tutorial and build on it; explore and discover!

Photoshop Tools

Photoshop is a big and intimidating program for those who aren't experienced with it, and

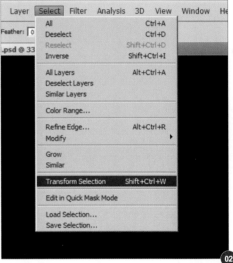

hell, at times even for those who are! There are plenty of options and menus and filters and checkboxes, all of which are useful for certain types of jobs, but not necessary for all. So let me lay down the major tools we'll be using, and hopefully you beginners won't be too overwhelmed with everything Photoshop offers.

First, get familiar with your selection tools (**Fig.01**). I'm referring to your more precise ones and not tools like Quick Mask, which is very useful but doesn't always result in the cleanest of selections. The ones I'm referring to are your Lasso tool (hotkey T) in all of its variations (Polygon and Magnetic), and also your Marquee Tool (hotkey M - Rectangular, and Elliptical). Knowing how to add and subtract from your selection quickly and cleanly will speed your process up tremendously. Trying to make that perfect circle by hand when you've

got a tight deadline pressing down on you is really not the best position to be in at 3:37am…

Lasso Tool tip - With the Lasso tool selected, hold down Alt and click on the canvas. The Freehand Lasso tool will behave like the Polygon Lasso tool, generating straight lines. When you wish to revert back to the Freehand tool, just release Alt whilst your pen is still touching the canvas.

Marquee Selection Tool tip - Once you've drawn a selection with the Marquee tool, access Select >Transform Selection (**Fig.02**). **Note**: I've take the liberty of making a shortcut for Transform Selection, as you can see in the image. If this option proves useful to you I recommend you do the same. Now you will be able to Free Transform the actual Marquee selection. Remember to hold down

Ctrl and grab the corners if you want to adjust perspective. Also, while you've got Transform Selection on you can click Warp Mode (**Fig.03**) if you want a more organic sense of control with the selection.

Using the Pen Tool - Finally, the Pen tool is pretty simple. It's main benefit is that it functions with anchor points, which act like vertices (something I'm sure all you 3D artists understand). These can be pushed, pulled or rounded out by holding down Alt and click-dragging on them and their handles. As long as the anchor points are present, the resulting shape made with the Pen tool is a path. To transform a path into a selection you need to select the path(s) you wish to transform (hold down Ctrl while still using the Pen tool and just pick your paths) and then right-click on any of the selected chosen paths and pick "Make Selection…" (**Fig.04**). The screen that pops up will allow you to play around with things a little, but hitting "OK" right off should work just fine.

There you have it for the selection tools. Next, let's tackle brushes!

Photoshop Brushes

Now, I realize that silhouettes are covered in a separate chapter in this book, but it never hurts to reiterate the basics. When you are searching for concepts, focus on the larger forms first, not the tight details that certain fancy brushes might spew out randomly.

There are a few benefits to this. Firstly, it usually results in a less intimidating concept – that minute detail might be very difficult to replicate correctly in 3D, while the overall larger forms most likely will be comprised of basic shapes and be a much easier challenge. Secondly, those minute details will be totally lost on anything further out than a medium-

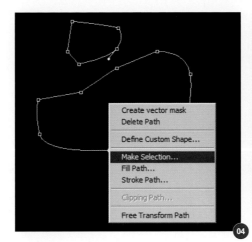

close up of your character. The further you step back from your design, the more important it will be for the silhouette to read, so we must be able to recognize all major features at a glance. This is especially important in feature films, animation, video games – basically in any form of entertainment where characters might spend a significant time interacting with their environments and each other at a distance. There are few better ways to make a hero more generic than to have his body shape look just like everyone else's.

So for the purpose of this project, I've made three basic shapes for my brushes (**Fig.05**), and I do mean basic. With these I'm going to play with the options under the brush panel and hopefully make them intricate enough to create interesting shapes while still keeping the resulting design relatively simple. Don't worry, I'll include an intricate brush with the tutorial as a download that I built using paths, but I think keeping it to these simple shapes will better illustrate the variety you can find with all of the options under the brush panel in Photoshop.

Circles

Circles - Fig.06 shows the default setting of the brush. From here, I access the brush panel

(F5) and click on Scattering. I set Scatter to 103% (Pen Pressure on), Count to 10 and Count Jitter to 51. Once done with those I click on the Transfer option in the brush pallet and choose Pen Pressure under Opacity Control. Finally the spacing is set at 150% (under Brush Tip Shape). This will still keep the brush quite rudimentary, but now some interesting shapes can start to develop at random, as **Fig.07** illustrates. I build on the shape, bigger masses first then smaller, alternating between the custom brush and a regular hard round brush, letting the randomness design interesting shapes for me. It's starting to look like some sort of wonky robot dog…

From here I continue to further play with the brush options. Under Shape Dynamics, Size Jitter is set to 67% with Pen Pressure on. Angle Jitter is at 50% (Direction on). Roundness Jitter is at 100% with Minimum Roundness at 1%. Also, Flip X Jitter and Flip Y Jitter are both checked. Under Transfer, both Opacity and Flow Jitters are set to 50%. Finally, I tightened Spacing to 68%. These options resulted in a more organic feel.

Through varying the size of the brush while adding and subtracting (using the brush both as

a brush and also as an eraser) to find shapes, I build up to what looks to me like a hot-air-balloon-helicopter (**Fig.08**). I actually like where this one is going; this process can be really enjoyable at times, especially if there are no tight deadlines looming. After building on the helicopter I also do two more quick thumbnails (**Fig.09**). The first looks similar to the previous helicopter except it resembles the upper torso of some 1950's robot design more. The second looks like an obese frogman. Charming!

I develop the frogman into a more usable concept… I just can't resist (**Fig.10a – b**)!

Squares

Now that we've gone through the process with the circle brush, here we'll just replicate the same settings and see what pops out.

> **Quick Tip:** If you don't wish to go back and forth in the brush panel checking the specific setting we applied to the circle brush, you can just click on Lock (**Fig.11**) for the categories you want to keep while you have the circle brush picked. Now when you choose any other brush those locked settings will be applied.

The shape of this brush, being so straight, lends itself to a harsher, less organic, feel – something more robotic. Despite that (maybe it's the frogman influencing me) I start to see a Samurai in his war regalia (**Fig.12**). I use the Lasso tool to cut away some portions and to give him horns on his helmet. Instead of stroking across the canvas, I dab with this brush as it seems to give more of a sense of something being constructed.

For you tech-inclined individuals, I also hammered out a few more quick and dirty thumbnails of some sort of transport vehicles

(**Fig.13**). In these I also utilized the Marquee Selection tool (Elliptical shape), the Lasso tool and a Hard Edge Regular Round brush to paint and add texture.

Triangle

Now it's time to triangulate where we are with this final brush shape: the triangle!

Seriously though, I'm curious to see just how different the shapes will feel when compared to the square/rectangular brush we were just using, since all that's going to be technically missing is one corner and one side.

The settings for this brush are carried right over, as they were with the square brush, by locking the desired settings while the circle brush is picked, and then choosing the triangle brush (see **Fig.11**).

So, the results are definitely interesting (**Fig.14**) – at least to my eyes they are. I suppose, to me, the pointed nature of the triangle lends to both speedy and violent-looking concepts. The final ship work up feels overbearing and threatening, while also quick (**Fig.15**). All I do for these concepts is very simple: I decide the shift of faces with the use of values, the same way any 3D program generates a 3D-looking model. The faces hit by direct light are lit most, and as they angle away from the light they fall off into shadow. Very rudimentary stuff here folks; don't let the details intimidate. I guarantee any of you can handle it after a bit of practice.

Conclusion

So, judging from these three basic brushes

what have we learned? That with the proper settings in Photoshop even the most basic of shapes can create interesting concepts. It then falls upon the lowly artist to take it to a whole new level, be it 3D or more refined 2D. You'll need patience to deal with the trial and error, but as your eye for interesting designs develops you'll begin to see more and more possibilities from the abstract outpourings of any of these brushes, and those hopefully will serve as a springboard to fully realized 3D models.

On that note though, it should be stated that while this process can be quite successful in

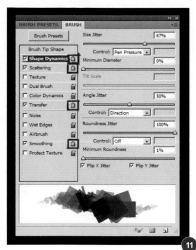

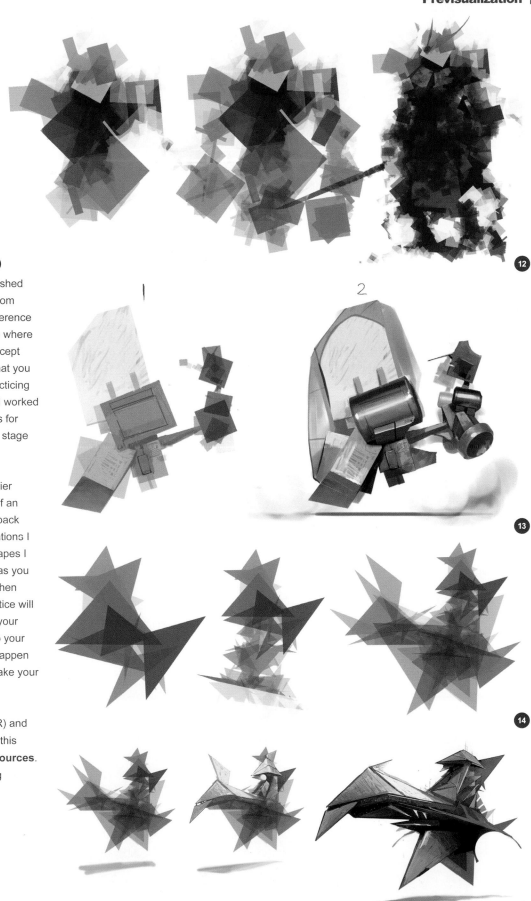

generating ideas, once you have established a concept, you will still need to draw it from other angles to make a 3D modeling reference (especially if you are working in a studio where other modelers need to build off the concept and cannot tap into your mind to see what you see). In other words, it pays to keep practicing your draftsmanship! All of the concepts I worked up took no longer than a couple of hours for each. It's important to keep loose in this stage and not get bogged down with detail.

Finally, I went ahead and created a fancier brush, one that resembles the chassis of an automobile. I included this in the brush pack along with a sheet of a few random creations I made with it – feel free to take those shapes I created and try to flesh them out as far as you can in Photoshop (without taking more then 2-3 hours on each). This little bit of practice will help greatly in the speed/confidence of your workflow once you take the concept into your preferred 3D software. If the concepts happen to be too complicated then no sweat; make your own with the basic brushes.

You can download a custom brush (ABR) and the practice sheet (PSD) to accompany this tutorial from: **www.3dtotal.com/p3dresources**. These brushes have been created using Photoshop CS4.

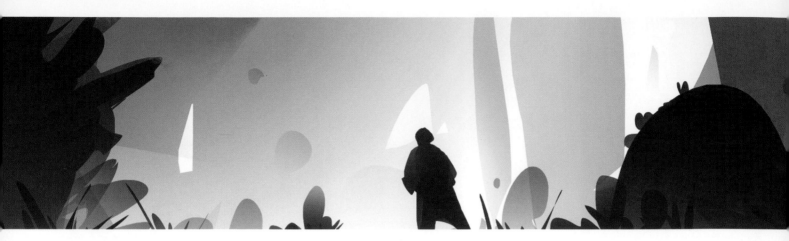

Creating Original Concepts
By Jama Jurabaev

Introduction

Back in early 2000 when I decided to learn about 3D modeling, I faced several problems. First was the lack of technical knowledge about the program, which in my case was 3ds Max, although this is a trial common to any software. There are a lot of buttons and techniques that need to be grasped in order to become a successful 3D artist. Over time I became efficient enough to model anything I wished. Then I faced the second problem – what should I model?

I modeled some cars, aircrafts and other vehicles, but at some point I decided to do something original from my imagination, which was not easy at all. Having some rough sketches and doing some simple research can be really handy and helpful, but because my drawing skills were poor I couldn't draw or visualize anything cool.

I believe that to be a very good 3D artist you don't have to be able to draw very clean and professional sketches. However, in this tutorial

I will share some methods that can be used to boost your imagination and create different designs and shapes very quickly.

Technical Notes

For this particular tutorial our main tool will be Adobe Photoshop CS4. Shapes are simple enough to draw with a mouse, but I use a Wacom tablet which makes it easier and quicker. Assuming that you are familiar with Photoshop, I'll briefly run over the tools that I used throughout this tutorial:

- **Lasso tool** – is a simple selection tool, which allows you to select a region on your canvas. I mainly use the simple Lasso tool, but when I require straight lines I often use the Polygonal version (**Fig.01**).
- **Gradient tool** – is used to make a gradient fill inside the selected region (**Fig.02**).
- **Layer modes** – I mainly use Multiply mode, but you can also experiment with other layer modes because they can produce really interesting results (**Fig.03**).

Abstraction

Some artists can clearly visualize a concept before they start to draw anything, whilst some artists need a spark to ignite their imagination. I think I fall into the second category. Our goal

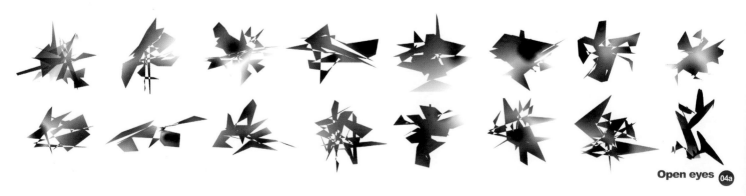

Open eyes 04a

in this article is to use simple tools to build some abstract shapes, or groups of shapes, within which we will hopefully see some cool concepts. The theory is similar to looking up at the sky and seeing animals and creatures amongst the cloud formations.

Abstract shapes can help us to create very different concepts across different genres, with the same abstract shape suggesting a car, robot, creature or environment. I find this technique to be a very powerful approach to thinking in abstract terms as it's free of constraints and therefore allows your imagination to fly freely.

Experimentation (Scribbles)

It may sound like a joke, but something I do often is to paint with my left hand and with my eyes closed. You may well ask, "Why would he do that?" The reason is because I want to get very unusual and irregular shapes, and my right hand and mind are so full of clichés. By using my left hand and painting with my eyes closed I am essentially trying to create unusual shapes across the canvas. I simply select a random region using the Lasso tool and then fill it with the Gradient tool (**Fig.04a – b**).

At this stage I don't care about light, shapes, anatomy or color; I am just blocking in some random scribbles. I don't apply a strict limit to the amount of these abstract shapes I create, and you should draw as many as you want, but I do prefer to restrict them to around 30 shapes on the page as this seems enough. The shapes are still very abstract, but now the fun begins.

I take any three shapes and put them into separate layers, changing the top layer mode to Multiply. I then move, rotate or scale them until I start to see something, which in this case is a robot (**Fig.05**).

Don't worry if your design looks simple and a bit goofy at this stage, because by using other shapes from **Fig.04** you can make it more complex. So as you can see in **Fig.06**, starting from just abstract forms I've developed several designs that I didn't have in my mind when I started. After I've done this I decide to improve those robots, as seen in the lower row.

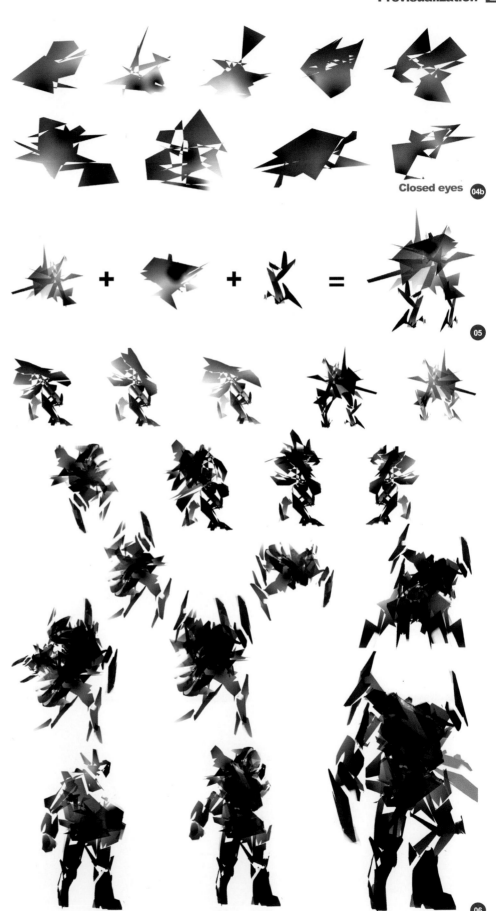

Closed eyes 04b

05

06

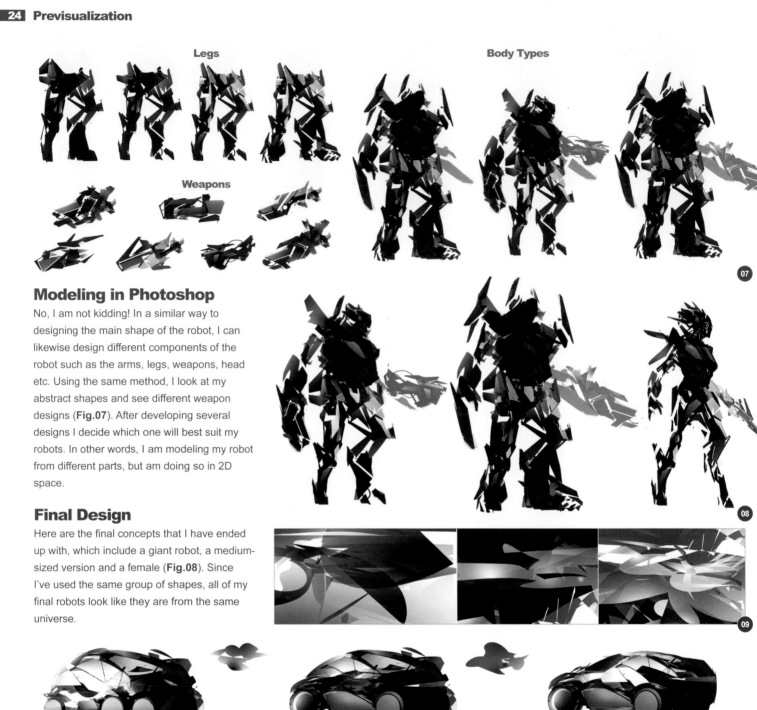

Legs

Body Types

Weapons

Modeling in Photoshop

No, I am not kidding! In a similar way to designing the main shape of the robot, I can likewise design different components of the robot such as the arms, legs, weapons, head etc. Using the same method, I look at my abstract shapes and see different weapon designs (**Fig.07**). After developing several designs I decide which one will best suit my robots. In other words, I am modeling my robot from different parts, but am doing so in 2D space.

Final Design

Here are the final concepts that I have ended up with, which include a giant robot, a medium-sized version and a female (**Fig.08**). Since I've used the same group of shapes, all of my final robots look like they are from the same universe.

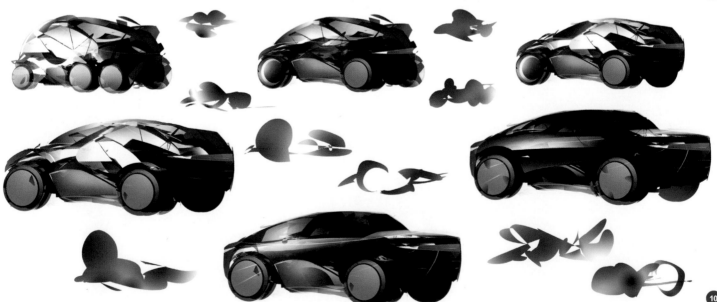

Cars and Environment

Using exactly the same procedure, I went on to create some car and environment designs (**Fig.09 – 11**). As you can see, this method is not bound by genre and using the same set of abstract shapes you can extract robots, organic aliens, cars, spaceships etc. Just feel free to experiment and don't be afraid to mess up something. Generate as many designs as you wish and then go back and select the most original ones. After this you are ready to jump into your 3D software and start your magic using the concepts that you've created.

Conclusion

How far can you go using this technique? It is all up to you! The more you work, the more complex your lasso drawings can become. I have included some of my other lasso experiments here, which all started from clouds of abstract shapes and turned out as interesting concepts (**Fig.12 – 14**). The Lasso tool is a really simple and quick way to produce interesting concepts, which can help a great deal when organizing your 3D artwork.

I have tried to use only the basic tools and methods to help focus the attention on imagination and inspiration. Art is not about tools after all, it is about creativity. Creating something new and unusual is the most exciting aspect associated with art, so take your time and experiment!

Texturing Techniques

For many 3D artists, two of the staple ingredients central to CG are modeling and texturing. Many individuals specialize in areas such as lighting and rendering, rigging and animation or shader and material set ups, but a large pool are dedicated to modeling and texturing, or at least require a working knowledge of each. With respect to texturing, Photoshop has established itself as a benchmark platform, proving to be an invaluable tool for artists of all descriptions.

This chapter will provide an overview of two different projects beginning with a simple 3D scene and following a typical approach, from selecting the base textures through to building detail and applying a dirt map. From here we will move onto characters, take a look at how to structure and paint a color map, and see how this can be used to generate a specular map. We shall deal with some of the general principles concerned with the process, as well as explore how to successfully combine different photo references into a template, and finish with a chapter that places our sample character into an environment.

Base Layers and Color Correction
By Richard Tilbury

Introduction

Note: All textures used can be downloaded from the link at the end of the tutorial.

Over the course of this tutorial we will be looking at some of the techniques used to texture a simple scene, and how to go about creating custom textures from a library of photos. We shall deal with some of the general principles concerned with texturing, as well as how to successfully combine different photo references into a single template. We will follow the process of selecting the base textures for the scene through to the building of details and culminating in a section devoted to adding dirt and grime and applying some dirt maps.

Fig.01 shows the 3D scene in question, and the eventual lighting that will be used. In terms of a

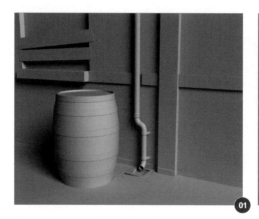

single render, or "still", I find it is very useful to set up the camera and light rig before opening Photoshop as this determines what will be evident in the final image. In this case, one could realistically get away with texturing just one half of the barrel, for example.

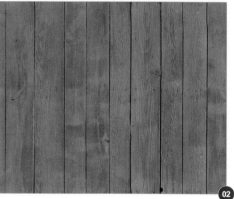

The first thing to do before doing any texturing is to gather some reference material and look at a variety of different surfaces and photos in order to better understand your subject.

I am not going to provide an account of mapping and unwrapping in this tutorial, but suffice to say that this is a crucial part of the texturing process. I've decided to unwrap the barrel and drainpipe onto a single template, and begin with these, as they are the focal points in the scene.

Base Layers and Color Correction

I've looked at quite a few wood textures and decided that the most suitable is "america_02", which comes from the Total Textures Volume 12 – Textures from around the World 1 DVD (**Fig.02**).

This texture has an even, all-over look with the right sized gaps between the wood, and with a suitable sense of age. The main problem is the

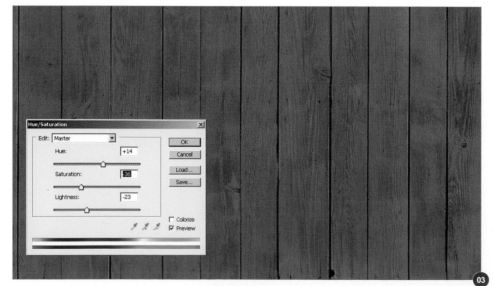

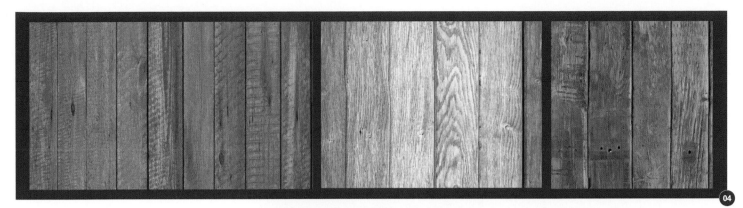

color, but by going to Image > Adjustments > Hue/Saturation I can make it a little darker, as well as reduce the red tint (**Fig.03**).

This will now make a good base for the barrel and allows me to have a "blank canvas", as it were, to start building the detail. Some other wood textures I considered can be seen in **Fig.04**, but these were rejected for various reasons. The upper left one could have been used, but looks more symmetrical by comparison and therefore does not have such an interesting and hand-made appearance. The lower left image looks too clean, with hardly any spacing between the slats, but more importantly has the wrong scale. The image to the right also has too small a scale, but also shows more rounded edges, which do not fit in with the subject. What I like about the chosen texture is that it has a suitable scale and some variation between the slats, but at the same time it is tileable without too many obvious patterns that will repeat – important factors when selecting an image.

After being color corrected the photo is pasted into the template, scaled and tiled accordingly. Any image that is tiled will show some evidence of this, and although this picture is pretty consistent there is a small hole that shows up (**Fig.05**). The best way to solve the problem is to use the Clone Stamp tool and remove it. The other issues are the two slightly wider gaps, which can be resolved by copying another section and pasting it over the top, and then blending in the edges using a soft eraser.

Layer Styles

It is now time to choose a metal texture that can be used to form the metal strips around the barrel.

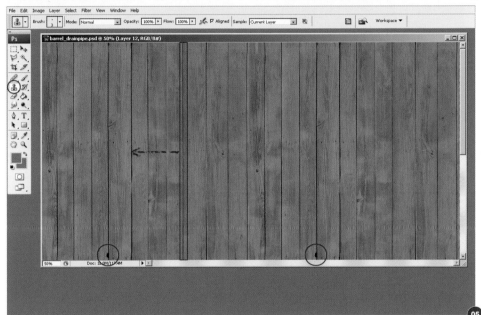

Fig.06 shows a metal texture that has been used, but with some much needed corrections (a combination of Image > Adjustments > Color Balance/Brightness/Contrast/Hue/Saturation). Again, you can see that in context it shows variation, but with no conspicuous markings that repeat. In this instance I have actually extruded the sections of geometry that constitute the metal sections (see **Fig.01**), but even so, it is often a good idea to reinforce this in the texture, thus emphasizing the volume and solidity within a scene. Adding subtle shadows into the texture adds depth and richness, and although it has a bigger impact on low poly models, it can also help on more highly detailed meshes by creating some shading even under low or indirect lighting conditions.

To achieve this on the metal I use a drop shadow by going to Layer > Layer Style and using the settings shown in **Fig.07**.

If you are rendering a still you can save out an ambient occlusion pass for a similar effect, or alternatively set up a light dome rig in your 3D scene and bake the shadows directly onto the texture.

Despite extruding the metal strips around the barrel, I decide to texture the studs as they are so small and do not warrant extra geometry. To do this use the Elliptical Marquee tool to form a

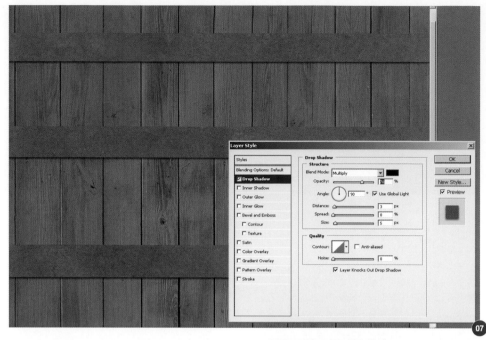

circular selection on the metal strip (shown as red in **Fig.08**) and copy and paste into a new layer (Layer 12). This, at first, will appear almost invisible, but now go to Layer > Layer Style and apply a Bevel, Emboss and Drop Shadow. This can be enhanced later in the Bump map, but is a useful technique to use if the object is small scale with minimum dimensions.

Blending Modes

To add some variation to the barrel I am now going to use three slats from an earlier wood

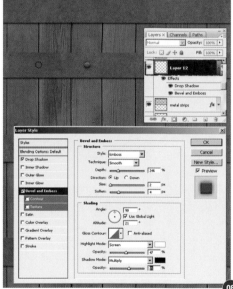

texture ("wood04" from the Total Textures Volume 2 – Aged and Stressed DVD – see **Fig.04**). I copy and paste three sections into my file and scale them to fit neatly into three sections. I lower the saturation and brightness by way of Image > Adjustments > Hue/ Saturation and also reduce the contrast, and then chose Overlay as the blending mode (**Fig.09**).

This is the first stage of creating variation across the barrel, but a further step will enhance it even more. This time I select "overlay 02" from the Total Textures Volume 1 – General Textures DVD and color correct it

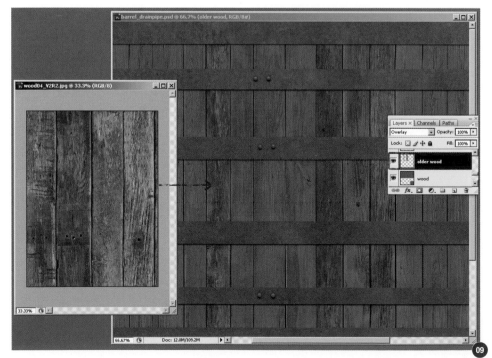

to look greener with a higher contrast (**Fig.10**). I then paste it into my file and use a textured eraser to form some random shapes.

Once happy, I set the blending mode to Soft Light at 50% opacity, as seen in **Fig.11**. Alternatively, it could have been left on Normal mode at around 30% opacity for a similar quality.

As we have done with the wood, the same approach can be used on the metal. In **Fig.12** I have selected a rusted metal ("metal19" from the Total Textures Volume 2 – Aged and Stressed DVD), color corrected it, and then pasted it into a new layer. On the left you can see the photo set at Normal mode at 100%, and the eventual setting on the right at Soft Light, 68% opacity. You will notice that I have darkened the section next to the arrow, just to break up the symmetry a little more.

In **Fig.13** we can see on the right the difference these extra layers have made, compared to the single base metal and wood texture on the left. The barrel still looks reasonably clean but it has more variation across its surface and appears older. There is still more detail to add with regards to staining, rust and grime, etc., which we will cover later, but you can see how using multiple layers with various blending modes and opacity can enrich your textures.

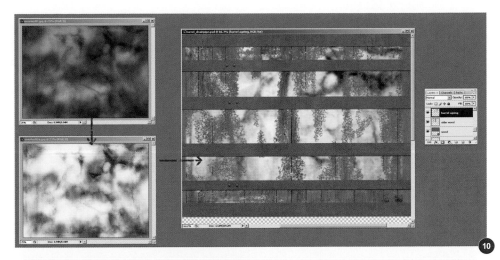

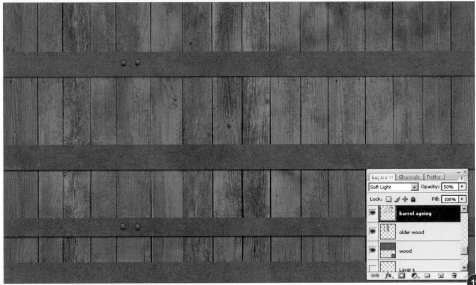

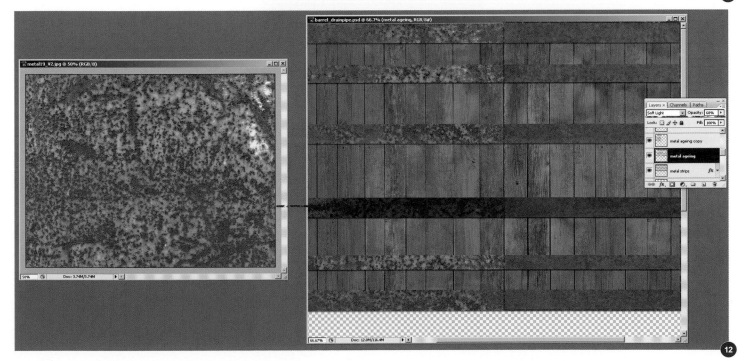

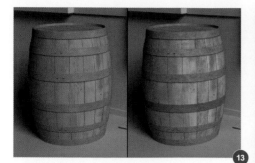

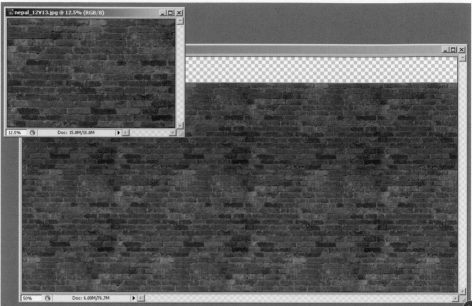

Geometry vs. Textures

We will come back to the barrel later in the tutorial, but I am going to shift the attention to the wall now as this makes up a large section of the scene.

Elements of the wall have been modeled, such as the window, column and row of bricks parallel to the windowsill, but I want to contrast this with purely textured aspects to draw a comparison between the two approaches.

Firstly I apply a brick texture to the entire wall section. I scan through the numerous examples in the Total Textures collection and eventually choose "nepal12" from the Total Textures Volume 13 – Textures from around the World 2 DVD (**Fig.14**). This has to be scaled and tiled accordingly, and you can see how this method can reveal the problem of symmetry. If you have unwrapped the mesh then this can easily be rectified by "painting out" conspicuous areas. The best thing to do is to assign the texture to your scene and see which areas require attention, as some problem areas may be hidden from view (behind the barrel, for example).

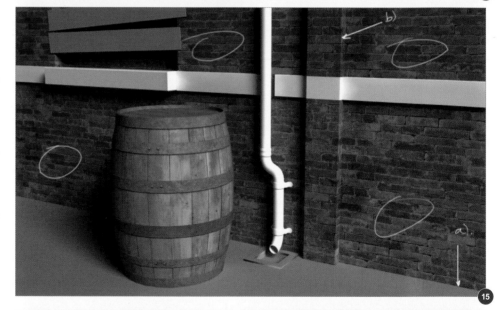

In **Fig.15** the bricks have been applied and overall the texture works well, barring a few problem areas. My eye is drawn immediately to the areas ringed in white, which show tiling problems:

- The bottom edge (a) ends abruptly, although this will be covered by a concrete edging (see **Fig.01**) and so can be overlooked
- The other key problem area is the protruding column (b) as the bricks run through it without adhering to building laws; however, this will also be rendered and so can also be ignored.

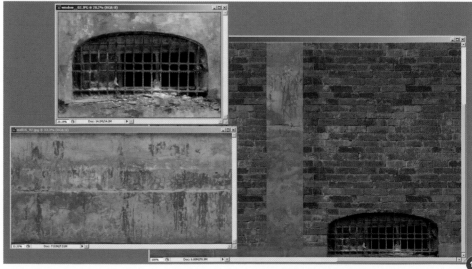

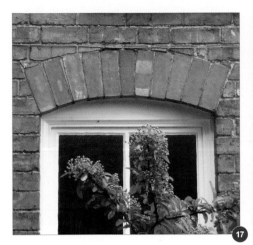

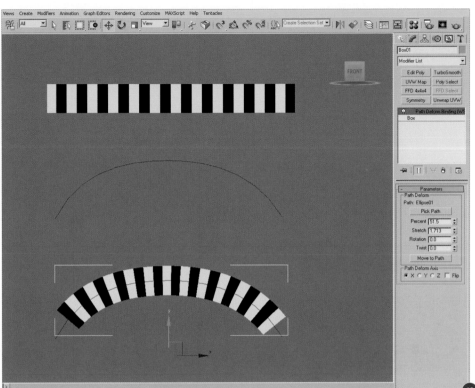

Before fixing any tiling problems I merge in some other references, as these will conceal some of the issues straight away – e.g. a vent that will occupy the near side of the wall. You can see from **Fig.01** that the vent is not modeled, nor is the concrete edging in this panel, but it will be interesting to compare the differences between these and the 3D aspects in the final render.

For the concrete I choose "wall16" from the Total Textures Volume 2 – Aged and Stressed DVD, and the vent comes from the Total Textures Volume 19 – Destroyed and Damaged DVD (**Fig.16**).

Building an Arch

The vent looks OK in the texture, but it does not look fully integrated into the wall. To help this we will use a method common in architecture, which is to crown it with a brick arch, similar to **Fig.17**. This is quite a tricky task as we need to make sure the bricks are consistent with those used in our wall, and also conform to the curve of the vent. We could copy and paste an arch into the template and skew and color correct it, but here is a more effective way…

Create an oblong box in 3D and map some of the bricks onto it, making sure they are vertical, similar to the format in the photo. Once done you should end up with something akin to the top shape in **Fig.18**. Imagine that the black and white shapes represent the bricks. Now create a spline shape that traces your arch (blue line) and then apply a Path Deform. In other words, thread your box along the spline using the parameters to position it correctly. You can now render this out and import it into your file and,

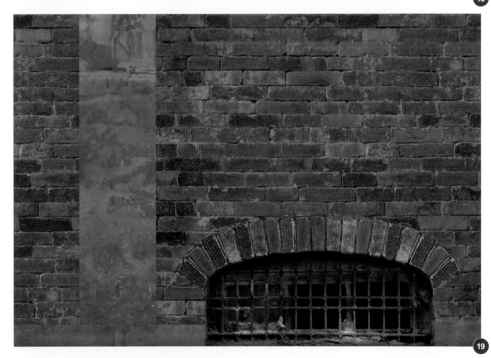

once scaled, it will fit neatly around the vent. If you need to alter the shapes a little or taper them, then go back into your 3D package, alter the UV co-ordinates and re-render.

Once done, be sure to clone in some mortar or cracks around them to embed them into the wall, and do not worry about odd shapes or unevenly shaped bricks – just look at **Fig.19**!

Here is the finished image (**Fig.20**).

You can download the Total Textures that accompany this tutorial from: **www.3dtotal.com/ p3dresources**.

Bump and Specular Maps
By Richard Tilbury

The Barrel

Note: All textures used can be downloaded from the link at the end of the tutorial.

At the end of the last chapter we dealt with building a brick arch, and now we will move back on to the barrel.

In **Fig.01** you can see the section of wood used for the top, with a white circle that represents the wireframe export/outer edge. This will also benefit from some subtle shading around the edge, similar to the drop shadow under the metal strips. The best way to achieve this is by using the Circular Marquee tool and creating a selection area that matches it. Now go to Edit > Stroke, select black for Color, choose Center, and set Width between two and four pixels. This will add a black line, and with a little Gaussian Blur and Multiply set at around 60% opacity, it will form a good shadow around the rim.

One remaining detail that is yet to be added is the plug in the side of the barrel. This will be made on a separate layer and will comprise of a circular selection area into which we will paste the same metal that was used for aging the metal sections earlier. To give this a sense of volume we will apply a layer style once more, in the form of a Bevel and Emboss and Drop Shadow (**Fig.02**).

I have altered the brightness and contrast to make it look less rusty, but you will also notice that it is slightly squashed. This is because when it was mapped onto the geometry I

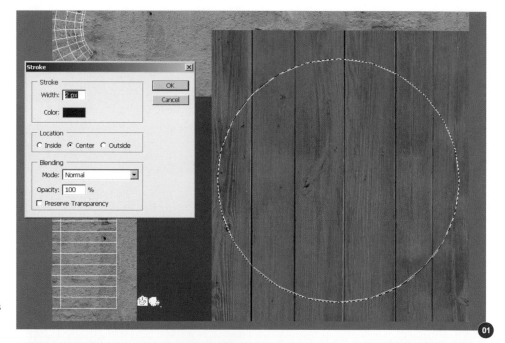

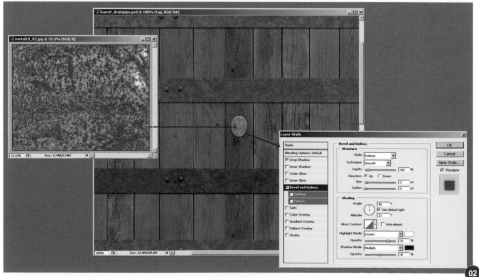

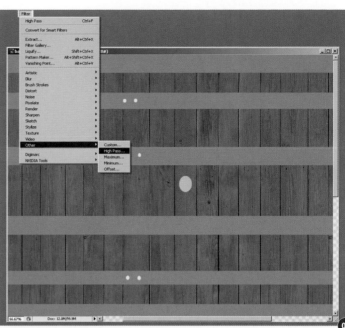

saw that it was distorted, so I simply scaled it horizontally until it looked correct in the render. You can do it this way, or you can alter the UV coordinates, depending on which is the easiest option for you.

Bump Maps

This concludes all the detail necessary for creating the Bump map, as dirt and staining etc., is not relevant because it has no depth on the object itself.

To create the Bump map, first remove all detail that does not actually affect the volume of the object. These are:

- Layer Styles, as these represent lighting effects and as such are without volume
- Stains and overlays that just affect color.

In **Fig.03** you can see that the wood and metal overlays have been switched off along with the

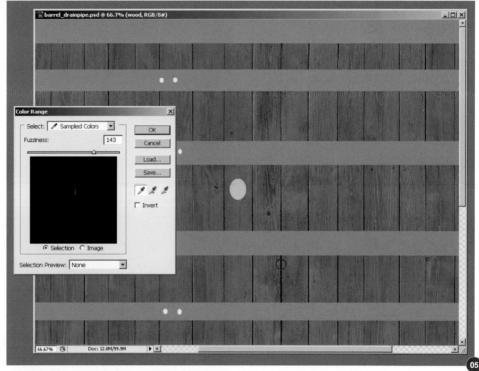

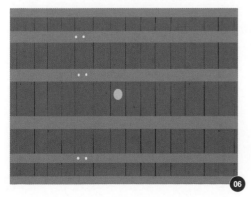

Layer Styles on the plug and studs (these have been made lighter so they are visible). These four components are the key layers we require, but the metal, studs and plug can be a flat color and so are simple to convert.

To do this go to Filter > Other > High Pass and ramp down the value until you have a pure gray.

Bump maps use grayscale values to determine depth; the darker the color the more it recedes,

and vice versa. Therefore, after applying the filter, alter the brightness accordingly (**Fig.04**).

Next is the wood, which is a little less straightforward. Some people simply desaturate the layer and then alter the Curves to create the Bump map, but I find it is more effective to use Select > Color Range to do it in stages.

Use the sampler and select one of the darkest areas (see the red circle in **Fig.05**). Now

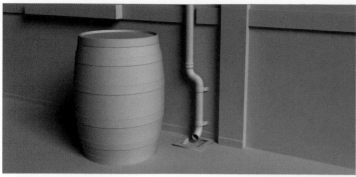
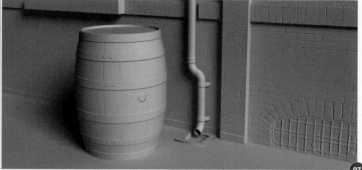

alter the Fuzziness value until you contain similar values across the layer. Desaturate the selection and apply the High Pass filter.

Now invert the selection area and do the same thing again. Once done, you will have something similar to **Fig.06**. If you feel that some of the wood grain is too noticeable, simply reduce the contrast or paint over the suspect areas with a semi-opaque gray sampled from the texture.

When the Bump map is applied to the barrel you can see what a difference this makes (**Fig.07**). Smaller volume details such as the metal studs, wood grain and even the brickwork and mortar can be represented well by a bump map, as long as the camera does not get right up close. In this instance, as the tutorial is concerned with texturing, I have decided to describe the vent through a bump map as it is near the surface of the wall.

Color Overlays

You may remember that the brick texture, once tiled, showed problems relating to repeatable patterns. You could clone and stamp these out using the Clone Stamp tool, but another effective way is to use an overlay texture.

Fig.08 shows the brick texture and tiling problems (please ignore the darker band along the top because I altered the brightness to conform to a section that would have been rendered in concrete at one stage).

To show that these bricks were once concealed I select the painted section from "brick_02_V2" from the Total Textures Volume 2 – Aged and Stressed DVD, and paste it into the upper section, and will eventually set it to Soft Light 100% (shown in Normal mode in **Fig.09**). I also

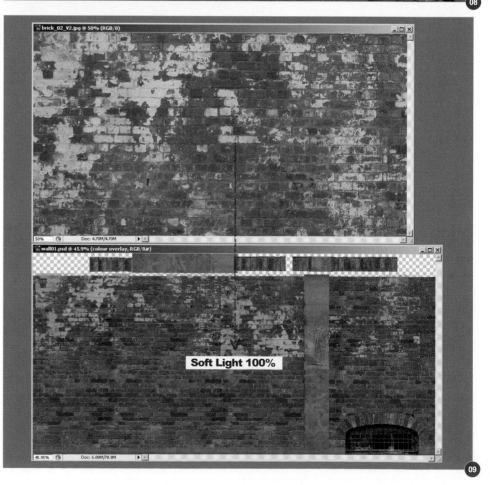

use one of the overlay textures ("overlay01") from Total Textures Volume 1 – General Textures DVD, which I color correct and then set to Soft Light at 63% opacity. Here it is in Normal mode at 100% (**Fig.10**).

When the two textures are applied you can compare the final result in **Fig.11** with **Fig.08**. There are still a few problem areas, but by following this quick procedure you can add variety to your textures and also reduce the amount of clone stamping needed.

It is also advisable to add all of the elements before you start cloning, because you may well be working on areas that will be hidden – in this case by some concrete render. In **Fig.12** you can see that I have used sections from two textures to create the worn render ("misc19_V2" from the Total Textures Volume 2 – Aged and Stressed DVD, and "window_06" from the Total Textures Volume 19 – Damaged and Destroyed DVD). I use the Lasso tool to select an irregular selection area, and then use a textured eraser tool to soften the edges and blend it into the brickwork.

The floor is built up in exactly the same fashion. In **Fig.13** you can see the numerous images

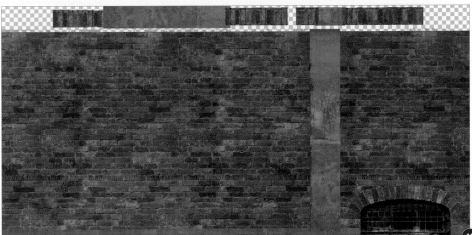

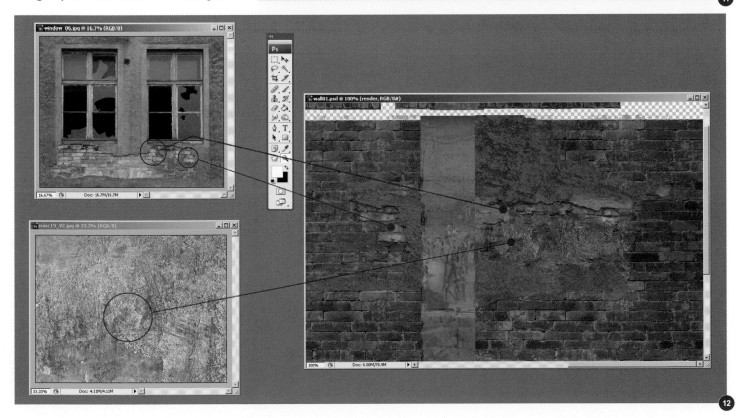

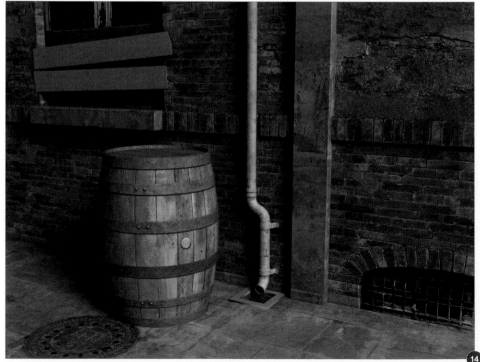

that have been used to create the floor and their corresponding layer blending modes and opacities. The layer set to Overlay covers all of the stone and helps relieve the tiling issues, but because the barrel will disguise

part of the texture I don't alter it further. I use a section from the vent photo itself to help blend it with the floor plane, and use Select > Color Range to sample the orange tinted areas from "stone02_V2".

To help set the manhole into the stone I add an Outer Glow layer style using the same color as the grout, along with a Drop Shadow. There are a few dark lines painted on a separate layer, called "manhole edge" (seen in the layers palette in **Fig.13**), which show some small gaps and cracks around the cut slabs.

Fig.14 shows the state we are at now, with the render added to the wall along with the corresponding Bump map, together with the floor texture. You can see at the moment how the 3D edging at the base of the wall behind the barrel differs from the 2D version left of the vent.

Specular Maps

We have seen how effective Bump maps can be, but Specular maps are of equal importance and essentially determine the shininess of a surface. These are also Grayscale maps with whiter areas showing more specular intensity and reflectivity.

To start the map, first create a new layer and fill it with black (Layer 12 in **Fig.15**), and then place this below all other layers that will be

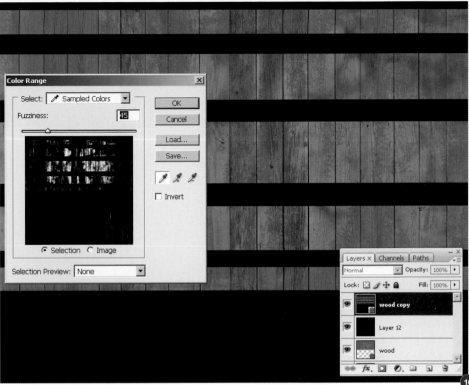

relevant. I also duplicate the wood layer as a precaution (wood copy) and place this above the black layer.

Now go to Select > Color Range, pick one of the lighter areas and then alter the Fuzziness value until you have a satisfactory selection (**Fig.16**). You will notice that I have already deleted the wood sections below the metal, which are irrelevant.

Click "OK" and then copy and paste this selection into a new layer and desaturate it. I call this "specular wood", which you can see above the base black layer in **Fig.17**.

This process can then be repeated for all sections of the texture. It is a good idea to use

your PSD file so that you can mask selections quickly and accurately, for example the details and dirt layers.

In **Fig.18** you will notice that the plug and studs are brighter, as they will reflect more light. You can also see from the layers palette that the dirt and grime layers are also present, unlike the

Bump map. This is because these will affect the way light bounces off the materials, so any areas like this should be set to Multiply and retained, for example the drain rust/dirt.

When the Specular map is applied you can see the subtle enhancement it creates when compared to just a color and bump map

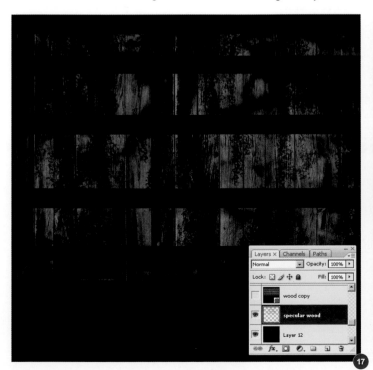

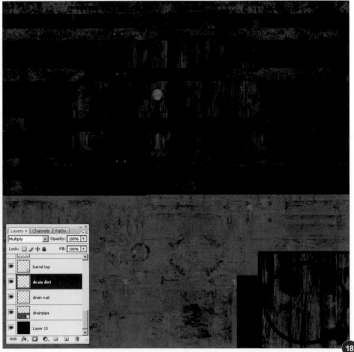

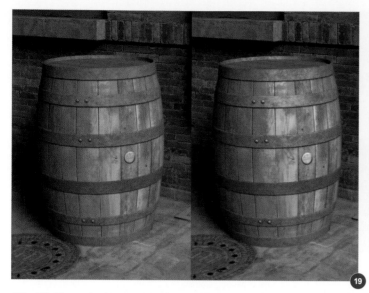
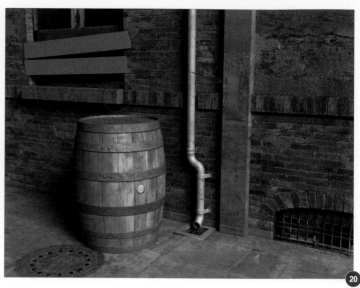

19

20

(**Fig.19**). If you need to emphasize the effect, either ramp up the amount in your 3D package or increase the contrast on the map itself.

Creating and Softening Edges

The less geometry there is in 3D models, the more we need to rely on texturing for detail. I add a small chamfer to the edges of the concrete column and windowsill in the scene,

but because they have no subdivisions they have pure angles with no deviation along the edges. When you are working with a restricted poly count it is necessary to decide which areas will require more geometry, which in this case is the drainpipe.

In **Fig.20** you can see where the edges appear crisp and show no signs of wear, which does not appear in keeping with the scene. We shall

add some highlights to help soften the edges and also put in some chips and cracks to help disguise the straight edges.

To create highlights you can duplicate part of the wireframe guide and then blur it, as this will correspond exactly to the actual edge, or you can add a new layer set to Soft Light and use white to highlight edges.

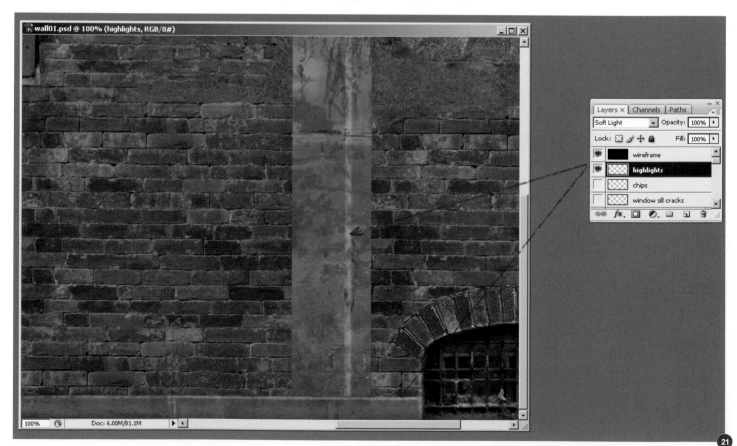

21

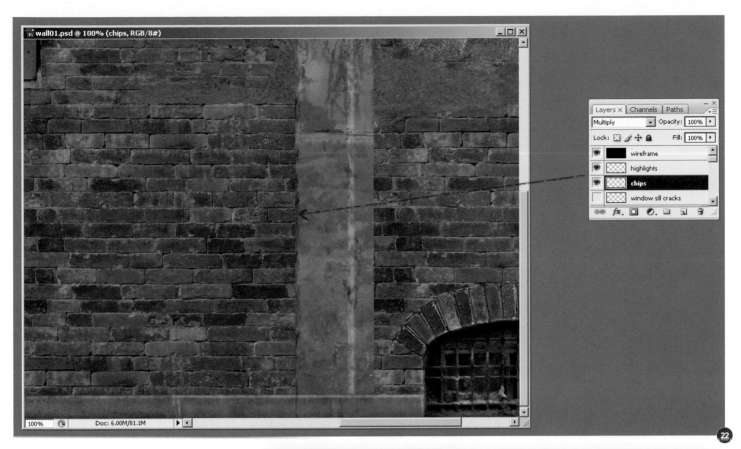

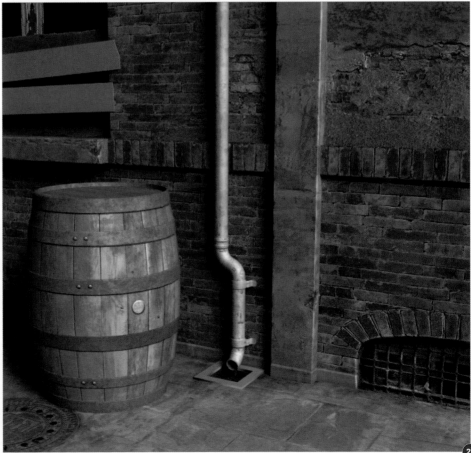

Next I add a highlights layer; using a brush I paint in the white lines, which are then blurred (**Fig.21**).

To help further, I paint some chips along the left edge of the column, along with some small cracks on the windowsill which I clone from one of the concrete render layers (**Fig.22**).

In **Fig.23** you can compare the "before and after" results and see how the painted highlight along the concrete skirting has now integrated this part of the scene, demonstrating how textured detail can successfully substitute geometry in certain instances.

The painted highlights help to show a more worn edge down the column, and the chips on the windowsill help to disguise the right angles.

You can download the Total Textures that accompany this tutorial from: **www.3dtotal.com/ p3dresources**.

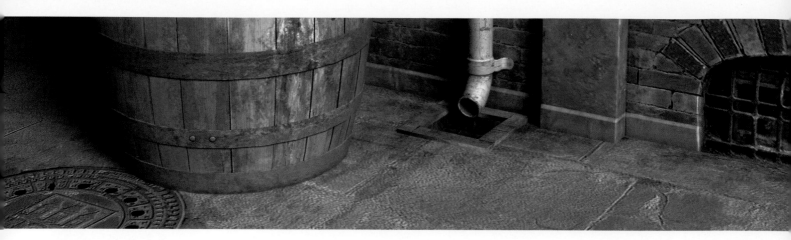

Dirt and Grime
By Richard Tilbury

Introduction

Note: All textures used can be downloaded from the link at the end of the tutorial.

In this final section we will go on to complete the texturing of our scene and have a look at adding dirt and grime.

First of all we will finish the barrel, as this is one of the key focal points. We have already given the wood and metal an aged quality, but we can now start to add the small number of details that will give it character and make it appear more authentic.

Barrel Stains

I select one of the Dirt maps from Total Textures Volume 2 – Aged and Stressed DVD and paste this in as a new layer (**Fig.01**).

I invert the image (Ctrl+I) and then use Image > Adjustments > Color Balance to give the dark areas a reddish tint. I then scale and move it to fit the template, setting it to Multiply with 27% opacity.

I use the Clone Stamp tool to modify the pattern across the barrel and a soft edged eraser to better blend it in with the wood.

To show that the barrel has been used to store ale or liquor it needs some staining around the tap itself. You can do this by either painting it in using a textured brush or alternatively cloning sections from one of your dirt maps, which is what I am going to do in this case. I use two

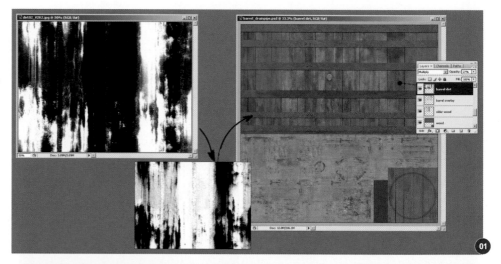

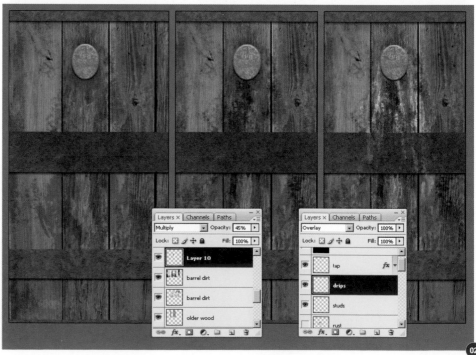

separate layers to do this; one using black and set to Multiply and one using a pale gray set to Overlay.

In **Fig.02** you can see the effects of applying these and the corresponding blending modes. I decide to have the darker stains below the metal as I'm going to add rust in this area, but the lighter drips work better above the metal.

To add the rust I use "metal14" and "metal15" from Total Textures Volume 2 – Aged and Stressed DVD, both of which are set to differing blending modes (**Fig.03**).

As per usual I scale these accordingly and edit them to best blend in with the texture.

One last aspect to be added is the line of dirt around the base of the barrel, which I do by using another dirt map. The way I do this is by pasting in a dirt map along the base, then using the Eraser tool to create the desired marks and setting it to Multiply at 100% (**Fig.04**).

This concludes the texturing of the actual barrel and we can see how the culmination of all these extra details helps create a rich surface on the object (**Fig.05**).

Dirt Maps and Masks

We can use similar techniques for the wall texture, which can be broken down into three key stages:

- Invert the map
- Color correct it
- Set the blending mode to Multiply and reduce the opacity.

These three stages can be used to create the grime that builds up under the horizontal bricks

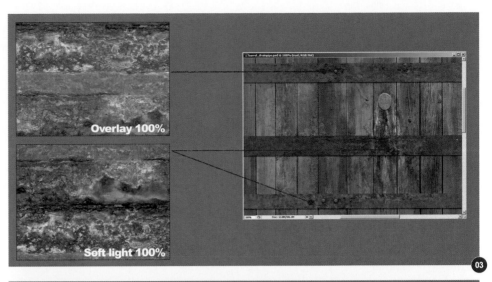

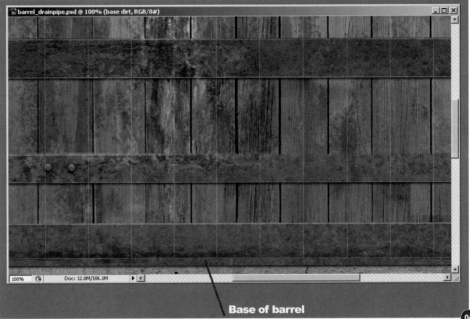

Base of barrel

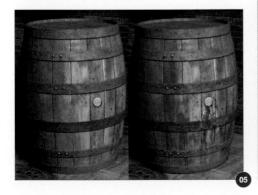

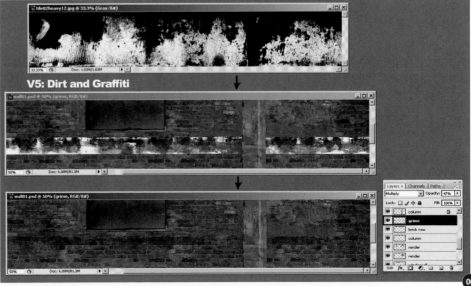

V5: Dirt and Graffiti

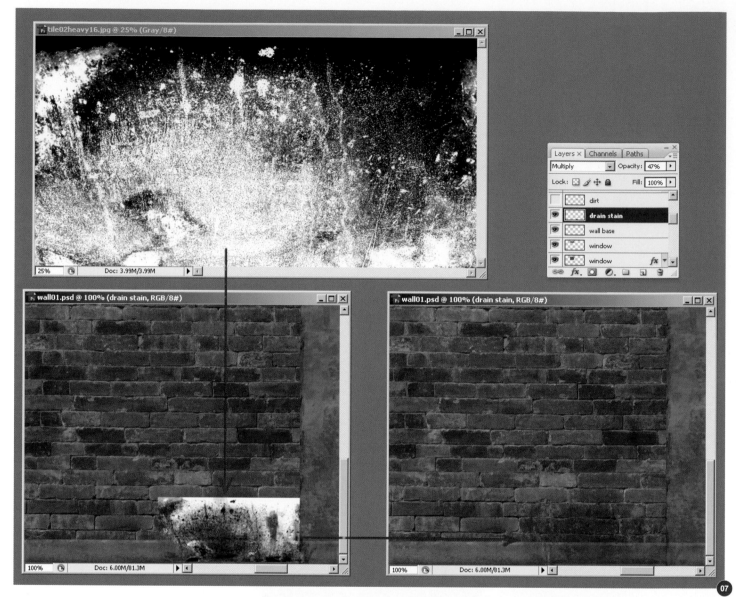

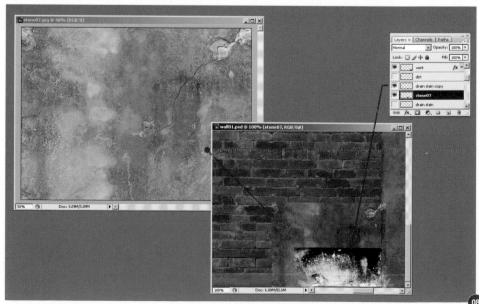

under the window. I choose to use "tile02heavy" from Total Textures Volume 5 – Dirt and Graffiti DVD, which has a wide aspect and suits the area in question. I flip it vertically, invert it and then color correct it before setting the blending mode and opacity (**Fig.06**).

I follow the same steps to create some staining around the base of the drainpipe (**Fig.07**).

There is an alternative method for doing this if you wish to add some extra detail into the stain or dirt itself, as opposed to having a more monochrome and "all over" look.

In the top left of **Fig.08** you can see I have found an image of stone that looks as though it could be modified to suit the context. I copy this

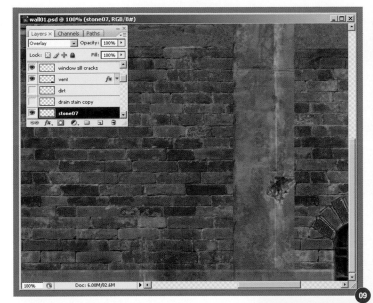

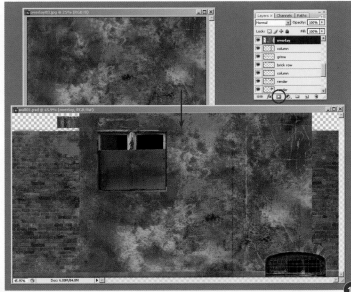

and then position it into the template (stone07 in the layers palette) with the drain Dirt map placed above it (drain stain copy).

If we now delete the black area of the map it will reveal the stone below and so once we set the blending mode to Overlay we have a different variation of our stain (**Fig.09**).

Another effective method of applying grime in a more liberal way that can offer the chance of further editing later on is by way of Layer Masks.

The first stage is to select a texture to represent your dirt or grime; in this case an overlay map from the Total Textures Volume 1 – General Textures DVD (top left in **Fig.10**).

It has been scaled down and color corrected and is the layer called "overlay" in our palette. The next step is to add the Layer Mask (small icon ringed in red), which will add a new thumbnail window beside the current one in the layers palette.

By using a brush set to pure black, simply start painting out the areas that are not required (**Fig.11**). You can see here that the map has been hidden across the wall, but it is evident along the column and windowsill as determined by the white "T" shape in the mask thumbnail.

The great thing about this method is that you essentially have a dirt map that can cover the

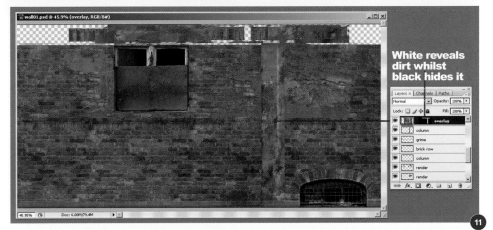

White reveals dirt whilst black hides it

entire template. You can hide areas by using black or alternatively reveal them by using white. The form and pattern your grime takes depends upon your brush, so a textured one with some scattering will prove useful.

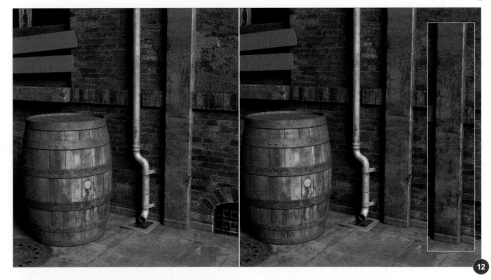

Once satisfied, change the blending mode and the opacity. That way if you wish to modify it in the future then you can just paint into the mask with either black or white – it's completely non-destructive.

In **Fig.12** you can see the wall before and after the dirt and grime has been added, and the subtle differences it makes. The dirt along the column is perhaps a little too subtle so by altering the opacity slightly we can see more of a difference.

Flagstones

The flagstones are looking somewhat clean by comparison, especially around the drain, and so this will be the next area to address. The foreground is the key area as the section behind the barrel is mainly in shadow.

I select a dirt map from the Total Textures Volume 5 – Dirt and Graffiti DVD, which I then position along the edge of the wall and set to Multiply (**Fig.13**). You can also see that I have added a soft shadow border around the drain (drain shadow) as well as using a subtle Drop Shadow.

In order to show that water has spilled beyond the drain itself, I decide to add the same Dirt map that was used on the wall, which I then tint green to convey a moist, algae-coated surface (**Fig.14**).

One remaining thing to do on the floor texture is to add some dirt stains around the manhole cover. For this particular section I clone sections from some of the Dirt maps I have used in my template and randomly place them around the circumference (**Fig.15**). You can see the final version on the right set to a darker color, and on the left is the same layer set to Multiply so you can better see what it looks like.

When we render out the recent additions you can see the difference it has made (**Fig.16**). You can only see part of the dirt around the manhole cover due to the camera angle.

Perhaps the stone adjacent to the left side of the vent could have the dirt reduced, as the top image adds a spatial element which is less apparent in the lower render.

This about concludes the main approaches to weathering our scene and all that is left to do is texture the wooden boards across the window, along with the section around the drain. The Specular and Bump maps are still absent from

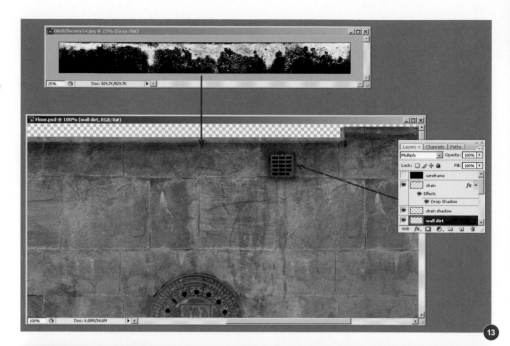

13

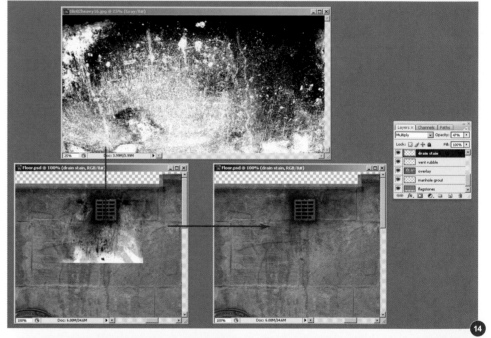

14

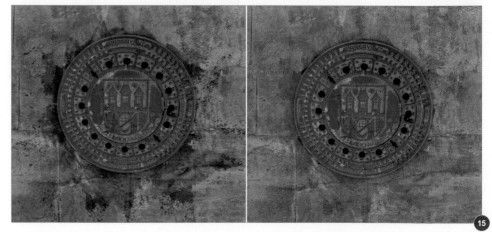

15

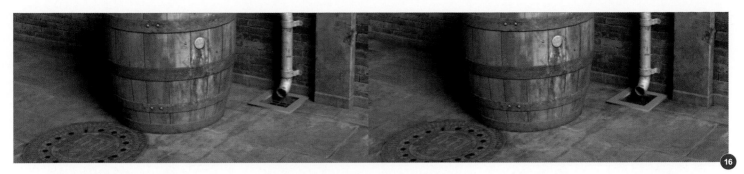

the wall and floor, but these can be created in the same way as already outlined in the previous section.

Conclusion

We have reached the end of this tutorial now and have seen how textures can be used to describe detail that is absent in the actual geometry. Hopefully you will have been given a glimpse into some of the methods used to

add various levels of detail on your texture templates and in turn, how these can enhance your 3D scenes.

As with most types of artwork, whether 2D or 3D, the best practice is to look at the world and observe how things look in reality. Find reference material that relates to your subject and it will provide much of the detail that makes the difference in your final models and scenes.

You can see the final version of the scene here (**Fig.17**).

You can download the Total Textures that accompany this tutorial from: **www.3dtotal.com/ p3dresources**.

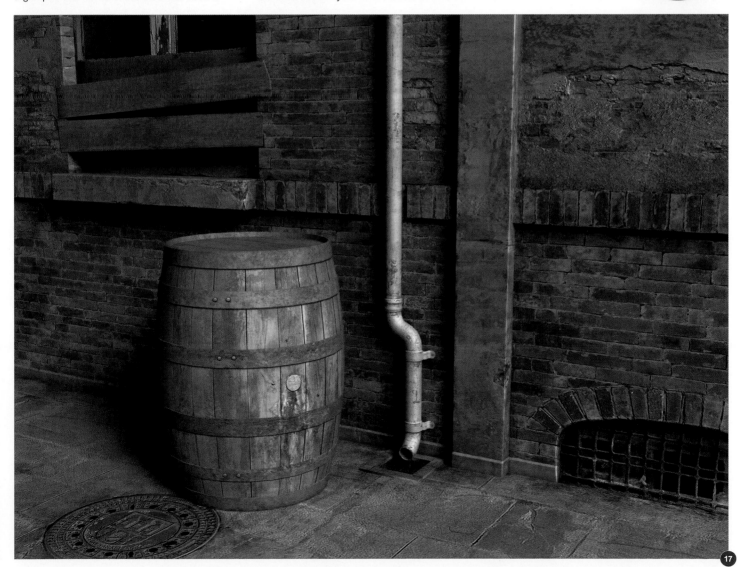

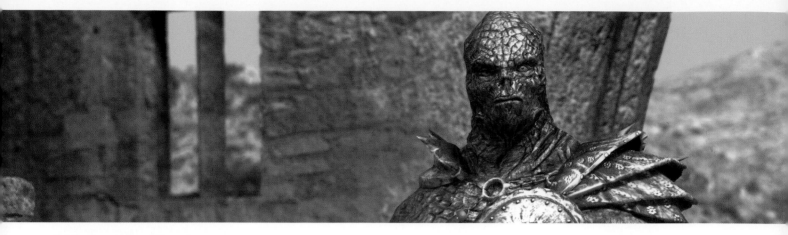

Character Textures
By Richard Tilbury

Introduction

This tutorial focuses on characters and will use an example model created by Pavel Terekhov. He has kindly permitted us the use his impressive Dominance War entry, a creature called Bubboka, as a basis for the tutorial so many thanks to Pavel for providing his model.

The character in question has been modeled in both a high and low poly state, so that a normal map can be extracted from the more detailed version. This is typically done in ZBrush nowadays and is a common technique employed in a large proportion of next gen game development to help minimize the poly count with as little loss of detail as possible. As Normal maps rely on high poly meshes for their information and are generated automatically within 3D software, they do not fall under the

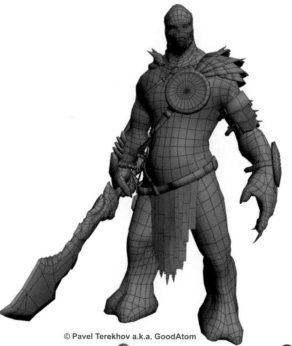

© Pavel Terekhov a.k.a. GoodAtom

banner of traditional texturing and hence will not be covered in much detail. Instead we shall outline the process of building up the Color or Diffuse map, and in turn look at how this can be used to create the Specular map. Current CG practices often employ an array of different maps that combine to form the final image and can include anything from the standard Diffuse, Specular and Bump maps through to Z-Depth, Occlusion and Reflection maps alongside those attributed to Subsurface Scattering.

Maps are integrated with shaders within the 3D packages and many are set up within the

material and rendering environments, but the key map which more than often requires the use of Photoshop is the Diffuse or Color map. This is where the overall look and color scheme is established and is the map that probably has the most influence over how we read or view a texture.

Creating the Skin

Fig.01 shows the low poly un-textured character. The model has already been unwrapped by the author and here we can see the template that has been provided (**Fig.02**). The high poly mesh was used to generate the following Normal map, which we shall utilize in our texturing process (**Fig.03**).

In **Fig.04** we can see how the Normal map affects the character on the right, compared to the opposite version which looks far simpler. As previously mentioned, this map is derived directly from the high poly model and is used to create the illusion of extra geometry, but it can also be used to enhance the Diffuse map and we shall look at this later in the tutorial.

It is common practice in the games industry to use an automated method of creating maps that helps contribute much of the detail in the Diffuse map, incorporating Cavity and Occlusion maps that can be combined to describe the volume and create much of the shading. Programs such as xNormal have been used extensively to carry out these very tasks and have proven an effective way of automating what was once a manual process. However, in this case we will use Photoshop and the Normal

map to recreate a similar result and show how texture baking, which is common across 3D software, can be used to generate Occlusion maps.

Fig.05 shows the wireframe export, which will remain at the top of our PSD and is set to Screen blending mode at 28% opacity, thus enabling us to see where we are painting throughout the process. Below is the initial skin layer, which is currently a dark gray and is limited to those areas that make up the actual body parts. As we already have the Normal map we can take advantage of the information

it carries and use it as a substitute cavity map to help define the reptilian nature of the skin. I first duplicate the Normal map and desaturate it before deleting the sections that do not correspond to the body. **Fig.06** shows this new layer below the wireframe (Normal map overlay), which is currently set to Normal. The blending mode will need to change in order for the skin layer to be visible and so may require some Curves adjustment.

Fig.07 shows the layer set to Vivid Light at 56% opacity, which provides some detail of the scaly structure as well as revealing the skin tone

Soft Light
100%

Soft Light
56%

beneath. This will contribute some extra depth
and volume to the skin and will also help as a
guide when highlighting some of the scales. In
order to add some randomness to the skin we
shall add two textural overlays, which in this
case have been taken from the Total Textures
Volume 11 – Alien Organic DVD. The first can
be seen in **Fig.08** from which I have selected
the lighter areas and then pasted them into the
template. This was then scaled accordingly
and duplicated to fill the three sections. Notice
I have reduced the scale across the face, albeit
in a crude fashion, but once the blending mode
is altered to Soft Light the transition will be
barely noticeable.

The second texture can be seen in **Fig.09**
which will also be set to Soft Light eventually
but with some transparency. You can see
in both instances that they have been color
adjusted with the saturation reduced. When
both layers are set to their appropriate blending
modes they add a subtle pattern across the
skin that helps create a random quality seen in
nature (**Fig.10**). Using the desaturated Normal
map as a guide, I add a new layer set to Normal
mode and then start to paint in some subtle
highlights using a warm brown (**Fig.11**).

A very useful and time-saving technique for
adding shadows and highlights can be achieved
through the Ambient Occlusion map. Typically
this is one of the most crucial aspects regarding
how we interpret a texture as it determines the
illusion of volume where there is none. With
the advent of the Normal map it is perhaps less

Normal
100%

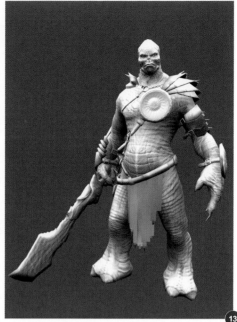

important but nevertheless plays an important role still. Most 3D software supports texture baking, which is how maps are generated, and despite me running through the process in 3ds Max, the principals are universally applicable.

The first step is to create a light dome rig, which you can see in **Fig.12**. This involves a series of low level spotlights that will generate some global illumination. Ideally your character would be in a neutral pose in order to receive

symmetrical and even lighting conditions, but for the purposes of the tutorial we shall use the current posture. When rendered the character looks similar to **Fig.13**, which demonstrates some soft edged shadows from a general overhead source which we shall now "bake" into our texture template. In Max you can find this under Rendering > Render To Texture. The important factors are that the relevant mesh is selected and that it uses the existing coordinates from the UVW Unwrap (**Fig.14**).

The next stage requires that the map output is selected, which in this case will be our Diffuse map, and that the size matches our template, which is 2048 x 2048 (Fig.15). With these settings active all that is left to do is hit "Render", which will result in the lighting information from the dome rig being baked into our template (Fig.16). This Occlusion map can be added into our PSD and the brightness and contrast settings adjusted accordingly. The best blending mode to use is Multiply, but because

our skin texture is quite dark already it is not as influential as it would be if the character were paler. **Fig.17** shows the head with the new map applied on the right. As you can see, this immediately outlines the features and main shadow areas.

Using this as an additional guide I then go back to the layer seen in **Fig.11** and start to add some extra shadows to the eye sockets and mouth. In order to further emphasize the scales I duplicate the grayscale Normal map once more (**Fig.18a**). One final refinement that helps are a few highlights across the forehead and cheekbones (**Fig.18b**). You can see now how the texture overlays become more apparent as a speckled pattern across the skin, especially where the skin is lighter. This procedure is repeated for the remaining body parts and once finished we can see the result of this skin on our character (**Fig.19**).

Armor and Clothing

In the case of metal and cloth, the best starting point is to find suitable photographs that can be used as a base texture from which to build the detail. **Fig.20** shows such a photo from which I have taken the basis for the shield texture, which just so happens to be an actual shield. Any metal that displays the qualities needed is fine and it could just as readily be a warehouse door or a panel from an old aeroplane.

As a general rule it is good to find images that do not have any stark shadows and highlights, as the light source will be determined within the game environment. This example is not ideal for these very reasons, but there are a few simple steps you can follow to remedy this. First make

Select – Modify – Feather – 30 Radius

21

22

23

24

a rough selection area around the section you wish to correct and then go to Select > Modify > Feather and enter a Radius value that creates a soft edge (**Fig.21**). Now alter the brightness and contrast using one, or a combination, of Curves, Levels or Brightness/Contrast (**Fig.22**). If necessary you can also color correct the area using Color Balance or Hue/Saturation (**Fig.23**). The last stage utilizes the Clone Stamp and Healing Brush tools, which can remove obvious seams and unwanted details (**Fig.24**). These four steps are a useful way of tidying up inconsistent lighting and creating a neutral texture. They can be applied in any context and can prove a time-saving device if you have trouble finding a perfect photo.

The detail in this particular shield is partially limited by the Normal map (**Fig.20** inset a), hence the gold star that corresponds to the center. To add some interest I decide to have part of the shield made up from a different metal and so make a new layer and block in a circular band which I then set to Soft Light (**Fig.25**). This blending mode is perfect for adding color variations whilst maintaining the metal base texture. Compare this circle with the star shape, which has been made by modifying the color of the base metal directly. This technique is equally applicable for adding multiple levels of detail, as shown in **Fig.26**, which shows the combination of two metal textures.

A feature I want to include are studs which will appear on the leather belts and straps as well as the shield. There are already studs on the shield evident in the Normal map and so I can use these as a guide to positioning the

Soft Light 25

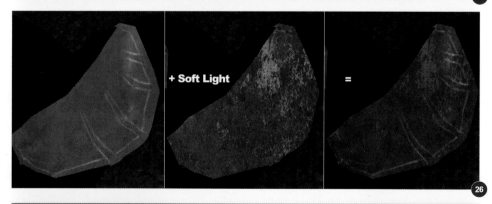

+ Soft Light = 26

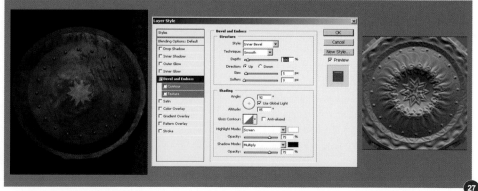

27

painted versions. The obvious way to create these is to find a photo that can be used (see photo in **Fig.20**) or alternatively make them in Photoshop, which is straightforward. Start by creating a circular selection area and then fill it with the relevant metal color. Next you need to go to Layer > Layer Style > Bevel and Emboss and select "Inner Bevel" (**Fig.27**). Here you can adjust the shape and extent of the stud and, more importantly, the direction of the light, which generally works best when it is assumed as being overhead. You can see how the Normal map has provided the stud positions and how the Layer Style has used a bevel to good effect. Another aspect that helps is the addition of a Drop Shadow, which is found within the same dialog box (**Fig.28**) and suggests the accumulation of dirt and grime as well as emphasizing the volume.

For the studded leather I simply sample a photo and then color correct it before scaling and duplicating the section to make up the rest of the clothing (**Fig.29**). I then use the Clone Stamp tool to make a continuous piece of leather. The stitching along the strap is sampled from a different photo, but with careful color correction and considered cloning this can be integrated.

I follow a similar method to create the blade of the sword (**Fig.30**). If two separate photos are combined with a Normal blending mode then image adjustments such as those used on the shield are necessary to unite them. However if you wish to "overlay" textures then the library of blending modes such as Soft Light, Overlay etc are great.

For example, I often create a separate layer for the highlights and shadows when texturing a character and set the blending modes to Soft Light and Multiply respectively (**Fig.31**). On the left is the base skin texture with both the highlights and shadow layers disabled. Next along we see the shadow layer enabled and the corresponding blending mode. The following version shows this along with the highlights layer, which is set to Soft Light. You may ask, "Why not paint these in Normal mode?", and indeed they could be, but it is when you have detail across the skin that the answer becomes clear. On the far right I have quickly painted in

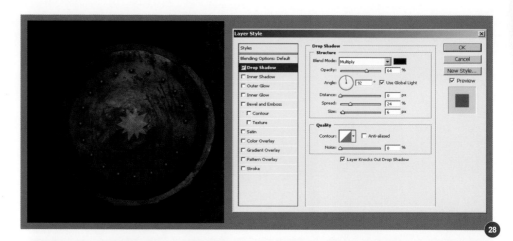

28

29

30

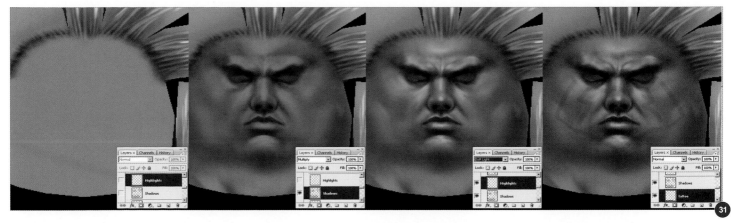

a tattoo (not realistically I grant you) to illustrate that details can be added whilst still maintaining the integrity of the lighting which is, after all, an independent factor. Separating layers and using blending modes allows you to change components swiftly without having to repaint everything, as well as gaining appreciation from your art director.

Another layer that I employ separately is dirt and grime, which is generally set to Multiply or Darken, and handles all the dirt across the whole texture as long as the blending mode is the same. It is helpful to structure your PSD in a way that other artists can follow because there is nothing quite so inconsiderate as being given a texture with forty plus layers all named "layer1", "layer2" etc., and no explanation as to what each refers to.

Fig.32 shows part of the dirt layer across the shield (a). The obvious source for this is a custom-made dirt map, which is simply a grayscale texture extracted from a worn surface. Quite often I color tint the map but this depends entirely on the context. Once the map has been applied it is then a case of using the Eraser tool to concentrate it in specific areas such as crevices; in this case around the studs and along the sunken center of the shield.

Fig.33 shows the map with a slight color tint, as well as a duplicate of the Normal map overlay to exaggerate the effect.

Specular map

Once the Diffuse map is made you can then use this to create the grayscale Specular map, which determines how a surface reacts to light. The main rule to remember is that the whiter

the area the more reflective it will be and vice versa. The first step is to make a copy of your PSD map and then delete any unnecessary layers that will not influence the map. For example, any color tints or pattern overlays across the skin that will not affect the way light

reflects off the scales can be deleted. **Fig.34** shows an orange face tint that can be deleted, as well as the bronze circle around the shield. Both could have been left if they contributed a different specularity, but in this case I don't think they have any impact.

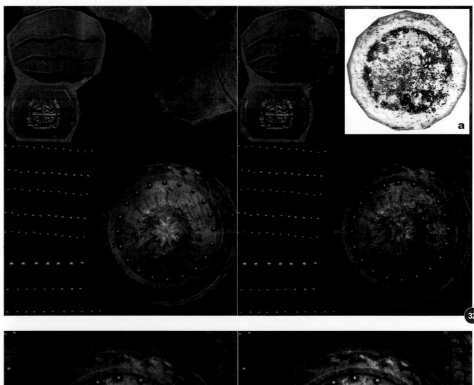

Delete orange tint

Make sure that each layer is desaturated as you cycle through them as we do not want any color information. Retain the Dirt maps and set the blending mode to Multiply as these will generally be areas that are less reflective especially on metal (**Fig.35**).

I use Curves and image adjustments to modify the contrast and increase the brightness of those areas that are more reflective (**Fig.36**). As the sword is worn I make sure it is darker than the edge, which has been crudely sharpened. Sometimes it is possible to desaturate the flattened Color map and tweak the Levels in order to instantly create the Specular map, but often this is at the expense of accuracy as the specularity of each material doesn't always correspond to the tonal range within the Color map. **Fig.37** shows a desaturated color map on the left and an adjusted map on the right that has had the individual components altered separately. Which method you choose depends upon the desired result, but in this case you can see how the studs are far shinier than the accompanying leather and how the hilt and blade have more contrast in order to emphasize the different sections of metal. **Fig.38** shows the character with (right) and without (left) the Specular map applied and demonstrates how it affects a texture.

Putting the character into a scene

Fig.39 shows the base render that has been saved out from 3ds Max and shows our character in a simply textured environment resembling a castle. The texture that has been applied is a generic rock that has been tiled a number of times to achieve the right scale. This provides a decent starting point, but at the moment lacks variation and so some work is required. In order to make the post-work easier I save out a number of separate passes which include the following:

- Background mask
- Object ID

These, along with two other passes, can be seen in **Fig.40**. The Ambient Occlusion and Specular passes will be used later, but the first

stage will be to add in a background. By using the mask I quickly select this area and then choose a suitable image to form the backdrop (**Fig.41**). Then I select the distant hill (1) and paste it into a new layer. The best method is to select the designated area and then use the "Paste Into" function, which creates a layer mask as opposed to Paste. I then roughly select the foreground hill (2) using the Lasso tool and paste this in on a new layer in order to have the option of flipping and rearranging the two hills. Once happy I then blend them together using the Clone Stamp tool and color correct each using a combination of Curves and Hue/Saturation. I make the distant hill deliberately lighter to create some atmospheric perspective and then the two layers are flattened.

The hill ridge seen through the left window is a detail from a different photo, which can be seen

in **Fig.42**. I sample a section of rock along the top and then paste it into the window area, color correcting it to match. You can just see the edge of the tower on the far left of the window and that the image has been flipped horizontally. This is then blended in with the other photo using a similar technique as before.

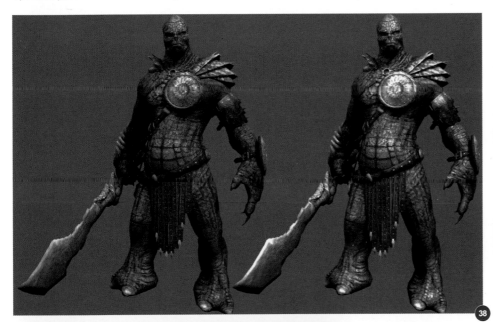

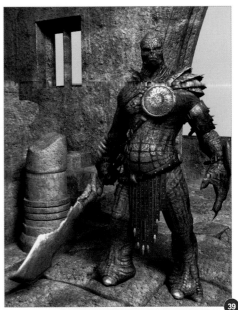

Object ID

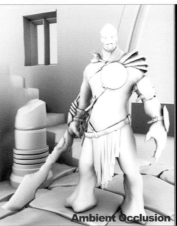
Background Mask

Ambient Occlusion

Specular

With the background complete, the next phase is to add some sand across the stone flagstones. Any kind of dirt or sand will work as a suitable texture, but you can see the one I'm using in **Fig.43**. I paste the photo into my render and then scale it down accordingly before using the Distort and Skew tools to roughly match the perspective. I then duplicate the layer a number of times and move the sections around to cover the gaps between the stone. The key is to color correct the texture to fit with the scene and then use a soft edged eraser to blend the different sections in with the stone floor to create the effect that the sand has blown across and settled in between.

A further detail I want to include are some blood stains on the column to suggest that it has been used for some kind of sacrificial purpose, especially since our character is holding a formidable weapon. If you can find a photo of a bloodstain then this can be copied in but in this case I'm using a default standard brush and manually painting it in. I choose a scarlet color and then set the blending mode to Multiply at 100% opacity (**Fig.44**). The stone pillar could have incorporated the blood stain had it been unwrapped, which would have taken more time, but as it isn't this proves to be a swift approach and perfect for a still. It also means that I can easily add some blood spatters across the floor in the appropriate position.

The other area that needs addressing is the wall, which looks a little bland in the original render. To help alleviate this I source a photo of an old stone wall and then paste it into the render, once again using the Transform tools to match the perspective and scale (**Fig.45**). I

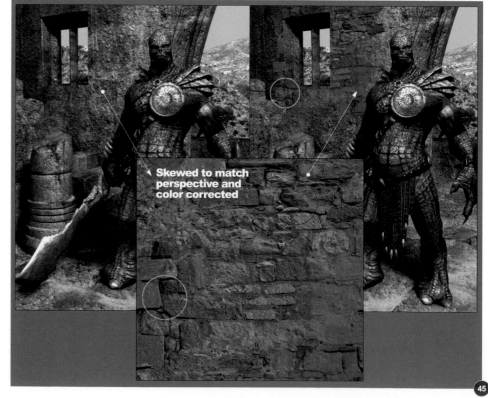

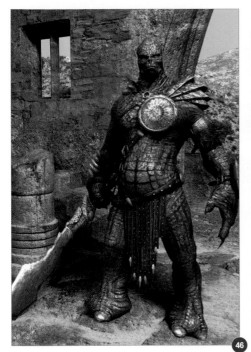

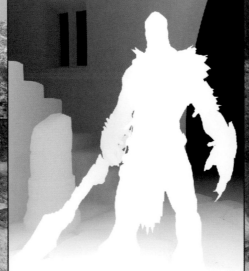

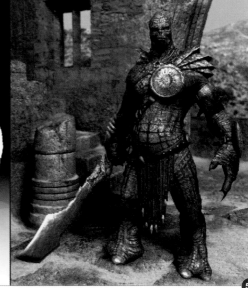

follow the usual procedure of color correcting and blending the texture in, and then, using the Eraser, I delete around the stone work to help integrate them into the wall. I will eventually add some depth of field using the Z-Depth pass and so having these areas perfect is unnecessary.

Fig.46 shows the stage we have currently reached, which you can now compare to **Fig.40** to see how things have progressed.

At this stage I decide to flatten the image as I still have the render passes that can be used to isolate parts of the image. I then do a few minor

tweaks that help to conceal the low poly nature of the scene and add some much needed detail. These can be seen in **Fig.47,** which shows a rough edge to the stonework and areas of sand that have gathered on the steps and balcony. I did both aspects by using the Clone Stamp tool once the image was flattened.

With the image now as one layer I can employ the Z-Depth pass to create the depth of field. The way to do this is to select Filter > Blur > Lens Blur. This brings up a dialogue box with a window showing your render and the various parameters down the right hand side.

The way to apply Z-Depth is to first of all copy the pass into a new channel (**Fig.48**) and then go to Lens Blur and select this channel as the source (**Fig.49**). Alter Radius to generate the desired amount of blur and if the foreground is blurred, check the "Invert" box. **Fig.50** shows the original render on the left, the Z-Depth pass in the center and the final result on the right.

This helps focus attention on the character and brings him forward from the background, but the overall color scheme for both is very similar. To fix this I use a Layer Adjustment (Layer > New Adjustment Layer > Color Balance).

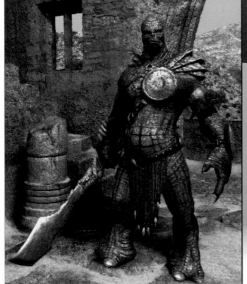

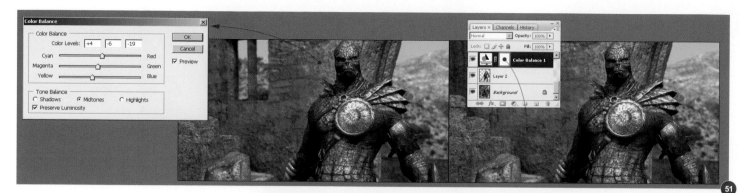

Fig.51 shows the result of tinting the image towards red and yellow and the corresponding adjustment layer in the palette. Using the ID pass I can then select the character and tone-down the color to somewhere between the original and the new version.

One aspect which seems a little inconsistent are the shadows falling across the character, which look too dark given the type of light. I render out a new version with some more ambient light and then copy this into my PSD. **Fig.52** shows the new version on the right, which has more fill light in the darker regions and reveals more of the texture under the arms and down the left of the legs (see inset).

Although the original looked too dark this new version is almost at the opposite end of the spectrum and appears somewhat flat. The Occlusion map from **Fig.41** can be implemented to remedy this.

Fig.53 shows the original map in the upper left inset which I have masked to only coincide with the character. To reflect the environment I tint the map to create warmer shadows and then set the blending mode to Multiply at 30% opacity (see right).

This final stage marks the end of the tutorial, which sees our original render having been transformed into a concluding scene featuring our character (**Fig.54**).

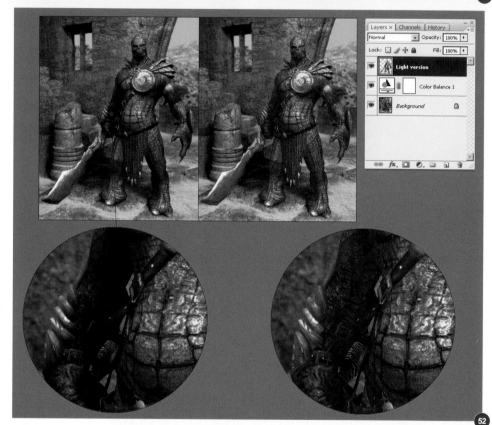

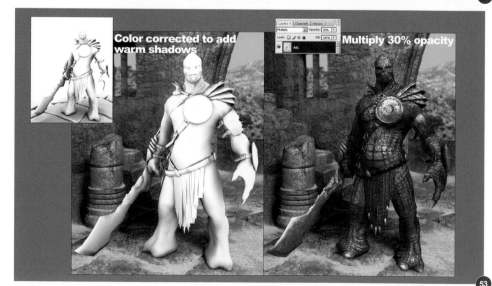

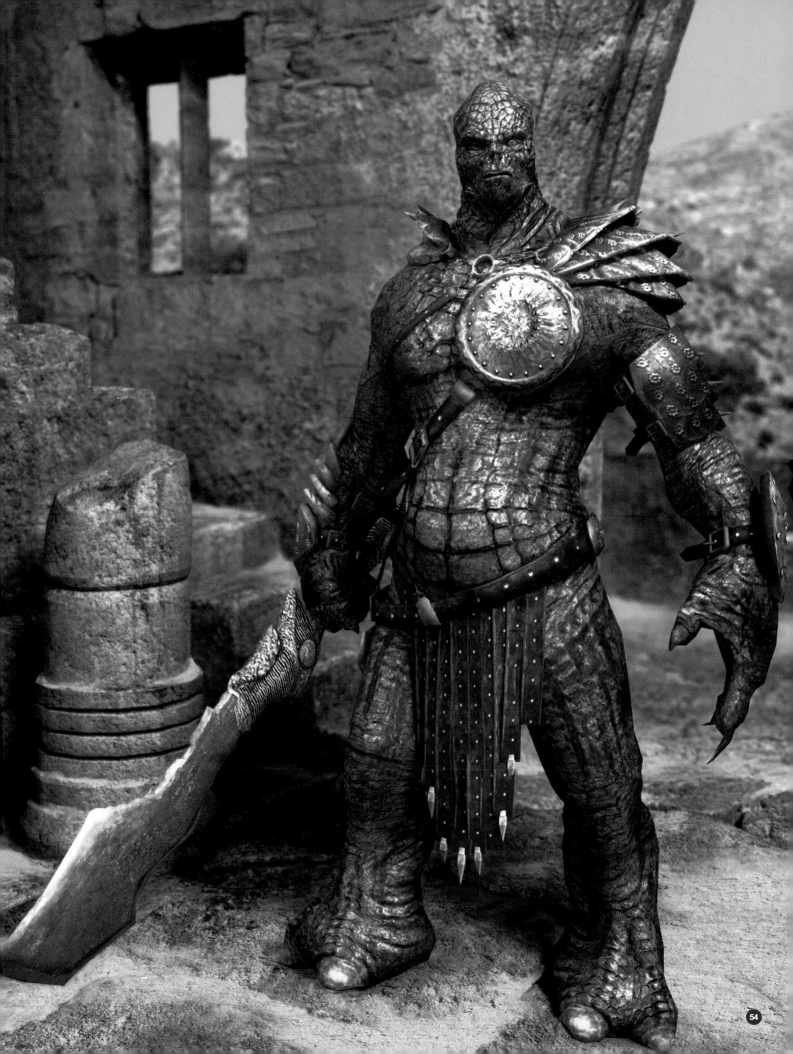

Post-production

Post-production has slowly adopted a more prominent role within the 3D pipeline and is an aspect that exerts a significant influence over the way we view an artist's final image. It has become a way of allowing a level of control and flexibility over isolated components that constitute a render, affording artists the luxury of still being able to redefine their work once the task of rendering is over. Even when separate passes are saved out it is often the case that many fall short of the author's aims due either to time constraints or simply not being able to set up the scene perfectly. All of these issues can be overcome in 3D but as we will see, a 2D approach in Photoshop can prove just as worthy and provide the opportunity to create future variations with ease.

Render Passes
By Zoltan Korcsok

Introduction

This article showcases the tools and settings typically needed for the compositing of render passes in Adobe Photoshop. Rendering images into passes from rendering software makes it possible to modify tone, color and certain effects in the rendered image, without the need to render it again.

Prepare Your Layers

To follow this tutorial, we need to have the following render passes to hand:

- **Final Color pass** – We'll use this pass as a reference for setting up the layer structure. It contains all the final effects, direct and indirect lighting, shadows, specular and reflection effects (**Fig.01**).
- **Diffuse (Total) Shading pass** – This contains the colors of the materials in the scene, and the shadows (**Fig.02**).
- **Specular Shading pass** – This contains the specular effects of the materials in the scene caused by the lighting (**Fig.03**).

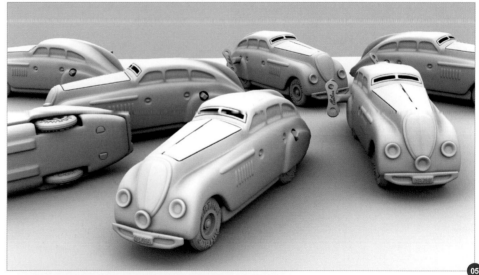

- **Reflection Shading pass** – This contains the reflection effects of the materials in the scene (**Fig.04**).
- **Ambient Occlusion pass** – This contains the ambient occlusion effect; it gives shading to the areas hidden to the ambient light and it shades the more obscure parts of the models in the scene. Using this pass gives more depth to the details (**Fig.05**).
- **Depth pass** – This contains the depth map of the scene measured from the camera. We use this pass in Photoshop to create a lens depth of field effect, amongst other things (**Fig.06**).

Other available passes can be utilized to achieve more delicate effects (e.g. Fog pass, Global Illumination pass, Specular Color pass, and so on).

Step 1 – Creating the Layer Structure

Create the base layer structure using the following order and blending modes (**Fig.07**):

- **Diffuse (Total) Shading pass** – blending mode: Normal
- **Ambient Occlusion pass** – blending mode: Multiply

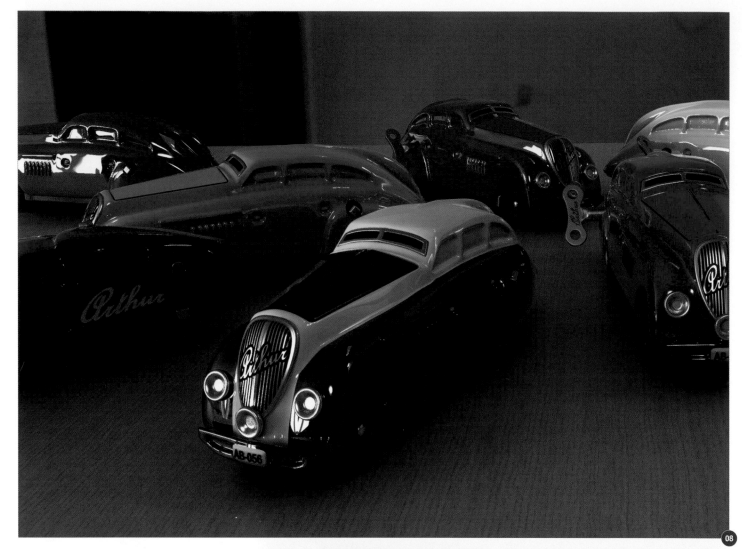

08

- **Specular Shading pass** – blending mode: Screen or Linear Dodge
- **Reflection Shading pass** – blending mode: Screen or Linear Dodge.

Here are the passes combined after putting the above layers together (**Fig.08**).

Step 2 – Fine-Tuning

Comparing the Final Color Output with the image put together using the passes reveals that the ambient occlusion effect is too strong (**Fig.09**). The simplest way to correct this is to set the opacity of the Ambient Occlusion pass layer to 30%. The strength of any render pass is easily adjustable by changing the opacity. The Ambient Occlusion pass can be used for brightening the midtones by duplicating it, and changing its blending mode to Soft Light or Overlay. The strength of this effect can also be adjusted by modifying the opacity.

09

Here we can see the composited image with and without the Ambient Occlusion layer with Overlay blending (**Fig.10 – 11**).

To change the opacity or fill value of a layer, select the layer in the layers palette and set the value using the Opacity and Fill text boxes, or by dragging the slider. Another method is to go to Layer (main menu) > Layer Style > Blending Options, enter a value in the Opacity text box or drag the slider under the General Blending section, and adjust Fill Opacity under the Advanced Blending section. This does not apply to the background layer; it doesn't have such values.

Here we have the settings for the opacity of the layer in the layers palette (**Fig.12**), and the setting of the layer's opacity in the Blending Options menu (**Fig.13**).

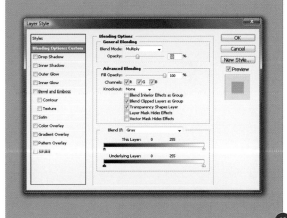

adjustment layer. Set the value of brightness and contrast to +5. To create a Brightness/Contrast adjustment layer, go to the layers palette, click on the "Create new fill and adjustment layer" icon, and select Brightness/

Contrast. Alternatively, you can select Layers > New Adjustment Layer > Brightness/Contrast. Here are the settings for our Brightness/Contrast adjustment layer (**Fig.16**).

Step 3 – Adjusting the Color

The image put together from the passes looks a bit pale compared to the Final Color pass (**Fig.14**). We can make the colors more vivid using a Hue/Saturation adjustment layer, and setting the Saturation to +15. To create a Hue/Saturation adjustment layer, go to the layers palette, click on the "Create new fill and adjustment layer" icon, and select Hue/Saturation. Alternatively, go to Layers (main menu) > New Adjustment Layer > Hue/Saturation. And here we have the settings for the Hue/Saturation adjustment layer (**Fig.15**).

We'll give a bit more contrast to the image now using a Brightness/Contrast

Step 4 – Using the Depth Pass to Make a Depth of Field (Lens Blur) Effect

Amongst other things, we can use the Depth pass in Photoshop to achieve a depth of field effect. This can be done using the Depth pass as a mask. First of all, merge all the passes into one layer (Layer > Merge Visible, or Shift + Ctrl + E), and then create a mask for it (Go to the layers palette and click on the "Add Layer Mask" icon, or alternatively go to Layers > Layer Mask > Reveal All). Turn on and select the Layer Mask in the channels palette, and paste the Depth pass into it.

The blur effect can be achieved using the Photoshop Lens Blur filter (Filter > Blur > Lens Blur) (**Fig.17**). The dialog for the Lens Blur filter contains a preview window where you can see it with the current settings, alongside the settings panel. The Preview section can be found on this panel, where it can be turned on and off, or switched to Faster or More Accurate.

Select the Layer Mask (with the Depth map) from the Source drop down menu of the Depth map section; the filter will generate the Lens

15

16

17

Blur based on this map. The focal distance can be adjusted either by using the Blur Focal Distance slider or by clicking the part of the preview image we want to focus on. The iris' shape can be adjusted under the Iris section; we use Square shape with an Iris Radius value of 25, and Blade Curvature and Rotation both set to the value of 0.

The brightness and threshold of the specular highlights of the image can be adjusted under the Specular Highlights section. In this case we set Brightness and Threshold to 0. The noise of the blur effect can be set up under Noise in the Specular Highlights section; we leave these at their default 0 values for this task. After applying the effect, delete the mask.

In this example, the composition of the image was suitable for a depth of field effect, but this is not always the case. You can see the final composited image here (**Fig.18**).

Tips for Handling Layers

- Another way of setting the layer opacity is to select the layer, select the Move tool, and then type in the number you want the percentage of its opacity to be.
- The mask of a masked layer can be easily switched on and off; just left-click on the mask while holding down the Shift key.
- Putting the layers into sets makes them easy to duplicate, so you can always leave a backup copy of the arranged layers in the file. This can be useful if you merge a set copy for lens effects.
- A layer or layer set can be easily duplicated by grabbing it on the layers palette and dragging it down onto the "Create new layer" icon at the bottom of the palette.
- A new layer set can be created by clicking the "Create new set" icon, which can be found on the bottom of the palette. You can then simply drag the layers into it. Another option is linking the layers belonging to one set with the currently selected layer, and then selecting New Set From Linked on the layers palette.

You can download the render passes that accompany this tutorial from: **www.3dtotal.com/ p3dresources**.

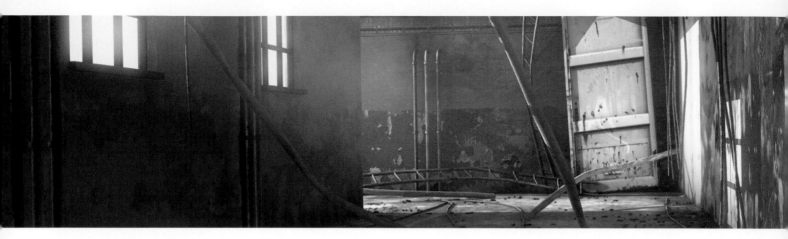

Retouching Final Renders
By Richard Tilbury

Introduction

In the previous section we looked at how various render passes can be composited in Photoshop to create a still image that integrates different components in a scene. We saw how, by rendering these elements separately, it enabled more control and flexibility when it came to producing a final image.

Photoshop is a powerful tool when used in conjunction with 3D renders, and affords the artist the chance to experiment with aspects such as lighting, as well as some of the surface qualities of objects in the scene. It can be a lengthy and time-consuming operation to get a final render exactly right from within the 3D package itself, whereas post-production often proves to be a quicker and simpler solution in many cases.

In this chapter I will assume that you have composited all of your render passes together, a technique described in the previous chapter. Even when separate passes are rendered out it is often the case that many fall short of exactly what the artists would like, either due to time constraints or not being able to set the scene up perfectly. Sometimes it is not possible to unwrap every piece of geometry and hand-paint each texture map to show the appropriate wear and tear caused by either human contact or through more natural means. Adding dirt and grime to specific areas, along with the many subtle details that make a scene tangible, can take many hours to get right through texture mapping and test renders.

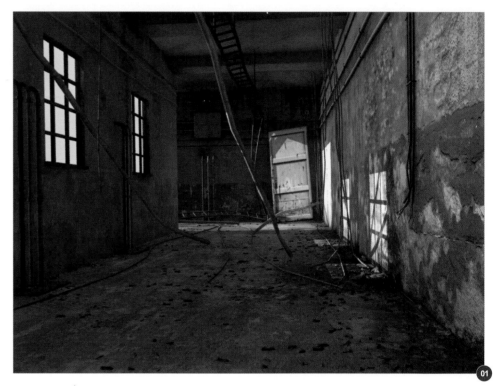

01

One of the other problems facing the 3D artist is finding the right photos at the right resolution, and often the solution comes at a price – namely, tiling. This is an effective alternative, but it does have its drawbacks in the form of symmetry, which is a rare thing.

All of these issues can be overcome in 3D, but as we are about to see, a 2D approach in Photoshop can prove just as worthy – and far more economical with regards to time.

Fig.01 shows our final render, which is made up of the Diffuse or Color pass, the Ambient

Occlusion pass and the Specular pass. All of these have been composited in Photoshop to create the still we can see here.

The scene on first inspection doesn't look too bad – and so it shouldn't given that it has been texture mapped and carefully lit. The right-hand side wall displays richer detail as this is nearest to the camera, and therefore more effort has been afforded to this portion of the scene. The staining along the floor where it meets the wall adds interest and helps integrate the two planes, but the opposite side looks somewhat inconsistent.

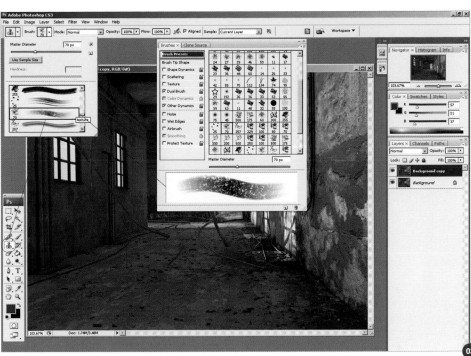

It is true that the same attention could have been equally applied to all areas of the scene, but assuming that time is limited then the less conspicuous sections will be granted swifter treatment.

The key problem areas are highlighted as follows, and indicated on the render accordingly (**Fig.02**):

1 There is evidence of tiling along this lower section of the wall
2. Although the AO pass helps bind the edge where the wall meets the floor, the lack of any dirt makes this area less convincing compared to the opposite side
3. This junction between the wall and ceiling suffers a similar problem, but also shows the edge of a texture overlay running vertically.

The first thing to correct will be the tiling, which can be done by using the Clone Stamp tool. Select a textured brush along the lines of the one shown in **Fig.03**, then hold down the Alt key and left-click on a section you wish to clone, evident by a white crosshair.

Now move the cursor to the area you wish to modify (see the red area in **Fig.04**), release the Alt key, and left-click to begin painting. Alternatively, you can use a graphics tablet instead of a mouse. You can very quickly

remove any tiling this way, and you will notice that I have also modified the seam directly above this section.

Now we will add some dirt to the left side of the corridor, and to do this we can take advantage of the Vanishing Point filter. Start by adding a new layer by going to Layer > New > Layer, or by clicking on the small icon at the base of the layers palette, next to the trash can (**Fig.05**).

Next choose a suitable dirt map (**Fig.06**), and then select the whole canvas (Ctrl + A) and copy it (Ctrl + C). If the map is horizontal, rotate it by 90 degrees, as a vertical map will be easier to manipulate in this instance.

Now, with the new layer selected in the scene file, go to Filter > Vanishing Point. This will open a new window similar to that shown in **Fig.07**.

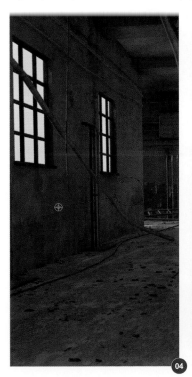

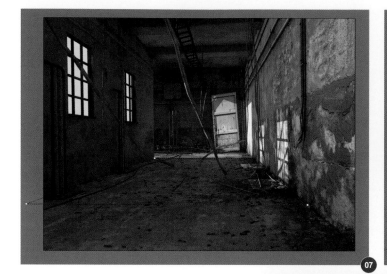

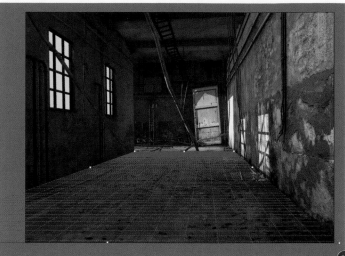

The Create Plane tool will automatically be selected, so simply drag and click to create a grid that matches the perspective of your render. Once you click to establish the fourth corner, a grid will appear and you will be in Edit mode (**Fig.08**).

Use the control points to accurately position the grid and, when satisfied, paste in your Dirt map (Ctrl + V). Left-click on the map and drag it over the grid, where it will automatically align with the perspective, and use the Transform tool to scale and position it more accurately (**Fig.09**).

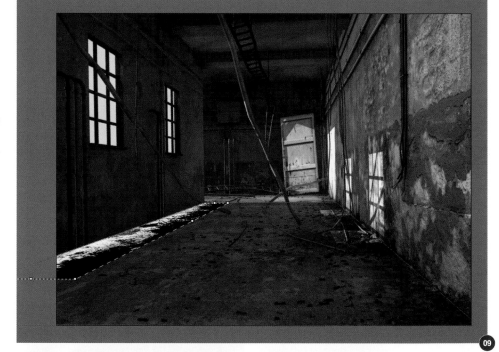

Now click "OK", and you will be taken back to the scene render – except this time with a new dirt map overlaid in a new layer (**Fig.10**).

Now hold down Ctrl + I to invert the map (black becomes white, and vice versa) and then set the blending mode of the layer to Multiply at around 45% opacity (**Fig.11**).

Because the Dirt map was a grayscale map it should have a little color to match the other grime in the scene, so go to Image > Adjustments > Color Balance and add some red and yellow.

All that is left to do now is to use the Eraser tool to delete sections that wrongly overlap, such as the panels below the pipes and the end of the metal pole in **Fig.12**. A tiny amount of blurring (e.g. 0.3) may help blend it in further.

This same procedure can be repeated for the Dirt map on the wall and the ceiling by adding

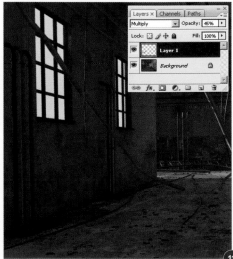

a new grid in the Vanishing Point window as before. Because the wall is adjacent to the floor, a grid can be pulled upwards from the existing one by holding down Ctrl and dragging one of the points in the relevant direction.

One final area that could benefit from a little more detail is the foreground section of the floor nearest the camera. Instead of adding more geometric particles, or perhaps a normal map, etc., it is possible to use the Healing Brush tool highlighted in **Fig.13**.

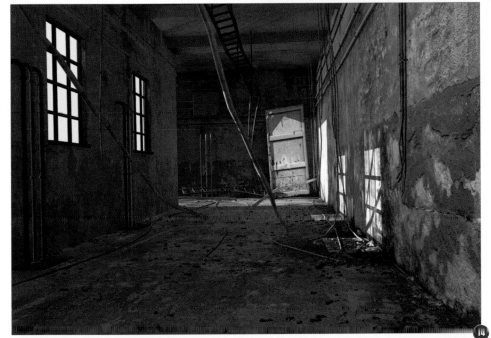

This is used in exactly the same way as the Clone Stamp tool, by holding down the Alt key and left-clicking on an area you wish to duplicate. Using this tool on the wall section highlighted in red means we can then transfer the rough appearance of the wall to the floor section, whilst maintaining the local color values.

Fig.14 shows the original untouched Color render, and **Fig.15** is the retouched version, both of which exclude the AO and Specular passes.

The Ambient Occlusion pass will certainly help bind the space, but you can see how these minor tweaks help improve the render and can be achieved quickly.

Conclusion

If a world existed without time limits and deadlines then we could all spend a great amount of time perfecting things, even though it may drive us to madness!

However, this is not the case, and invariably concessions have to be made and corners cut, but hopefully this tutorial has shown how post-production can be an effective remedy to more intensive 3D procedures.

It may appear as though the alterations make little impact upon the 3D render, but the sum of all these small changes contribute towards a more convincing and plausible outcome.

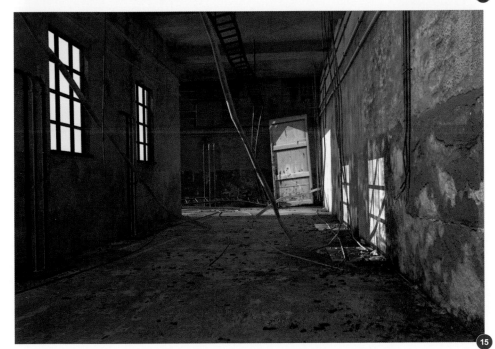

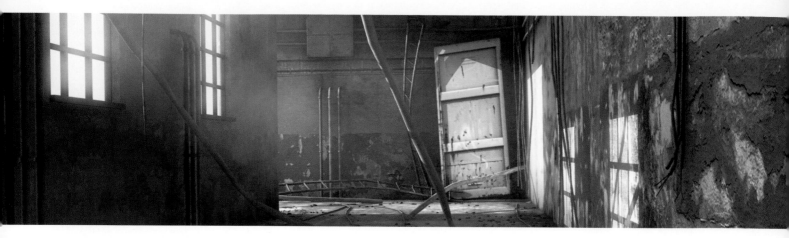

Lighting and Particle Effects
By Richard Tilbury

Introduction

This tutorial is a continuation of the previous section, and will use the same scene as before. We will look at ways to enhance the lighting effects and mood of the render, and create a dusty atmosphere that suits the subject matter.

In **Fig.01** you can see the stage where we ended the previous section. The render at the moment is composed of just three layers: Color, Specular and Ambient Occlusion passes (**Fig.02**).

You will notice that the Ambient Occlusion (AO) pass is set to Multiply at 49% opacity. You may need to alter the opacity depending on your preferences, as this is purely subjective, but I do find that 100% is always too dark. The Specular pass is set to Screen mode at 60%, in this instance.

I find that tinting the AO pass often helps, with the hue dependant on the particular scene, but in this case I have made it warmer. Go to Image > Adjustments > Color Balance and move the sliders accordingly (in this case towards the red and yellow) (**Fig.03**).

These three passes make up the 3D elements that have already been composited in Photoshop with the tweaks that we dealt with in the last section. We could leave the scene as it is, but instead we will use what we have so far in our render to suggest ways in which to enhance things a little.

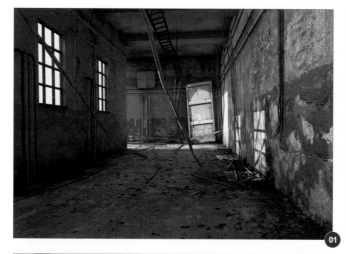

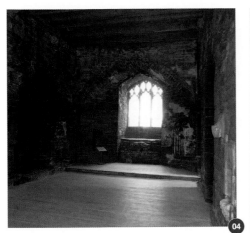

"Light Bloom"

There is a strong light source outside the building, left of the picture, which has cast highlights onto the opposing wall. As such, we can create what is commonly known as "light bloom". This is an effect often used in computer graphics and describes the way light can appear to "bleed" beyond its natural border when seen through a camera lens. In **Fig.04** you can see the result of this effect around the window.

The way to achieve this is by first duplicating the Color pass (the background layer in this case) and then putting this above all the other layers and desaturating it (Image > Adjustments > Desaturate) (**Fig.05**).

Next go to Image > Adjustments > Curves, click on the diagonal line and adjust it similar to what is shown in **Fig.06** until you have darkened most of the image, except for the sunlit sections. To tidy it up a bit you can use a brush to paint over any unwanted areas that are not black (**Fig.07**).

Next go to Filter > Blur > Gaussian Blur and set Radius to somewhere around 7 pixels (**Fig.08**).

You can either leave this layer black and white, or you can tint the white areas, which I have done by adding a warmer tint similar to the Ambient Occlusion layer. Place this layer above the rest and set it to Screen mode. In **Fig.09** you can see this layer, called "Background copy", and the effect it has. I decided that the door did not work and so erased this section, as indicated by the white area on the layer thumbnail.

To add even more intensity to the light from the windows, make a selection area around both and then, on a new layer, fill these with either a white or a pale yellow (**Fig.10 – #2**).

Now apply some Gaussian Blur (Radius around 14) and then set this layer to Soft Light (**Fig.10 – #3**).

With these effects complete we shall now go on to add some volumetric lighting to suggest a dust-filled corridor.

Volumetric Lighting

Begin by creating a new layer (named "Volumetric") and use the Lasso tool to make a selection area that will correspond to the beam of light that will filter through the near window (**Fig.11**).

Make the foreground color a pale orange and then select the Gradient tool (highlighted in red in **Fig.11**) and click on the box indicated by the arrow.

This will open up the Gradient Editor, as seen in **Fig.12**. Be sure to select "Foreground to Transparent", which is the second box from the left on the top row, and then click "OK".

Once done, click and drag from the window edge of the selection area to the opposite side against the wall. Apply some Gaussian Blur to soften the effect and aim for something similar to **Fig.13**.

Now duplicate this layer and scale it to match the distant window (**Fig.14**).

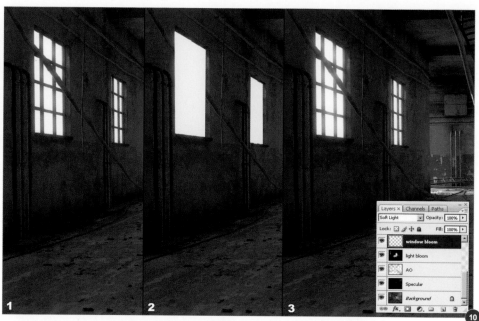

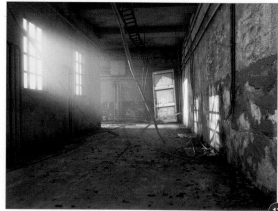

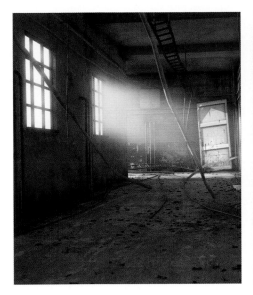

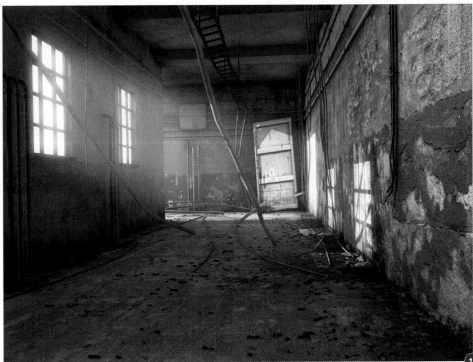

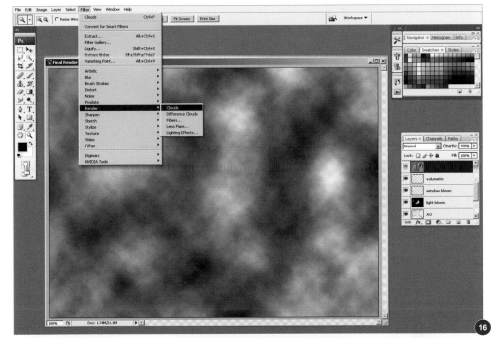

Turn the opacity of this layer down to around 25%, and the initial one to approximately 60%, and then merge the two together (**Fig.15**).

At this point you could refine the edges of the light beams using a soft eraser if need be, or even alter the Color Balance if you wish (I have added a warmer tint using the same method, as done previously with the AO pass).

The volumetric lighting now helps give the atmosphere a more dusty feel, but to enhance it further we are going to break it up slightly.

Create a new layer and, making sure you have black and white as the foreground/background colors, go to Filter > Render > Clouds. This will fill your layer with an abstract and random pattern similar to **Fig.16**.

Make sure this new layer is above the volumetric lighting, and then Alt + left-click on the red line that divides the two layers, as seen in **Fig.17**.

This will create a clipping mask that will only reveal the clouds layer within the boundaries of the volumetric lighting. Set the layer blending mode to Hard Light and then feel free to move or scale the clouds to refine the pattern (**Fig.18**).

You can increase the contrast of the clouds layer to make it more apparent, and even add some noise to create visible particles if you wish, but I prefer to keep things subtle.

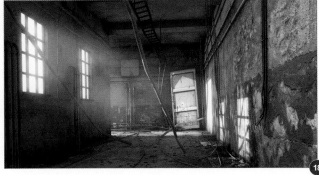

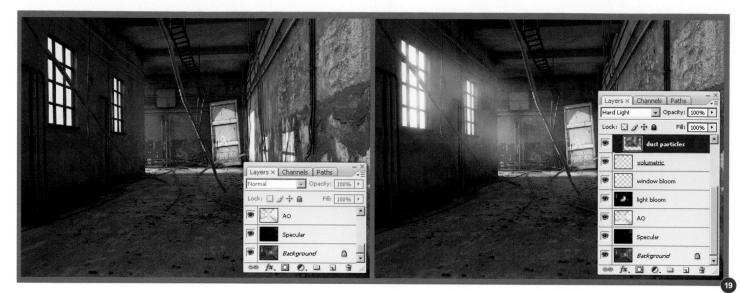

Through Photoshop we have been able to enhance the lighting, create the effect of strong sunlight filtering into our scene and give the impression of a dusty atmosphere. This has been relatively quick to achieve and I believe adds drama to the image (**Fig.19**).

Steam

One other enhancement we could add here is some steam emanating from the near set of pipes on the left. Again, this is a particle effect that could be achieved in 3D along with the dust, but it is quicker to produce in 2D.

In **Fig.20** you can see a custom brush I already had stored, which was extracted from a photo of some smoke. I have included the brush as a downloadable file so that you can see its parameters for yourself.

To load it, go to the root folder of Photoshop on your computer and then to Presets > Brushes, and copy it into this folder (you should see a group of ABR files there).

In Photoshop click on the Brush tool and then on the small arrow on the menu bar that is next to the brush thumbnail. Now click on the upper right arrow next to Master Diameter, and then on Load Brushes (**Fig.21**). Select the Smoke brush and hit "Load".

If you look in your brushes menu you should now find the brush at the very bottom of the list (**Fig.22**). If you click on the small icon ringed in red, this will open up the brushes palette

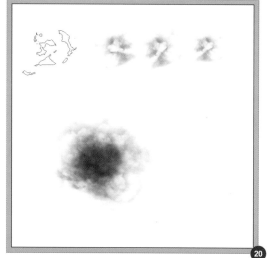

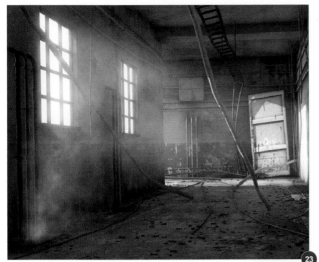

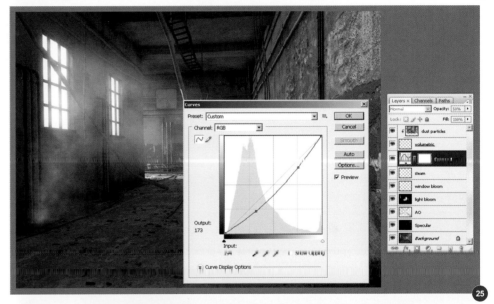

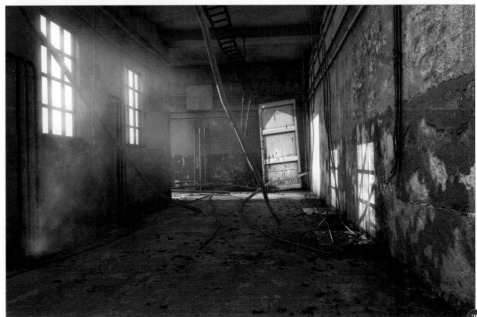

where you can see the settings for your brush. The key sections are the ones underlined, so go ahead and experiment with the parameters as this is the best way of understanding what they do.

Once you have your brush selected you can go ahead and paint in your steam. You can use the Soft Round airbrush to erase the edges if need be, and also alter the Color Balance to better integrate it (**Fig.23**).

This essentially wraps up this tutorial, but there is one last thing we could do to emphasize the lighting: add an adjustment layer.

Adjustment Layer

Click on the steam layer and then go to Layer > New Adjustment Layer > Curves (**Fig.24**).

Now adjust the curves similar to **Fig.25** by clicking and dragging on the line. This will have the effect of increasing the contrast slightly, and because it is below the volumetric layer it will make the sunbeams stand out a little more.

With this done, we have arrived at our final version, which can be seen in **Fig.26**.

You can download the custom brush (ABR) file to accompany this tutorial from: **www.3dtotal.com/ p3dresources**. This brush was created using Photoshop CS3

Curves, Levels, Color Balance and Layer Styles
By Richard Tilbury

Introduction

In the forth workshop of this chapter we'll be taking a look at some of the most commonly used techniques and tools in Photoshop to modify a 3D-render during the post-production phase.

The bulk of the tools we will look at are situated within the Image > Adjustments menu, as shown in **Fig.01**. These include Curves, Levels, Color Balance, and Hue/Saturation. We will also touch on some of the available layer styles and how these can be applied to your renders.

Photoshop can be used to refine and modify your renders to a greater or lesser degree, or indeed as a way of completely transforming the mood and lighting. Almost all of the effects are possible within a 3D environment, but as this tutorial will hopefully show, using Photoshop can prove a quicker way to tweak your lighting and color scheme, and make the minor changes you require. Even if the results are sometimes not as physically accurate as a 3D render, experimenting with the following

techniques means that you can get an accurate picture of what you may wish to achieve back in the 3D scene.

We can therefore use Photoshop to improve and alter our 3D renders, or simply as a way to explore alternative ideas that can then be applied in 3D.

In this tutorial I will provide a brief overview of the aforementioned tools, and then we will look at some practical examples of how these can be applied to our 3D renders, using a base image from the Total Textures V19: Destroyed and Damaged DVD (**www.3dtotal.com/ textures**) (**Fig.01a**).

Levels

The first tool we'll look at is Levels, which you will find under Image > Adjustments. When you open up this tool you'll see the following dialog box (**Fig.02**). There are two main sliders which affect the image: the Input and Output Levels (top and bottom, respectively).

The two outer sliders on the Input Levels correspond to the black and white values in the image – black being a value of 0 and white being a value of 255 – and these determine the darkest and lightest areas on the Output Levels.

In **Fig.03** you can see the original version on the left, where the four outer sliders are at the extreme edges. When the Output sliders are moved inwards, the contrast is reduced, meaning that the black value is made lighter and the white made darker. When we accept this and then re-open the Levels window, we can see that the range within the Input Levels corresponds to the adjustment, as shown by the red lines (middle and right image). To adjust the shadows and highlights manually, or return the values, we must now move the Input sliders to the outer edge of this new range, thus returning the black value to 0 and the white to 255. This means that all pixels with a value of 33 and lower will be set at 0 and those of a value of 228 and higher will be set at 255. The middle slider affects the midtone range, and moving it left makes the image lighter, and vice versa.

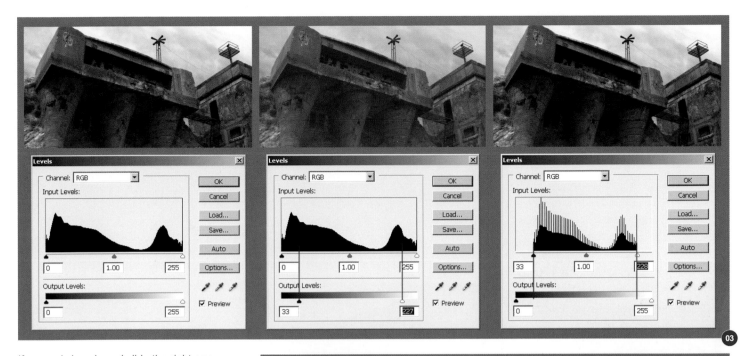

If we apply Levels and slide the right arrow inwards on the Input slider, we can brighten up the render and give the impression of a stronger sunlight (bottom image in **Fig.04**). Because the sky is the brightest area without much contrast, the adjustment has rendered it almost completely white. If you wish to avoid this you could have a separate render pass of just the buildings and apply it to the foreground only, which would enable individual control of both the buildings and the sky. Alternatively, if you save out the render with an alpha channel that carries a mask for just the buildings, then you could experiment by pasting in various skies to reflect the foreground conditions.

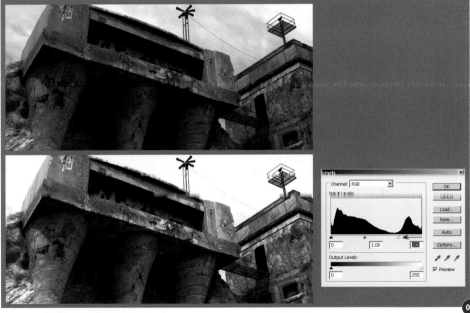

Curves

The Curves image adjustment tool essentially does the same task as Levels, except you have more control over the tonal range. With Levels you have only three adjustments: white, black and mid range (or Gamma). The Curves dialog box also enables precise control over the different color channels. When opening the Curves dialog box, by going to Image > Adjustments > Curves, you will see something resembling what is shown in **Fig.05**.

I won't cover every aspect of this as you can find all of the information in your Adobe Help Viewer, but the key things to note are the top right corner of the window representing the highlights, and the opposite corner representing

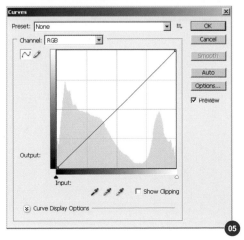

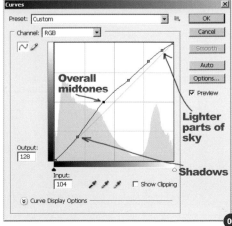

the shadows. You can click on the line to add points and then drag these accordingly to manipulate the tonal range, adding as many as fourteen. To delete a point simply drag it outside of the window.

In **Fig.06** you can see the number of points I have added to the baseline, and the resultant effect is shown in **Fig.07**. The top three points are controlling the sky, whereas the bottom-most point affects the shadow, with the black point affecting the general range of midtones. You can see that by adding numerous points I have been able to brighten up the scene, similar to using Levels, but I've been able to do so without bleaching out the sky (compare this to **Fig.04** to see the difference).

> **Quick Tip:** By using Curves you can gain more precise control over the tonal range, but which approach you use depends on the render and artistic aims – both can prove equally useful, especially when combined.

Color Balance

This command is used to add a tint to the overall image and is very useful when you wish to alter the general color of the lighting conditions. You access these controls by going to Image > Adjustments > Color Balance, where you will find a dialog box similar to that seen at the top in **Fig.08**. Here I have moved the slider

towards Red and Yellow to create a warmer light, perhaps suggestive of early evening. At the base of the dialog box you will see three radial buttons that allow control over a specific

tonal range. In this example, the sky and foreground have been altered individually to allow more control.

Hue/Saturation

The Hue/Saturation adjustment tool allows you to alter the overall hue, saturation and brightness of an image, or alternatively manipulate specific colors. In **Fig.09** you can see the original image at the top, with the unaltered values in the Hue/Saturation dialog box (i.e. 0, 0, 0).

The bottom image is a version that has been transformed into a nocturnal scene using all three sliders. Hue affects the color, Saturation the intensity of the color, and Lightness controls the overall brightness. At the top of the box is the Edit panel where you can choose to modify specific color channels or the overall image, which is labeled "Master". These are the key things worth noting and what you will use in most cases, but for a full explanation you can consult the Help menu.

As this image has been turned into a nocturnal scene we could also apply Curves to reduce the contrast and tonal range, as well as making the shadows darker.

These are perhaps the most commonly used tools with regard to manipulating 3D renders in Photoshop, but the best effects will invariably involve the subtle combination of all of the above. We will now go on and look at how we can apply some of these tools to create three variations of our bunker scene, as well as cover some useful layer effects.

Variation One

The original render looks fine, but to add a little drama and give it a grittier and more dramatic light, akin to some of the photography in the epic series, *Band of Brothers*, we will use the Exposure command (**Fig.10**).

First of all, duplicate the render layer and then go to Image > Adjustments > Exposure, and then increase the Exposure, which will essentially affect the brightest parts of the

scene without altering the areas in shadow. This tool is normally reserved for HDR images, but works well in other instances too.

You can see that the render now resembles the bleached-out version we saw when using Levels, so what we need to do now is to erase some of the areas that appear too light, to reveal the original render below. I've added a new layer between this one and the original and filled it with red so you can visually see which areas have been erased (**Fig.11**). Using a soft-edged eraser, I delete some areas that would receive less or no light, e.g: the underside of the bunker and facing wall of the building on the right, as the sun is casting light from left to right.

Using Hue/Saturation, I alter the sky separately and make it a touch darker and less saturated, then give it a very subtle green tint by way of the Color Balance tool. This greater contrast creates a more dramatic mood with strong sunlight, and the suggestion of an approaching storm (**Fig.12**).

We have created a more dramatic daytime version of our scene, but let's imagine that

we now want to set the clock forwards to late afternoon, somewhere around sunset…

Variation Two

First of all, I make a duplicate of the render layer and then go to Image > Adjustments > Color Balance and shift the palette towards red and yellow, as shown in **Fig.13**.

We only want the sky and roof fixtures from this new layer, but by changing the entire layer we obtain a better idea about the overall light when altering the Color Balance. When satisfied with the settings, I delete the foreground buildings so that we end up with something similar to **Fig.14**.

Now I make a duplicate layer of the original and then place this over the new sky; once done we'll apply a layer style to represent the light cast by the setting sun. Go to Layer > Layer Style > Gradient Overlay and you will see the top dialogue box in **Fig.15**. Here you can control the Blend Mode and Opacity of the effect, as well as determine the Angle, Scale, Color and Gradient Type.

Clicking on the Gradient bar to open the bottom dialog box, I choose a color that is sympathetic

to that of the Color Balance adjustment earlier (in this case, a pale orange) by clicking on the small square icon highlighted by the arrow. I also make sure that I select "Foreground to Transparent" from the upper row of Presets by clicking on the appropriate box. Once the Gradient Type and Color are determined, I accept the changes and return to the Layer Style dialog box. You can now experiment with the blending mode and other settings to refine the effect, most of which will be self explanatory.

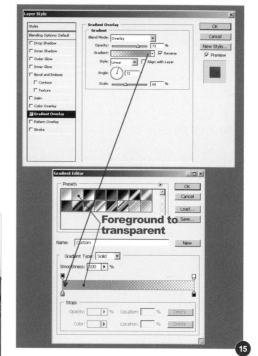

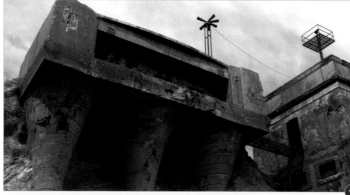

The Layer structure can be seen in **Fig.16**, with the Color Balance layer above the original, of which only the sky and roof attachments are visible. Above this is a duplicate of the foreground with the Gradient Overlay showing the sunlight. In fact you could leave the sky as it was, but I personally find that a subtle tint that reflects the sunlight helps bind the scene together more.

The final result can be seen in **Fig.17**. You could also go on to use Curves and Levels to adjust the contrast and tonal range to reflect the difference in time, if you wish. If you selected the orange color from the Gradient and then

added a new layer set to the same blending
mode (Overlay), you could also refine the image
by airbrushing in some soft-edged areas to put
some tinted sunlight on the near left section
where the light hits the rock face.

Variation Three

One other commonly used function of
Photoshop's Image Adjustments menu,
particularly amongst matte painters, is the
ability to turn a daylight scene into a nighttime
version. To do this, we will, as usual, make a
duplicate of the render and then firstly lower
the light levels by applying the Hue/Saturation
tool. **Fig.18** shows the base render with the
appropriate modifications.

I go to Image > Adjustments > Color Balance
and move the bottom slider towards Blue, and

the top one a touch towards Cyan (**Fig.19**). The
scene still looks a little too light and rather blue,
so I re-open Hue/Saturation and reduce the
Lightness and Saturation values once more.

The scene, as it stands, looks a little
uninteresting even though it resembles
nighttime, so to improve things we are going to
switch some lights on inside the bunker. To do
this I can either duplicate the window section
that corresponds to the glass, or render just
this face in my scene with an alpha channel,
meaning I have a ready-made mask. With this
area put on a separate layer I go to Layer >
Layer Style and apply a Gradient Overlay using
the settings shown in **Fig.20**. This essentially
puts a light inside the building with the source
being on the left, gently fading towards the
right-hand side.

The final result is a three tiered effect, as
illustrated in **Fig.21**. The above-mentioned layer
is at the top and below this is a duplicate with
all but the left-hand windows deleted. You can
see the corresponding blending modes in the
layers palette on the right hand side. The final
layer seen at the bottom is yet another duplicate
(but without the Layer Style) and represents
the light source; this one is set to Screen mode
at 75% opacity with the outer edges softened
with the Eraser tool. In order to make it realistic
you would need to also add light to the areas
that correspond to the broken glass to show an

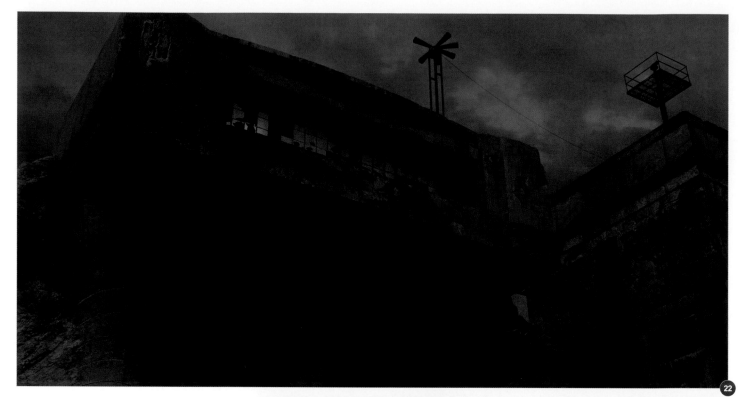

22

illuminated interior, but you get the idea at least. One final adjustment that will help is to substitute the sky. If you can find one with backlit clouds then that would be ideal as it will suggest moonlight lighting them from behind – this proves very effective for nocturnal scenes!

The final version can be seen here in **Fig.22**. This about covers the main image adjustment options and, more crucially, the ones you will most likely use. However, there is perhaps one more worth mentioning… the Photo filter.

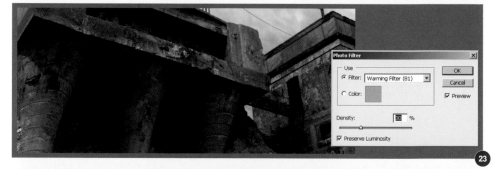

23

Photo Filter

This tool simulates a color filter being placed over a camera lens; it is again found under Image > Adjustments and can often prove effective, depending on your render.

You can see the effect of adding a warm filter in **Fig.23**, but you can find a list of alternatives under the Filter drop down menu. As a general rule, the warm filters work best with a cool palette and the cool ones work well under a warmer light, but it is worth experimenting for different results.

Layer Styles

You will notice that we've only covered the Gradient Overlay within the Layer Styles

24

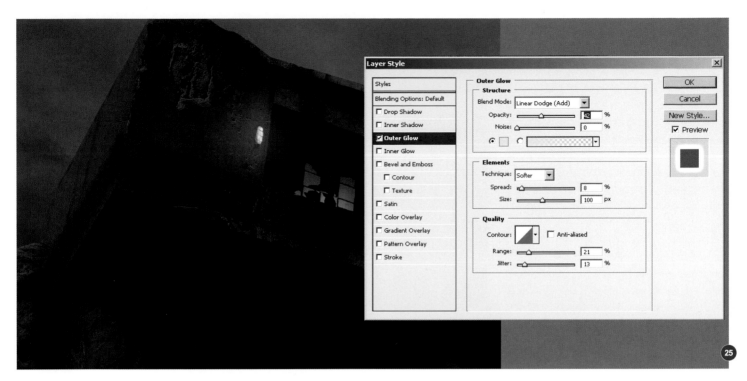

25

menu, yet there are quite a few styles in all. So before we conclude this tutorial I would like to mention two more styles that are often useful with regards to 3D renders, the first of which is Outer Glow.

Sometimes you may have a strong light source in your image, such as a lamp or bulb, or even a bright light filtering in through a window.

These conditions benefit from a glow to help convey their intensity, and are achievable in Photoshop.

Imagine that we want to place a bulkhead lamp on the face of our bunker. We would probably model it in 3D and assign a self-illuminated material to it to represent the actual light. For the purposes of this tutorial I have painted a

simple version onto the render to represent our 3D version, as seen in **Fig.24**.

We would then normally make a duplicate copy in Photoshop of just the 3D lamp, upon which we would apply our Outer Glow. However, in this case it already exists on a separate layer as a 2D version. So I go to Layer > Layer Styles > Outer Glow and apply the settings shown

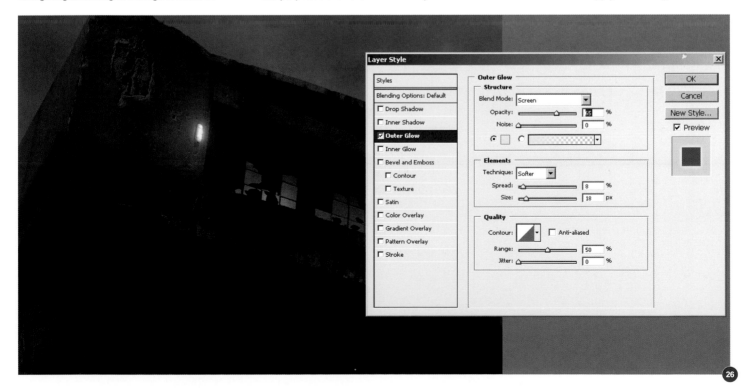

26

in **Fig.25** to create the full extent of the glow. Most of the settings are self-explanatory and you will best understand their functions by experimenting with them. At the top you can control the blending mode, opacity and color of the glow, and under Elements you have access to the size and extent of the glow, as well as how precisely it traces the source element. These are the main areas you will use, but you can also alter the shape and intensity of the glow by altering Range, and even add a pattern by adjusting Contour.

I now select just a portion of the white area of the light and copy this into a new layer, and once again apply an Outer Glow, except this time I apply different settings to create the glow immediately around the lamp (**Fig.26**).

When we look at our layers palette we can see the new structure and the effect of each glow (**Fig.27**). If you wish, you could also apply a Lens Flare once the image is flattened by going to Filter > Render > Lens Flare (**Fig.28**).

The last tool we will look at, which can be particularly useful to 3D, is Bevel and Emboss, which can be used to add surface detail to your scene that can incorporate shading effects, helping to mimic 3D much like a bump or normal map.

When you go to Layer > Layer Style > Bevel and Emboss, you will be faced with a dialog box similar to **Fig.29**. At the top you can choose

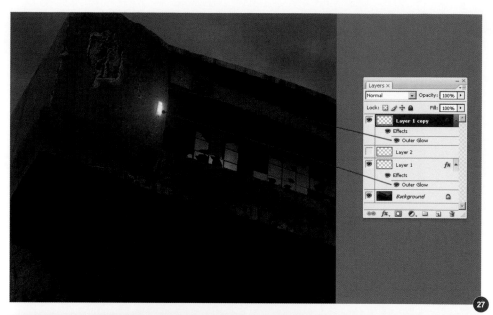

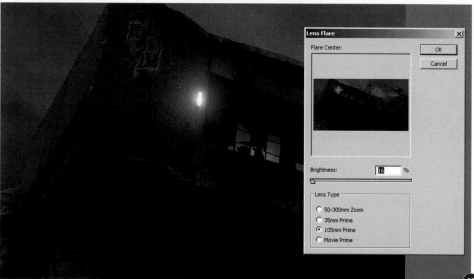

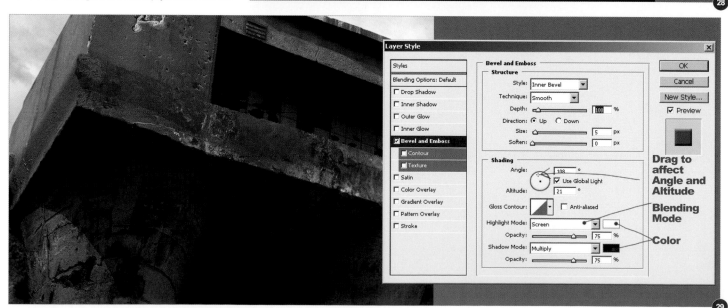

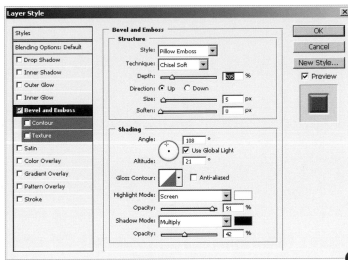

the type of bevel or emboss under Style and the Technique box effectively determines how sharply defined the edges are. Direction affects whether the layer recedes or appears to come forward, with Size and Soften affecting the scale and clarity.

In the Shading section you can drag the small crosshair to alter the direction of the light, and at the bottom you can specify the color, opacity and blending mode of both the highlights and shadows independently. "Use Global Light" allows you to use the same lighting angle

across multiple layer effects, such as drop shadow etc., but if un-ticked means the effect is local to specific layer styles.

To apply this effect I create a new layer, then select a brush with a neutral gray color and start painting in some marks that will represent extra bullet and shell damage. These look almost invisible in our bunker scene, but with a white background they look like **Fig.30**.

I apply Bevel and Emboss with the following settings (**Fig.31**), and the result can be seen

on the right in **Fig.32**. Selecting the right kind of brush helps when using this effect, and also enabling some of the brush settings, such as Dual Brush and Color Dynamics. You can also use the Eraser tool to edit your marks, as well as any of the previously mentioned image adjustments.

I also find it helpful to make a random mark to begin with and then apply Bevel and Emboss, after which the effect will be applied to any brush marks you add, meaning you can view the final effect as you work!

Layer Masks and Adjustment Layers
By Andrzej Sykut

Introduction

I don't think a 3D image should be called complete without some post-production in 2D. It can range from simple color correction and the adjustment of brightness and contrast, to a much more complex process in which you can totally change the look of an image.

The most popular tool for the job is, of course, Photoshop. The great thing about it is that you

can do a lot of the editing in a non-destructive, dynamic way using Adjustment Layers. This opens up some interesting workflows. For example, you can work out the color correction on the low resolution test render early in the process, and just move the layers to the final high resolution image at the end. Or you can process a series of images for the same consistent look by using the same set of adjustment layers on all of them. This is great if you have to show the same scene from many angles. Not to mention the ease of going back and changing things if you or your client decides that the background is too dark, for example. Sounds nice, doesn't it? So nice in fact that after a while you can't work without adjustment layers at all!

Photoshop CS2 has 15 kinds of adjustment layers (**Fig.01**). Newer versions possibly have

more, but not all of them are actually useful when processing 3D images. Every adjustment layer has a layer mask attached to it. That way you can decide which parts of the image should be affected.

When working with 3D images it's very convenient to render a RGB mask pass (**Fig.02**). This makes selecting the parts you want to tweak much, much easier.

Now for the layers themselves:

Solid Color is great as a background base, or as a colored overlay on top of the image (**Fig.03**).

Gradient is a nice tool for vignettes, to darken the sky a bit, or as a starting point for the background. Personally I often the use old

04

05

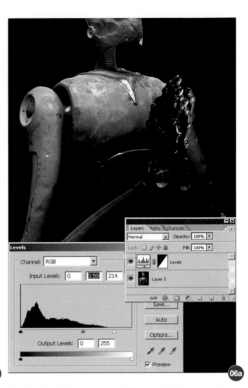

06a

Gradient Fill tool when creating a vignette. It's usually faster to draw the gradient four times in the image corners on a single layer, than to create four separate gradient layers. But this varies from image to image (**Fig.04**).

Pattern is most useful for texture overlays, using tileable textures. The ability to change the tiling comes in handy in many cases (**Fig.05**).

Levels allow you to adjust brightness, contrast, gamma (**Fig.06a**) and make some color correction, since it can work on either the whole image or individually on RGB channels (**Fig.06b**). You can either change the position of the sliders under the histogram or use color pickers to decide which parts of the image should be white, black, or somewhere in the middle. Levels are not quite as powerful as Curves, but probably easier and more intuitive to use in some ways, due to the displayed histogram.

Curves allow you to do everything Levels do, plus much more. This is because you can shape the curve in the way you wish. If you feel the shadows need to be warmer, you just change the curve in the lower part of the red channel. If you have only two points on the curve, this will make the highlights a bit cooler (**Fig.07a**), but by adding a third point you can

limit the effect only to the shadows (**Fig.07b**). You can do the same to the highlights, midtones – anywhere you want. You can do it on separate layers for greater control and order. The color pickers work in a similar way to how they work in Levels. Using Curves, you can also replicate the effects of Color Balance and Brightness/

Contrast adjustments, a Channel Mixer, and if you really try you can draw a curve that'll look similar to Posterize.

Color Balance allows you to quickly and easily change the color temperature; for example, by adding some blue to the shadows, or red-yellow

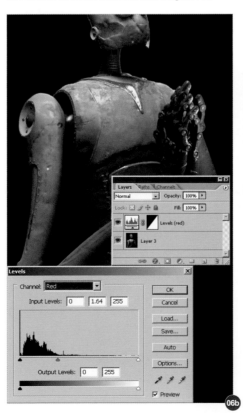

06b

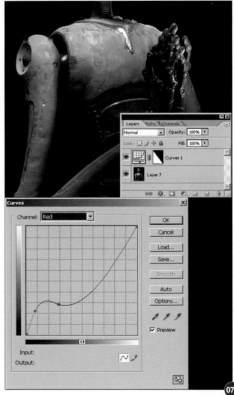

07a

to the highlights. This is less powerful than Curves, but quite often it's powerful enough (**Fig.08** – separately adjusted highlights, midtones and shadows).

Brightness/Contrast is a very simple tool. If simple adjustment of the brightness or contrast is what you need, it'll do. For anything more advanced, use Levels or Curves.

Hue/Saturation, as the name implies, allows you to adjust the Hue, Saturation and Lightness. By default it works on the whole image (Master). It can also work on any selected part of the spectrum – Yellow, Red, etc. You can adjust which part is affected by using the slider at the bottom of the window (**Fig.09**). You can also use the color picker to choose the color that needs to be changed directly from the image. In Colorize mode it makes the image monochromatic.

Selective Color can be used in a similar way to Hue/Saturation, but the effects are more subtle and you don't have as much control. Nevertheless, it's often quite useful for fine-tuning.

Channel Mixer lets you change the amount of contribution from each of the channels. You can do all of that easily, and more, using Curves. I therefore don't remember using the Channel Mixer much in the last few years.

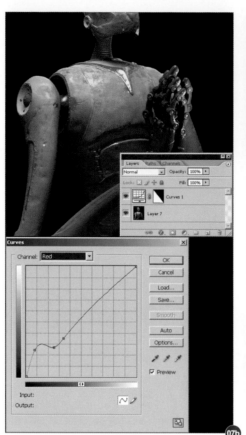

07b

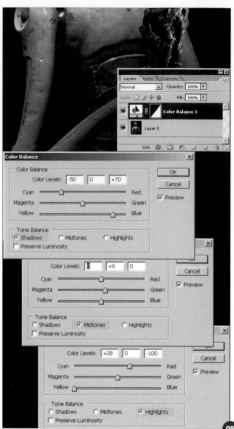

08

Gradient Map is one of my favourites. It lets you achieve a wide variety of effects, from predator-like thermal vision and color correction, to a bleach-bypass kind of effect. The magic lies in choosing the right gradient and the right layer blending mode. Overlay and Soft Light are the most useful ones (**Fig.10**).

Photo filter mimics the effect of a colored filter applied to the camera lens. If you need to quickly make the whole image cooler or warmer, it'll do.

Posterize and **Threshold** (**Fig.11**) I have found to be almost totally useless. That doesn't mean

09

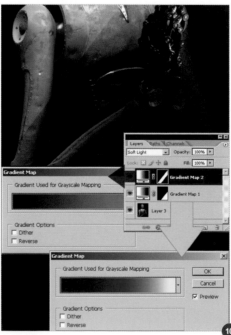

10

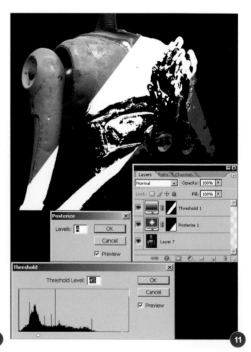

11

they are useless to everyone, I just don't need the kind of effect they generate and so don't use them in my work.

Invert is actually more useful as an old-school adjustment. That's because I use it mostly to invert masks and channels for selections.

Ok, so enough of the theory. Let's see how all this works in the real world!

The image I've been using as an example is a raw render. The final post-processed image looks quite different. I've done quite a lot of things to it, and I'll try to cover the most important techniques here. You can also download the PSD file with this tutorial so you can dissect it and follow this tutorial as you go.

The background started as a layer filled with a light blue color, which I then added some shading to using Gradient Fill and blurred it a few times. I then added a few layers of photographed smoke (using Screen or Soft Light mode), and some adjustment layers to adjust the brightness and colors (Fig.12).

12

13

Curves, overall color correction

Vignette

Paint-out

A bit of glow (Color Dodge)

Some colorization (Overlay)

Smoke (Screen)

Fade (Normal)

Leaves color correction

Leaves Render

Leaves volume shadow (Multiply)

The main character was rather more heavily edited. Using the rendered RGB masks and separately rendered passes containing HDR reflections, I added some reflections to the exposed metal, glass, eyes, and very subtly to the whole robot.

Using the Ambient Occlusion pass I darkened the details of the hands and the eyes, and made the separation between the jaw and the head more visible.

Using Curves, I changed the coloring of the blue paint a bit, and made a few more subtle adjustments using both Levels and Curves.

The fading into the background was created by painting over the character using a soft round brush and colors sampled from the background. This was augmented by a duplicated background layer, masked using the ZDepth pass and some subtle smoke screened on top (**Fig.13**).

The leaves were corrected and faded in the same way. Using a motion-blurred copy of the layer, I created subtle volume-like shadows of them.

Then came a few gradients to both darken and brighten the image. The first serious color correction came next: Curves, to warm up the whole image (**Fig.14**).

Final color correction - Gradient map (Soft Light)

Texture overlay (Soft Light)

Highlight glow (Overlay)

Eyes burning 2 (Linear Dodge)

Curves, darkening everything

Vignette

Paint-out

Eyes burning

Vignette

The glow of the eyes was done with a couple of round brush strokes in Overlay mode, some photographed, overlayed smoke, and again a couple of strokes in Linear Dodge mode to make them feel alight.

Curves were then used to darken the image a bit, along with some vignetting and some subtle texture overlay.

The final color correction was done using a gradient map in Soft Light mode (**Fig.15**).

The last thing I did to the image was to add a tiny bit of chromatic aberration. A word of caution here: it's easy to do a lot of harm to an image this way, simply by overdoing it. I don't really like this technique because it simulates photographic artifacts – I do however like it because it changes the sharp edges, softening them, but in a slightly different way to just subtle blurring; it softens the harsh bump-mapping nicely, adding some color variation to the bump shading. The easiest way to apply chromatic aberration is by using a tool designed to remove it – Filter > Distort > Lens Correction, and carefully playing with the settings.

As mentioned earlier, you can dissect the PSD on your own; the low resolution version of this image is avaliable to download, so take a look and see how the various layers work for yourself.

> **Quick Tip:** Use Curves! It's the most powerful and efficient of all the adjustment layers that Photoshop has to offer. Don't be afraid to experiment, to change blending modes and the opacity of the adjustment layers, or even simply duplicate them. Accidents and errors are easily fixable, even for a long time after they have happened. And sometimes, of course, these accidents can even produce some interesting effects themselves!

You can download the layered PSD to accompany this tutorial from: **www.3dtotal.com/ p3dresources**.

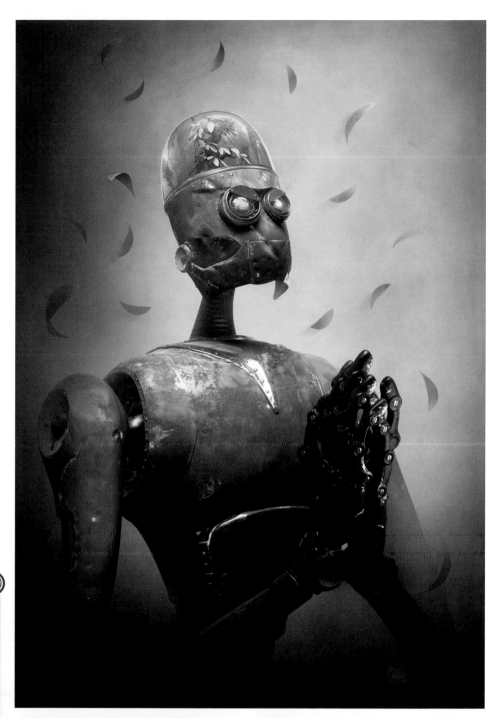

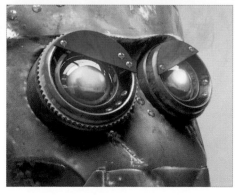

Creating Backgrounds
By Fábio M. Ragonha

Introduction

This tutorial will aim to show you how to use Photoshop to compose a still image. Using some nice renders and masks we will discover an efficient way to achieve a good image, which will enable you to easily change and test colors and settings in the post-production stage. We'll then continue by looking at how to create backgrounds for our 3D characters. So let's get started.

In this first example, after modeling my character in 3ds Max and choosing an interesting and appropriate pose for him, I made five basic render passes:

- **Render Layer 1** – Glossy metal (**Fig.01**)
- **Render Layer 2** – Car paint shader (I've used the same pass to render the black parts that will look like rubber accessories later on) (**Fig.02**)
- **Render Layer 3** – Ambient Occlusion (**Fig.03**)
- **Render Layer 4** – Here I've had to render each part with a different color as these will be used to select each part to make masks and adjustments (**Fig.04**)
- **Render Layer 5** – This one was done in the same way as the last, but with more details to get all those screws and small parts (**Fig.05**).

With all the render passes ready, we can now go into Photoshop. We need to open all these renders in the same PSD file, so go to File > Scripts > Load Files into Stack, click on

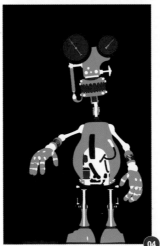

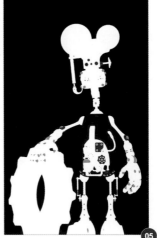

"Browse", then select the five renders and click "OK". Rearrange the layers into the rendered sequence and hide all layers apart from the first one (**Fig.06**).

First things first, we need to create a mask for the first image. So go to Channels, hold the Ctrl

key on your keyboard, and click on the Alpha thumbnail to select the character's silhouette (**Fig.07**).

Back to the layers palette now, press the "Add Layer Mask" button to create a mask for the character. Connect the two layers above by

holding the Alt button on your keyboard and clicking between the two layers. We then want to create a black layer for our background (**Fig.08**).

Unhide and select the rendered mask layer with the part you want to select, press the Magic Wand tool (W on your keyboard), hold Shift on your keyboard, and then select the parts where you want the car paint shader and the black parts to appear (**Fig.09**).

Hide the mask layers now. Then unhide the car paint shader layer and select it, and click on the "Add Layer Mask" button again (**Fig.10**).

If you've forgotten to select some parts – no problem! We just need to go back to the mask layers, select the parts we want to appear, press the D shortcut key on our keyboard to reset the color palette to black and white, and then with the mask of the car paint shader layer selected, press Ctrl + Backspace to paint the selected parts in white.

Sometimes a line with a color that doesn't correspond to the background appears (**Fig.11**). To fix this, we can hold down Ctrl and click on the thumbnail of the first glossy metal layer, selecting the silhouette. Press Ctrl + Shift + I to invert the selection, and use the right arrow key on your keyboard to move the selection one pixel across to the right. Press Ctrl + H to hide the selection that's still there. Do this for the left side, too. This method is much better than erasing the line or using a black brush to paint it out (**Fig.12**).

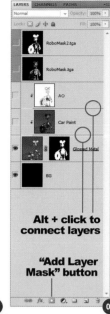

Alt + click to connect layers

"Add Layer Mask" button

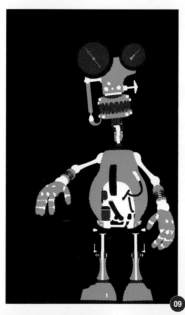

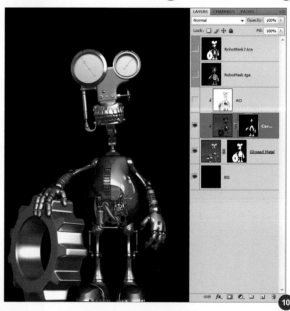

White lines and black background

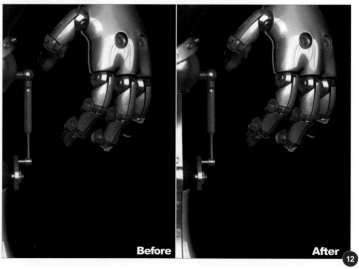

Before

After

Now the fun begins! Let's change the blue metal color for another one: using the self-illumination renders. Select the parts that correspond to the blue car paint shader, click on the "Create new fill or adjustment layer" button, and select Hue/Saturation. Select Colorize and you can then play with different choices of colors for these metal parts (**Fig.13**).

Let's now add more detail to this image. For this purpose, I've rendered a texture for the manometer eyes, and for those pipes in his belly (**Fig.14**).

In your 3D software, remember to set the area to render to Region (if you're using 3ds Max), and then scale the selection around the object you want, and render it. This way, when you import this render as a new layer in Photoshop, it will fit perfectly in your composition.

Import these new render layers into your PSD file and select the parts that correspond to the eyes. Select the eyes layer and click the "Add Layer Mask" icon. Do the same for the hoses (**Fig.15**).

Turn on the Ambient Occlusion layer, choose a good opacity for your image – I've set mine to 80% – and then change the layer blending mode to Multiply (**Fig.16**).

Use the masks to make some adjustments to your image now, like Curves, Color Balance, or whatever it needs (**Fig.17**).

I've missed some reflections on the face and glasses, so I've changed the HDR image for

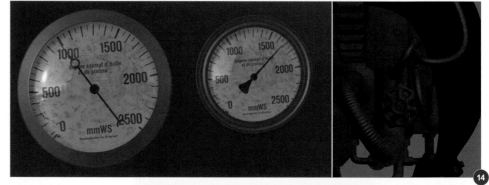

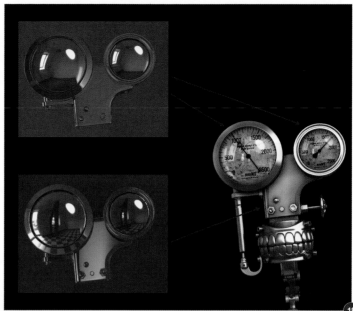

another one that has some different reflections in these areas. I've used masks to make these images appear only in the reflective parts, and changed the layer blending mode to Overlay as the finishing touch (**Fig.18**).

Now let's dirty the image up a little – we'll need some dirty and scratched maps for this job (**Fig.19**).

In the same way that we've made all the masks, use the self-illumination renders to mask these dirty maps to each part of the model. You can repeat parts, rotate and copy using the Clone Stamp tool – whatever it needs – and then change the blending mode. Sometimes it will look good in Overlay, sometimes Multiply or Soft Light; you'll need to test the different settings out on your own composition to discover what the best blending mode to use is for your own purposes. If you need to, you can also adjust the Levels of the maps for better contrast in your textures, and then find a better opacity for their layers (**Fig.20**).

Now select all layers – except the background and the two self-illumination mask layers – and press Ctrl + G to group them, just for a better workflow (**Fig.21**).

For the background, I've mixed two maps (**Fig.22**) and placed them above the black background layer. I select the first layer, hold Alt and hit the "Add Layer Mask" button – this

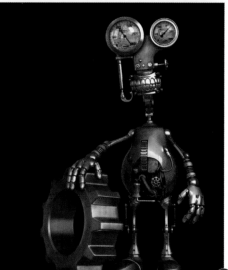

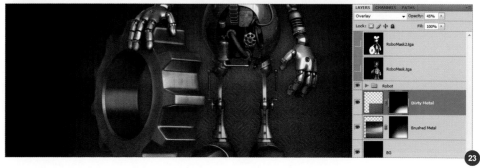

creates a black mask. With a white brush now, I paint the areas where I want the map to appear.

Do this with the other layer, too, and then change it to Overlay (**Fig.23**).

Now it's time to make some final adjustments, the first one being to the Hue/Saturation. Enable the Colorize checkbox and enter zero for the two parameters above; change the blending mode to Overlay and find a good level of opacity. This will give the image a nice contrast (**Fig.24a**).

Let's simulate a glow effect now. Go to Channels, choose the channel that has the most contrast – in this image it's the blue one – and duplicate it, dragging the channel to the "Create New Channel" button. Press Ctrl + L for Levels, and make an adjustment to increase only the highlights (**Fig.24b**).

Now hold Ctrl and click on the thumbnail of this channel to select only the white parts. Go back to the layers and put a Curves adjustment to clear it. Now go to the masks and feather it to

look like a glow effect – if it needs it, duplicate this new layer to get more of a glow, and then paint in black the parts that are exaggerated (**Fig.24c**).

The last adjustment to make is a Color Balance one (**Fig.24d**).

And here we have the final image. You can have fun changing the colors, making adjustments and finding out what best fits your needs (**Fig.25**).

Creating Backgrounds

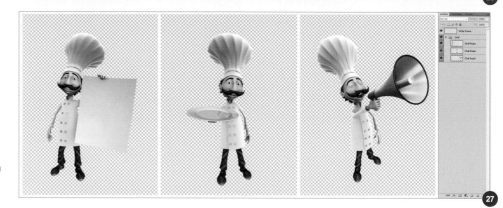

The second tutorial example is a character that I created at Infinity Design (**http://www. infinitydtv.com**) for the Brazilian company, REF Comunicação. I will use this image to show you how to create a background for your own characters (**Fig.26**).

After I composed the character in the same way as I did for the robot, I merged all the layers together for each pose, and opened then in a PSD file. I also created a white frame to separate the three poses (**Fig.27**).

We need to make three render passes:

- **Render Pass 1** – The first one needs to be our Ambient Occlusion pass. In your 3D software, select the entire character, keeping only the parts that touch the floor, and hide it. Select these parts, right-click, and go to Object Properties. In 3ds Max, I disable the checkbox "Visible to Camera" and click "OK", as this makes the shoes affect the floor but doesn't appear to render. It keeps only the floor visible to the camera and renders it. I do the same thing for the other two poses, as well (**Fig.28**).
- **Render Pass 2** – Configure a black Matte Shadow, only to reflect. I disable the "Visible to Camera" checkbox and render it, doing the same for the other two poses (**Fig.29**).
- **Render Pass 3** – For the third and final render layer I make a quick design for the

floor in 3ds Max (**Fig.30**). A texture map looks good too – you could use a wood map, for example.

In Photoshop, create a Gradient color for the background, import the new renders and position them in the right order, grouping each series of renders for a better workflow. Then hide them (**Fig.31**).

Unhide the Reflections group and change the blending mode of the group to Screen. Click on the "Add Layer Mask" button to create a white mask for this group. Press D on your keyboard to reset the color palette to black and white, and then, with the Gradient tool, paint a small gradient at the bottom to smoothly fade out the reflections (**Fig.32**).

Turn on the Ambient Occlusion group now, change the blending mode to Multiply, and find a good level of opacity (**Fig.33**).

Now unhide the Floor Design layer, change it to Screen, and find a good level of opacity. Make a gradient mask to fade out the top and, with a black brush, paint the parts you don't want to appear (**Fig.34**).

If you have Photoshop CS4, go to the Masks tab and feather it a little; if you have an earlier version you can select the mask, go to Filter > Blur, and apply a Gaussian Blur to smooth this mask (**Fig.35**).

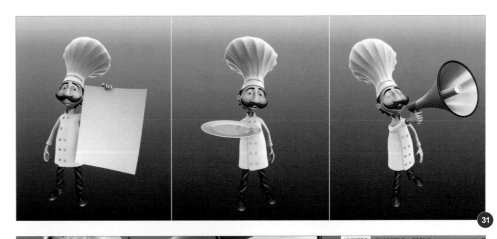

31

32

33

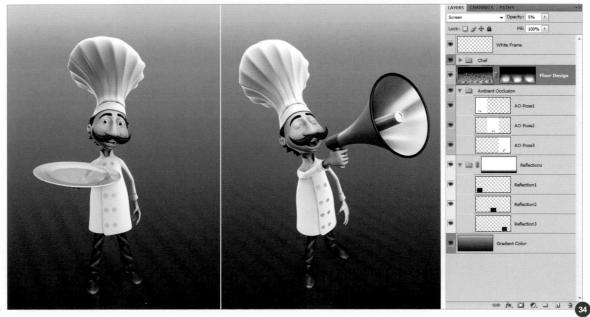

34

I've chosen to change the background color for each pose. To copy this technique, make a selection around the pose, go to the "Create new fill or adjustment layer" icon inside the white frame, apply Hue/Saturation and enable the Colorize checkbox. I've used a green color for the left background, purple for the right one, and I've kept the central one orange; I've also used a Curves adjustment for added contrast and enhanced colors (**Fig.36**).

Now let's make some adjustments that will really make him "pop" in the scene! First of all we can simulate a backlight, so choose the Elliptical Marquee tool and, holding down the Shift key, make an oval selection over each pose (**Fig.37**).

Apply an exaggerated Curves adjustment to clear the selected oval areas (**Fig.38**).

Go to the Masks tab (if in PS CS4) and feather the mask with a good value (again, you can use the blur options in earlier versions of PS if you're not running CS4) (**Fig.39**).

Now hold down Ctrl + Shift and click on the three character thumbnails to select them (**Fig.40**).

Again, you'll want to use a Curves bar to clear this, and feather the mask a little to create a glow effect. With a black brush, paint the dark areas around the character, and the result is our final image (**Fig.41**).

Conclusion

I can go as far to say that these techniques have changed my life! No longer do you have to lose hours setting up a final render for your image for just one pass, and then render more and more passes. Now you can make tests and adjustments as necessary – you can also even add details that weren't even modeled when you first came up with the concept! The possibilities are endless.

You can check out more illustrations made using these techniques on my website. I hope you've enjoyed this tutorial and thanks for reading!

39

40

41

Post Effects for 3D Renders

This chapter looks at how Photoshop and the principals of post-production can help enhance a 3D render. The premise behind this is to demonstrate how certain aspects can be achieved via a 2D approach and yet still work in harmony with the rendered components. This approach can save doing repeated test renders and often yield results that are just as effective in the context of a still. Over the next few pages we will look at various ways to add particle effects and other elements to a number of contrasting scenarios that could prove difficult and intensive to achieve successfully in a 3D render, but can be "mimicked" with great effectiveness in Photoshop.

Underwater
By Richard Tilbury

Introduction

This tutorial explores how to transform a regular
scene into an underwater environment. We will
begin with a base 3D render, which in this case
is a scene created by Yannick Lecoffre that he
has very kindly given us permission to use. The
scene depicts a small bar in Paris and so we
will imagine that through some terrible natural
disaster the city has become engulfed by the
sea and is now completely submerged. If we
ignore the title it is also plausible to see the
scene as a bar on a luxury ocean liner that has
sunk and now resides at the bottom of the sea
somewhere.

Fig.01 shows the original render by Yannick.
We can see that the main light source is coming
from the window on the right. If one was setting
up a render in preparation for some Photoshop
work, then it follows that the lighting and any
special conditions would be set up beforehand
in order to support the post-work and minimize
the level of adjustment. Regarding the case in
question, the light would probably have been
less intense given the eventual conditions and
perhaps there would have been some bottles
and debris floating around the room. If you want
to depict a scene that had been submerged
for any length of time then you may also want
to create some grunge textures to coat the
furniture and walls, as well as some barnacles
etc. However as we are transforming a render
that was not been intended to be underwater
we will assume it has just been flooded and so
still looks quite pristine. We will also assume
that the water is not too deep and so there

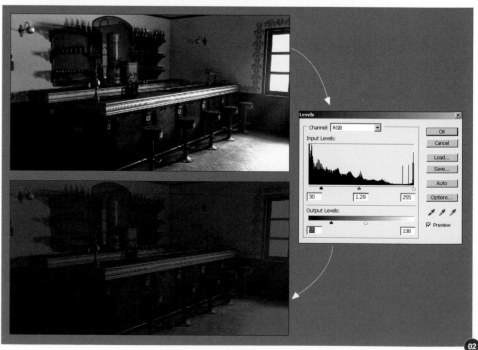

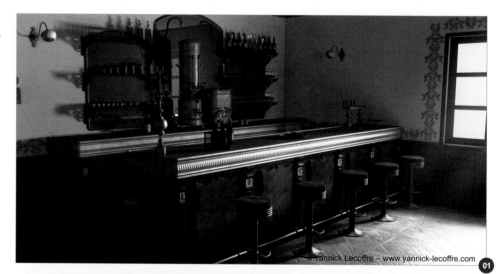

© Yannick Lecoffre – www.yannick-lecoffre.com

01

02

is still a reasonable level of light streaming through the window which will conform to the current lighting.

The first port of call is to duplicate the render, so I went to Image > Adjustments > Levels. Here I reduced the brightness of the overall image and narrow the tonal range to make the whites darker and the blacks a little lighter (**Fig.02**).

The next phase is to change the color scheme so that the scene looks as if it is underwater. To do this I created a new layer and then used the Gradient tool, making sure to select the Foreground to Background preset (**Fig.03**). I selected an aquamarine blue as the color for one end of the gradient and a slightly darker version for the opposite side, and then dragged this across the image, making sure that the lighter shade was on the window side. Once done I set the blending mode to Vivid Light at 100% opacity.

As the light is now more diffuse and less intense it is necessary to restrict its effect further by darkening the foreground somewhat. I created a new layer and then, using the Gradient tool once more, I chose a dark green and dragged from the left-hand edge across to the opposite side. This time I used the Foreground to Transparent preset, which has been made visible on a white background in the upper image in **Fig.04**. I then set the blending mode to Multiply at 65% opacity to complete this layer.

The front of the bar is particularly shiny and so to reflect this I thought it would be good if some highlights were picked out even though the bar is underwater. I went back to the original render, then went to Select > Color Range and picked the brightest part along the bar front (ringed in red in **Fig.05**). I adjusted the Fuzziness to around 112 to capture just the brightest areas. I then copied and pasted these areas onto a new

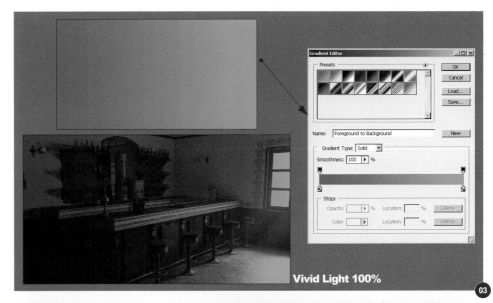

Vivid Light 100%

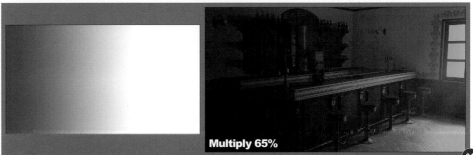

Multiply 65%

layer and erased the floor and window, leaving just the areas apparent in **Fig.06**.

I then set the blending mode to Overlay at 60% opacity, the result of which can be seen in **Fig.07**.

So far we have achieved a lighting scheme and color palette that suggests a submerged room, but the window – the source of the light – looks too dull compared with the interior. To fix this I went back to the original render layer and color selected the three panes of glass

(Select > Color Range). I copied and pasted this into a new layer and changed the color to a slightly off-white (**Fig.08** – inset 1). I set the blending mode to Color Dodge at 100% opacity, but because it is underwater the light needs to appear more diffuse and so I applied a glow effect (Layer > Layer Style > Outer Glow). I used the settings seen in the dialog box, which resulted in the version apparent in the main image.

To help convey the fact that the room is flooded I decided to add some volumetric lighting. On a new layer I used the Lasso tool to select a diagonal area stretching from the window to the floor. Using a Foreground to Transparent Gradient I then dragged from the top of the window down using a blue similar to that show in **Fig.09**. Once done I applied some Gaussian Blur to soften the edge and then set the blending mode to Screen at around 50% opacity.

It is now time to start adding some particles into the water, which is akin to a random array of noise in many ways. A photo of a natural surface such as rock, sand or even moss and lichen can prove useful as a reference but in this case I chose to use a dirt map from the Total Textures Volume 5 – Dirt & Graffiti DVD by 3DTotal.

Fig.10 shows the map in question from which I have sampled the white areas and pasted into the scene. The layer is set to Screen at 45% opacity and then the Eraser tool has been used to balance the particles.

I repeated this technique using a different map to help add an extra dimension to the scene as well as some depth (**Fig.11**). I sampled an

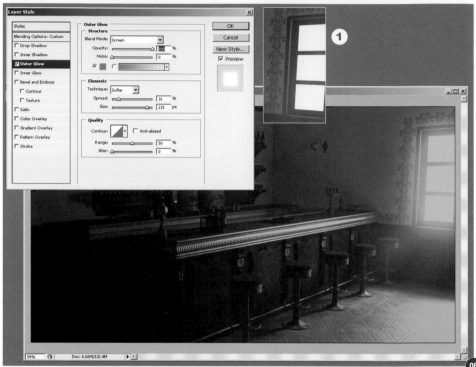

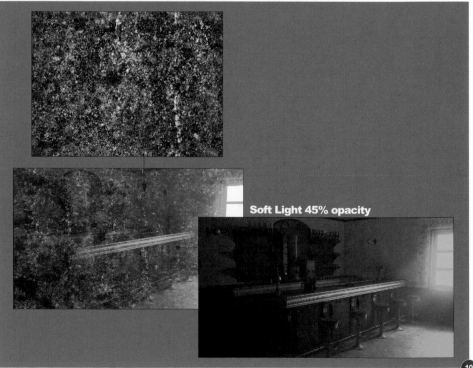

Screen 49% opacity

Soft Light 45% opacity

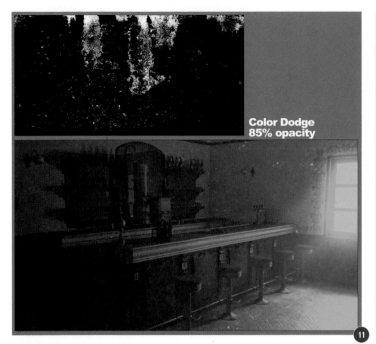

Color Dodge
85% opacity

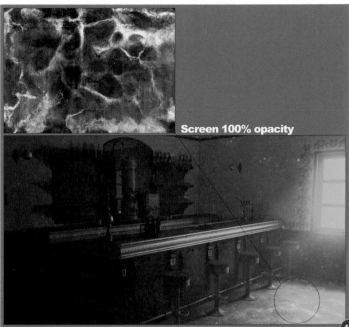

Screen 100% opacity

area on the left of the map (ringed in red) and then set the blending mode to Color Dodge at 85% opacity so that just the white parts remain visible.

To show that the room is near the surface of the sea, and also to include an effect common to aquatic environments, I decided to incorporate some caustic lighting. Again this was generated from a dirt map which bore a resemblance to those patterns cast by water.

Fig.12 shows the map and how it looks when set to Screen mode and blended in. The important factor to remember here is the perspective and so it is necessary to use the Transform tools to skew and distort the map so that it is aligned with the floor. You can also opt to use the Vanishing Point filter if you are struggling. The decision over which map to use and how you blend each into your render will require some degree of artistic merit as there are no strict formulas to follow when enhancing 3D scenes. These approaches do follow some easy steps, but as with anything visual there is always room for interpretation and therefore you will need to make decisions about which aspects to erase once the maps have been copied in.

In order to give the picture a more realistic sense of being underwater it helps to degrade it somewhat by way of some subtle noise and

blurring. I achieved this by selecting the levels layer in **Fig.02** and going to Filter > Noise > Add Noise (see settings in **Fig.13**). After applying this I went to Filter > Blur > Gaussian Blur and set the Radius to around 0.6. You can see the result of these two filters in the lower image in

Fig.13, which includes the Dirt map particles, and compare it to the crisp version above. Another aspect that is also common to underwater environments is the sight of air bubbles. Ideally we would have a library of free images at hand that we could simply copy into

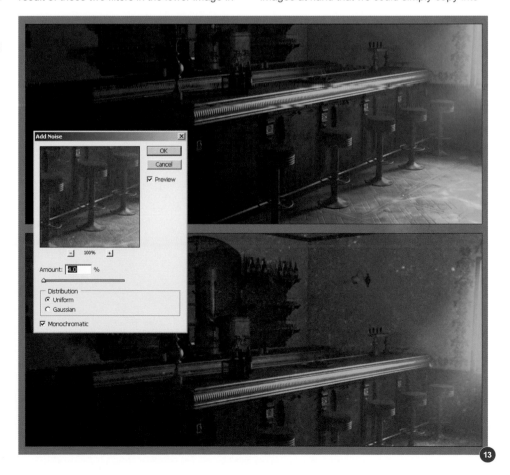

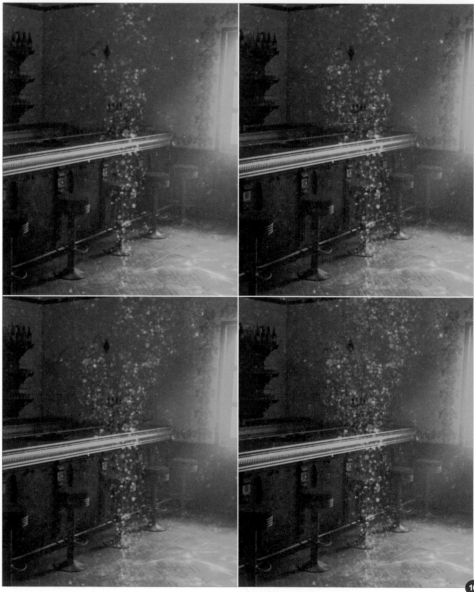

our scene, but as these often carry restrictions we shall look for an alternative solution. I again turned to my trusted library of Dirt maps in order to find something that could work, which in this case was a map called "tile02medium05" (**Fig.14**).

The area I was specifically interested in was the section highlighted in red, which I felt could work as air bubbles. The first stage involved copying and pasting a selection area into the scene (see marquee in upper image in **Fig.15**). Once this section had been copied in I set the blending mode to Linear Dodge (1). These did not really resemble bubbles as they were too crisp and so I applied some Gaussian Blur (2).

Once done it was simply a case of duplicating and scaling them to create a stream rising upward (3). You can use the Clone Stamp tool to do this, or just copy and paste the original selection and then use the Eraser tool to modify the composition.

Fig.16 shows four stages that involve these steps. The top two images show the larger bubbles whilst the lower two show duplicates that have been scaled down and given a lower opacity to create the smaller bubbles. The entire stream was generated from the original Dirt map selection and modified using the Transform tools, namely Scale and Rotate.

The last phase involves adding some highlights across a few of the large bubbles, which again

utilizes the same map. I selected an area that was composed of some of the brighter specs and ones that have a slight curvature, as indicated by the red rectangle in **Fig.17**. These are then set to Linear Dodge at 100% opacity and positioned so they look correct. I used the Eraser tool to form small arcs to replicate the shape of the bubbles.

One last additional layer will complete the transformation and constitute a few larger particles that are nearer the camera. To do this I selected an area on the map shown in **Fig.11** and scaled it up so that the white areas were larger. Then I applied some generous blurring and set the blending mode to Linear Dodge at around 75% opacity.

This concludes the transformation of the bar into a flooded chamber, the final version of which can be seen here (**Fig.18**). I hope this tutorial has demonstrated how Photoshop and post-production can prove both a useful and valid alternative to 3D with respect to creating certain effects, and be of some help in your future projects.

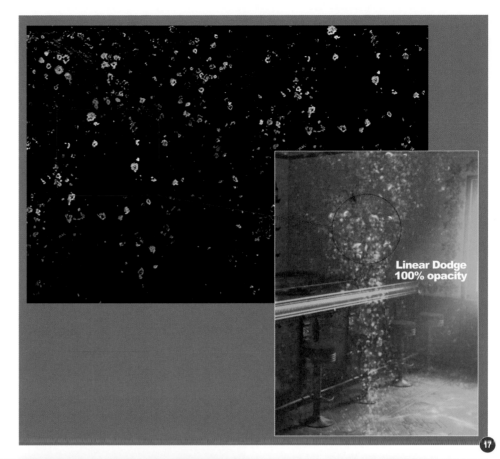

Linear Dodge
100% opacity

17

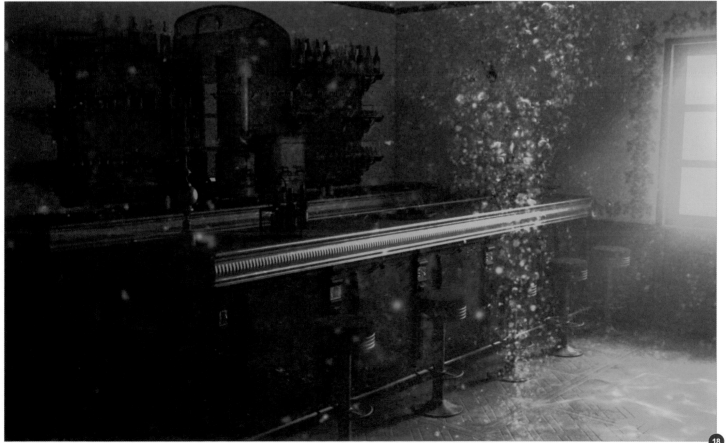

18

Sparks and Glows
By Richard Tilbury

Introduction

In this tutorial we will look at a few ways to add some particle effects that could prove difficult and time consuming in a 3D environment. We will begin with a base 3D render, which in this case is a foundry, and then discuss the techniques used to add in smoke and molten metal to give the scene a heated atmosphere.

Fig.01 shows the base render that has been exported from 3ds Max and which incorporates a series of Area Omni lights, focusing the main light source within the foreground container which will house the molten metal. The background has been left blank as this

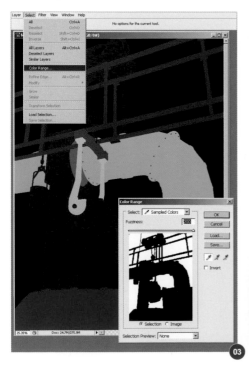

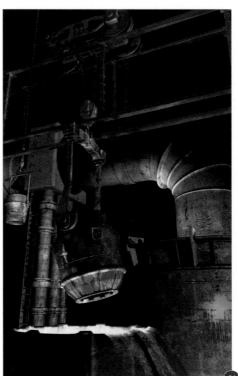

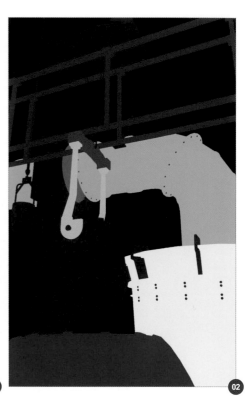

will comprise of smoke that will be added in Photoshop. The idea is to render out the crucial components in 3D and deliberately leave out anything that can be done in post-production afterwards, e.g: the molten metal and smoke.

> **Quick Tip:** One useful render pass to save out for any kind of post-production is an object ID pass, which you can see in **Fig.02**. This provides a quick and effective way of masking specific sections of the render, which is very useful during any post-production.

The first step is to add in some background smoke, which will help add some sort of context as the objects are currently situated in a void. Using the Object ID pass, which is on a separate layer in my PSD file, I went to Select > Color Range and then selected the black background, setting Fuzziness to 200 (**Fig.03**).

Smoke is a difficult effect to get right in 3D and so being able to do it in Photoshop is a great shortcut. It also enables you to use photographs, which guarantee a certain level of realism. Now if you have some good reference

photos of smoke then these will prove ideal, but a good substitute that is readily available to photograph yourself are clouds. This is also a heavily documented subject amongst reference libraries and so makes a good starting point. In this case I found a suitable image in 3DTotal's free resource library, which can be found here in the skies section: **http://freetextures.3dtotal.com/preview.php?imi=8491&s=c:Skies&p=0&cid=17**

Using Select > Color Range I selected a large proportion of the main cloud. You can vary the selection area by altering the Fuzziness and by moving the color picker around. Once satisfied it was time to copy the selection (Ctrl+C) and then paste it into the background area of the render. I ensured that the background was selected and then hit Shift + Ctrl + V, which restricted the cloud layer to just the background (**Fig.04**).

Once it was pasted in it needed some color correcting by way of Image > Adjustments Hue/Saturation and Color Balance. I darkened it slightly and then tinted it towards a warmer color to help blend it in with the lighting (**Fig.05**).

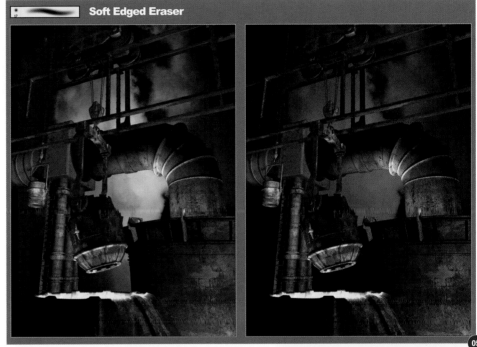

Because the selection area grabbed some unwanted areas around the cloud, it is necessary to erase these using a soft edged eraser. The left-hand edge running vertically needs to be softened and the lower central section is also not necessary as this will be hidden by the molten metal (see red crosses). You can see the final result in the right hand image.

The brush I used is one of the standard soft round airbrushes, the settings of which can be seen in **Fig.06**.

There is still a void on the left-hand side of the image. To fill this, I duplicated the cloud layer, flipped it horizontally (Edit >Transform > Flip Horizontal), and then moved it to the left-hand side (**Fig.07**).

The smoke in the upper part of the render looks OK, but it's a little too bright towards the bottom half. To help alleviate this I used a Gradiant. I first selected just the background using the object ID layer and then selected the Gradient

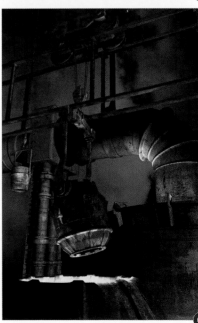

tool, making sure the preset was Foreground to Transparent. On a new layer I then dragged from roughly the base of the red arrow in **Fig.08** to its tip using the reddish brown in the editor. The result can be seen in the inset render. I then set the blending mode to Multiply.

In **Fig.09** you can see the before (1) and after (2) effects of this gradient in the first two images. I then applied a new gradient set to Multiply, but this time using an olive green (3). This ensures that the yellow light of the foreground affects the smoke lower down and gradually fades to a more reddish tint towards the top of the frame. The final result of both gradients can be seen in image 4.

To help create a warmer light in the upper part of the foreground we can add a further gradient using the color seen in **Fig.10**. I used the object ID layer to isolate the foreground objects and then applied a Foreground to Transparent gradient, starting from the top of the frame and dragging down to roughly the lower rail. I then set this to Soft Light, the result of which can be seen on the right.

In order to create the molten metal, I created a new layer and, using a hard round airbrush, painted in some simple strokes in pure white (**Fig.11**). Once done, I applied an Outer Glow (Layer > Layer Style > Outer Glow) using the settings seen in the upper dialogue box. The result can be seen in the lower right image. Settings will vary according to the size of your render so experiment with the Spread and Size settings.

I duplicated this layer and then changed the Outer Glow settings to add another layer,

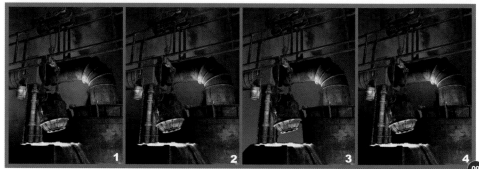

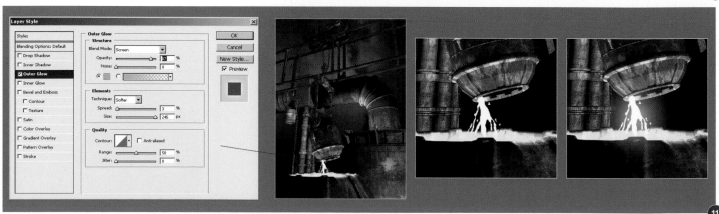

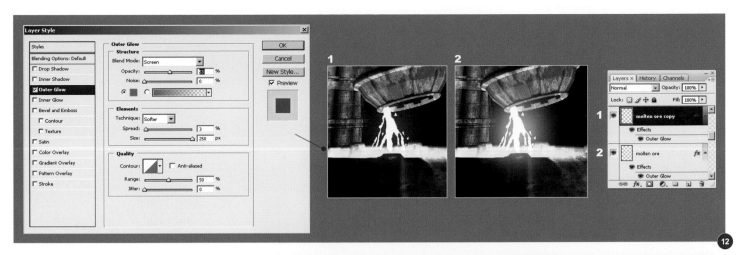

which can be seen in the lower left image (1) in **Fig.12**. You can see the two copies in the layers palette on the right and the combined result in image 2.

It was now time to start work on the vat of molten metal and create some heat (**Fig.13**). On a new layer I created an elliptical selection area that roughly matched the size and perspective of the vat (1). I then filled this with a pure white and erased around the ribs (2). I then returned to Layer > Layer Style > Outer Glow and applied the settings seen in dialogue box. The final result can be seen in the lower right image.

To enhance the sensation of heat emanating from the center of the vat I added a further layer (**Fig.14**). Using a soft round airbrush,

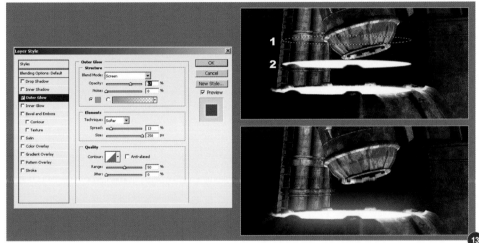

I painted in a small elliptical area of yellow using the previous method, and then blurred it heavily (Filter > Blur > Gaussian Blur (1)). I then applied another outer glow using the settings

seen in the upper right (2). When both layers are combined they create a more intense glow (4) compared to the initial layer (3).

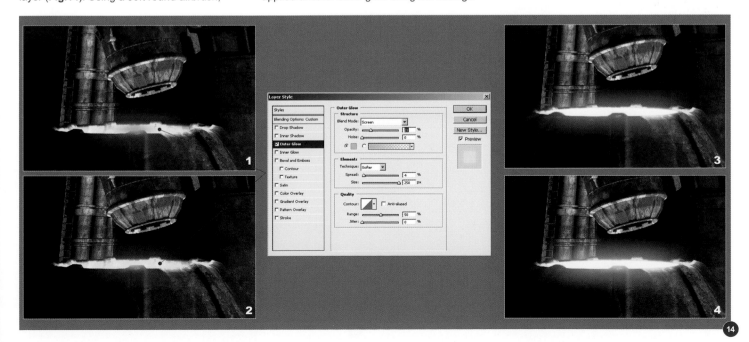

The glow from the vat requires a warmer tint around its origin and so to do this I added a new layer and, using a large soft round airbrush approximately 600-800 pixels wide, I clicked once with the mouse at the point where the poured metal enters the vat using an orange color (**Fig.15**). This looks similar to the small inset seen on the right (1). I then applied some Gaussian Blur to soften the shape and expand it (2). This layer is set to Overlay blending mode and eventually appears as shown in inset 3.

As has become the pattern now, I decided to use an additional layer to enhance the effect of this one. I duplicated the layer, but this time reduced the opacity to 68% and set the blending mode to Lighten (the combined effect can be seen in the right image in **Fig.16**).

The right-hand edge of the image looks a little disjointed and because there is a smoke-filled backdrop there needs to be some form of integration with the foreground. I left this part of the render blank in order to use some foreground smoke that will help bind the two spaces.

The image of clouds that I used before was perfectly adequate to be used once again and so using the same technique, I copied and pasted in a portion of the cloud as before. I color corrected it by way of Image > Adjustments > Color Balance, Hue/Saturation and then used a soft edged eraser to soften the edge. You can see this layer isolated on the left in **Fig.17** and the consequent final effect to the right.

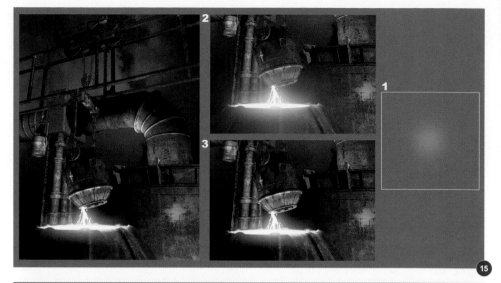

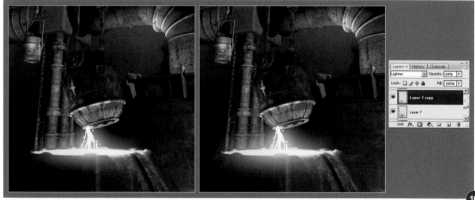

I followed exactly the same technique when adding some smoke to the small bucket on the left hand side (**Fig.18**). I copied and pasted a section of the cloud into the image and then scaled it down whilst using the Eraser tool to soften the edges. Once again the isolated smoke can be seen on the left and the final result on the right.

One of the final elements to add in to the image is some splashes of molten ore. After browsing the free library of photos on 3DTotal I chose two photographs from which to start experimenting.

In **Fig.19** you can see two images of branches with different scales. I started by going to Select > Color Range and then picked a random

highlight on one of the branches in the right picture and copy this into the image.

I then locked the transparent pixels layer by clicking on the icon at the top of the layers palette (small checkered square ringed in red) and started to paint over the branches using a bright yellow. By doing so you can confine any painting to the opaque parts of the layer, e.g: the branches (**Fig.20**).

Once done I scaled it accordingly and then used a hard edged eraser to randomly delete sections of the branches (1) in order to create some splashes around the top of the vat (2) as seen in **Fig.21**.

I then applied a Layer Style > Outer Glow to the remaining branches, using the settings shown (**Fig.22**).

Then I repeated the same exercise twice more, using slightly different selections from the same photo. These were then scaled and erased so that the general direction of the branches corresponded with the arrows in **Fig.23**. There is no formula to this particular process; just use the Transform and Eraser tools carefully in order to give a random look to the splashes.

Final Touches
Because the background of the initial render was black it needed to be lightened very

slightly in order to help situate the smoke more convincingly. Using the object ID layer I selected just the background (black area) and then, on a new layer, filled in a with a brown color similar to the color-adjusted smoke. I also ramped the opacity down to around 20%. It's only a slight difference, but you can see how the whiter areas are now a little darker in the right-hand image in **Fig.24**.

One final touch was to increase the contrast to the highlights in the foreground by way of Curves. This can either be done by applying a new adjustment layer, which generates a mask, or alternatively you can duplicate the initial render and then go to Image > Adjustment > Curves and erase the parts you do not wish altered, which is what I did in this case. Once the Curves dialogue box opened I changed the curve by adding two points similar to **Fig.25**.

The temporary white areas (1-2) reveal the parts of the new adjusted layer that have been erased. The images in the lower right show the before (3) and after version (4) in the final state with the white area deleted. You can see that the highlights on the large pipe and suspended buckets are now a little more intense (**Fig.26**).

Here is the final version with all of the post effects (**Fig.27**).

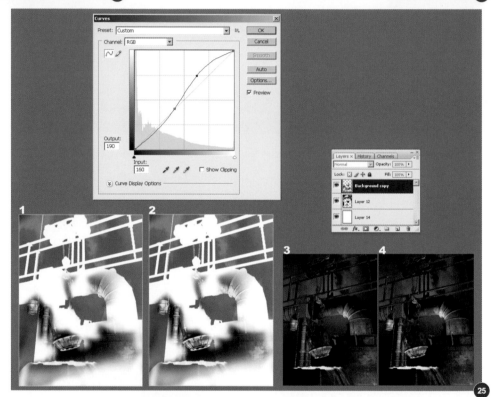

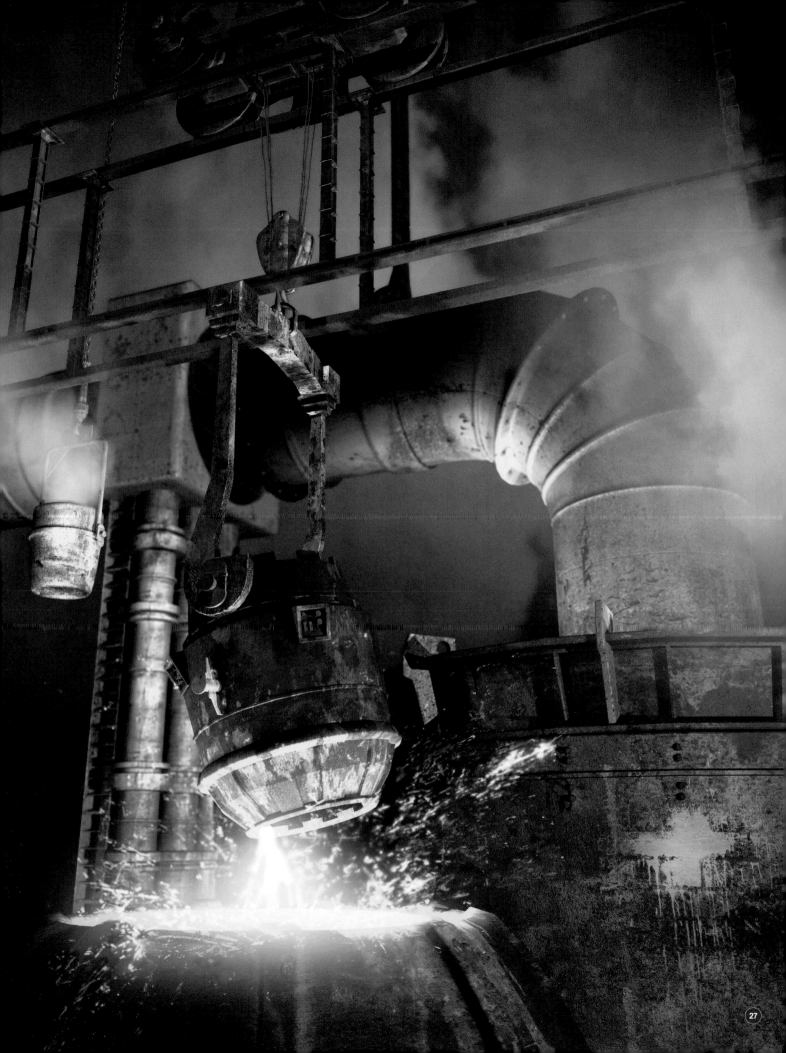

Sci-Fi
By Richard Tilbury

Introduction

This tutorial focuses on creating a space environment that could make a suitable backdrop to a sci-fi scene. As this is the main focus I have prepared a space hangar that deliberately leaves a large void that can be filled in Photoshop. We shall begin with some techniques used to create a star field and take a look at the value of using a custom brush. No space scene would feel complete without a planet or two and so we will also look at how to add these alongside a nebula.

Stars

I made sure to choose a pure black as the environment color within my 3D package for obvious reasons and then saved out the image as a TGA in order to quickly select the background, which would be a little tricky along the ceiling edge (**Fig.01**). The difficult aspect to convey with any view into space is a sense of depth as we are looking into a void and as such there are no visible markers by which to gauge distance. Of course there are plenty of stars, but these vary in size and brightness and so can be deceiving. If you had an alignment of similar planets you could have a measuring stick, however this would look unnatural and so we need to vary the size and brightness of the star field in order to create a feeling of depth.

The best method is to use a few layers, but perhaps the quickest and easiest way to start is with the Noise filter. I created a new layer which I filled with black and then went to Filter > Noise and added a value which suited the size of the

render (**Fig.02**). This will comprise the farthest stars, after which we will gradually move closer toward the camera.

At the moment the scene has far too many equidistant stars. By increasing the contrast and lowering the brightness it is possible to add some variety and depth (**Fig.03**).

Another useful way of creating stars is by way of a custom brush. Using this approach I began by using a hard round brush and painting in a few random spots of varying sizes (**Fig.04**). This is turned into a brush by making a selection area around the dots and then going to Edit > Define Brush Preset and naming the brush. I then accessed the brush settings and altered the Brush Tip, Shape Dynamics and Scattering, using the parameters seen in **Fig.05**. Once done it is necessary to create a new brush by clicking the small icon ringed in red and saving out the brush once more in order to preserve the new settings.

A new layer can now be created and then the brush used to broadly paint in a larger group of stars. It is best to paint randomly across the

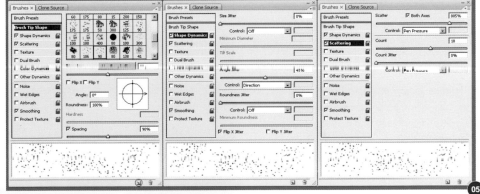

designated area and not worry too much about placement as you can always erase individual stars later and refine the composition. A good practice is to use an eraser with no pressure sensitivity to fully delete certain stars and once you are happy, reduce the opacity in order to vary the brightness – as much depth as possible is the aim here (**Fig.06**).

The third and final set of stars concerns the largest, which appear nearest to the viewer. Using a hard round brush I added in a few dots and then duplicated the layer. Going to Filter > Blur > Motion Blur, I added a blur along a diagonal axis. This layer was then duplicated and flipped horizontally to add the "twinkle" effect (**Fig.07**). By keeping these on a separate layer you have the option of moving, duplicating and re-scaling them without affecting the rest add these alongside a nebula.

Planets

For the purposes of this tutorial we will have a look at creating planets in two different ways, which should suit most scenarios. First of all we will focus on how to create a distant planet before moving on to a close up one. As this book is aimed at 3D artists, this technique will seem elementary but very effective. In this instance I am using 3ds Max, but this method can be followed in any 3D package.

I created a standard sphere, ensuring I had the "Generate Mapping Coords" box ticked, and then added some smoothing via Turbosmooth (**Fig.08**). I then found a texture that resembled a planet (**Fig.09**). In my case this was a

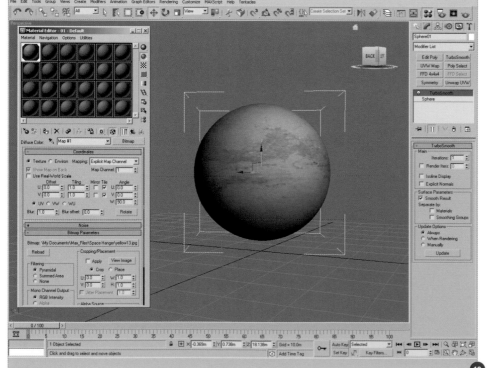

painted surface, but there are many textures that can work. For example, **Fig.10** shows a stone surface that could be used to describe a desert planet and **Fig.11** is a stone wall that could be the basis for a moon. **Fig.12** is similar to the one I chose, which could also work. I suggest picking up your digital camera and taking a stroll – you will be surprised at how many common and everyday surfaces can be transformed into a planet, especially with a macro lens!

I applied the texture directly to my sphere without any UVW mapping and then rotated the

angle so that the general flow was horizontal instead of vertical (**Fig.13**). Using the default lighting I hit "Render" and then the planet was ready to be exported (**Fig.14**). If you wish to control the direction and intensity of light then some lights can be added into the scene. Once in Photoshop I duplicated the planet, darkened it slightly and then used a large soft airbrush to delete the lower left, which created a broader shadow across the upper right hemisphere (**Fig.15**).

We shall now add a planet in the foreground, but only show a portion of it due to the proximity and so the first thing to do is to create a large shape using the Elliptical Marquee tool. **Fig.16** shows the position of the planet, which starts its life as a flat block of color. The next phase requires some evidence of land masses and so I again resorted to the same texture, although this is dependent on the type of planet you are interested in creating (**Fig.17**). I decided on a planet similar to Earth, as this is familiar to everyone, and so I needed to show evidence of the clouds that are always visible from space. A great resource which I use regularly is the huge library of free photos at 3DTotal, which can be found here: **http://freetextures.3dtotal.com/**. I was looking for a general photo of clouds to wrap around the planet, but found some that were especially suitable as they were photographed from an aeroplane.

I made a selection area that encompassed the curve and then pasted into the planet shape. It is important to first select the planet so that when you transfer the clouds you can paste into (Shift + Ctrl + V) the shape and thus create a layer mask. This way you have the freedom to move them around whilst still keeping within the planet outline (**Fig.18**).

Using the Warp tool (Edit > Transform > Warp) I then created some curvature to the clouds so that they echoed the shape (**Fig.19**). I set the blending mode to Screen and altered the Curves in order to correct the color (**Fig.20**). Using a combination of the Transform tools, Eraser and the Clone Stamp I then edited the cloud composition until I was happy with it (**Fig.21**).

The next step is to flatten all of these components into a single layer and adjust the color balance and contrast using Curves, resulting in a far more vibrant planet (**Fig.22**). You can also see here that I used the alpha channel from the initial TGA to select just the exterior, and then trimmed the planet to fit within the hangar opening.

The final stage involves adding an atmosphere, which is achieved using glows. I duplicated the planet layer and then added a glow via Layer > Layer Style > Outer Glow (**Fig.23**).

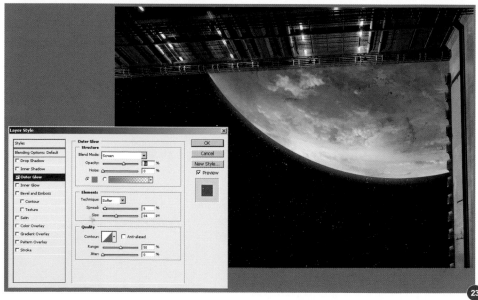

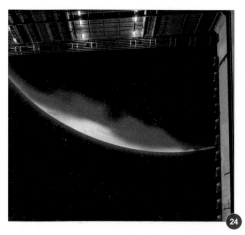

The glow will naturally follow the entire outline and we only want it along the curved edge so, using a soft eraser, I deleted all but the lower portion which is visible in **Fig.24**. I repeated the procedure except this time I left just the area apparent in **Fig.25** and increased the size of the glow to 250px.

The finishing touch is the addition of the thin outer atmosphere, which appears as a blue film around the circumference. To do this I selected the area around the planet and then inverted this, therefore selecting just the planet. I then went to Select > Modify > Expand and entered a value between 5 and 10. Using an

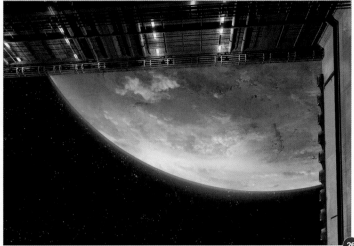

appropriate color (blue in this case) I went to Edit > Stroke and entered a value of around 3 before applying some Gaussian Blur to soften it. After deleting the line along the two right angles the planet was complete, which you can see here in **Fig.26**.

Nebula

The last feature we will add into our scene as an alternative is a nebula, or interstellar cloud, which often appears very psychedelic in color. These vary dramatically, but are certainly a well-known feature of space and worth exploring. The great thing about nebulas is that they do not seem to have any discernible structure and so you can really be creative. The key technique is to separate out your layers and experiment with the blending modes and color schemes, as you will be able to produce a whole array of different clouds from a limited number of layers.

The first layer can be seen on the left in **Fig.27**, which is nothing more than few random strokes using a soft round airbrush with the opacity turned down to around 50%. I chose

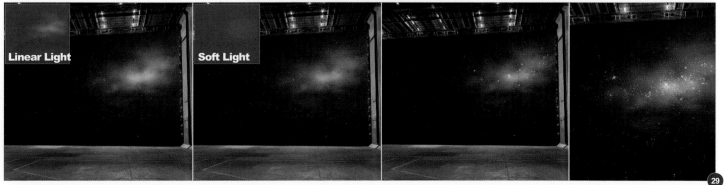

to use a dull purple, but any color works really depending on your desired final effect.

On a separate layer I painted in a large cloud (upper right), which I faded out on one side before setting the blending mode to Overlay (lower right). A new layer was used to add a brighter area around the center and, using a Radial Gradient with a Foreground to Transparent preset, I dragged from the middle outward using a pale pink, as shown in **Fig.28**. The blending mode was then set to Linear Light, which gave the nebula an ethereal glow emanating outward from the center. You will notice on the right that I used a soft eraser to reveal a few lines that look like clouds, which helps break up the symmetry a little.

The following four images (**Fig.29**) examine the process of building the detail using separate layers. In the first (upper left) I added another small cloud using the same pink and blending mode apparent in **Fig.28**. The Soft airbrush is the best tool for this job, especially with the opacity turned down, as it conveys a quality that resembles the dispersion of gas.

The next layer incorporated a different color, but this time the blending mode was set to Soft Light (upper right). The bottom two images reveal two sizes of star clusters, the largest being on the left. These were done using the same techniques covered earlier in the tutorial, with the smaller of the two clusters utilizing the custom brush.

Here is the final version. With the layers remaining intact it is easy to experiment with the colors and change the composition (**Fig.30**).

This completes the tutorial, which I hope has given you some useful pointers for tackling your own space scenes in Photoshop. The only thing remaining is to populate the scene with some fighter ships, but we shall leave that for another day (**Fig.31**).

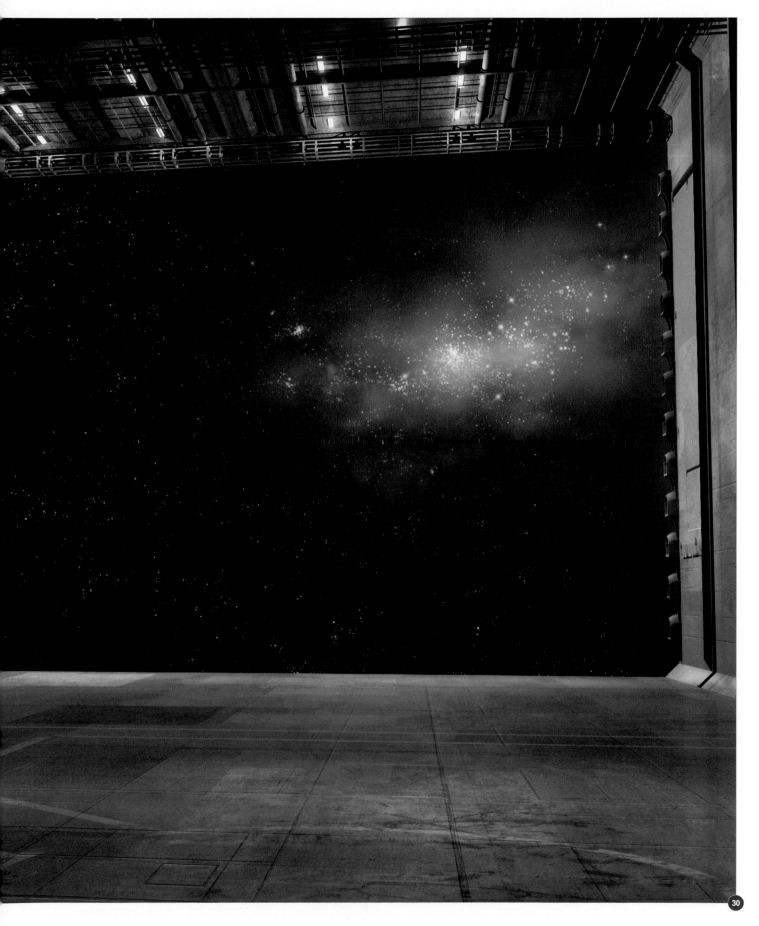

Sci-Fi

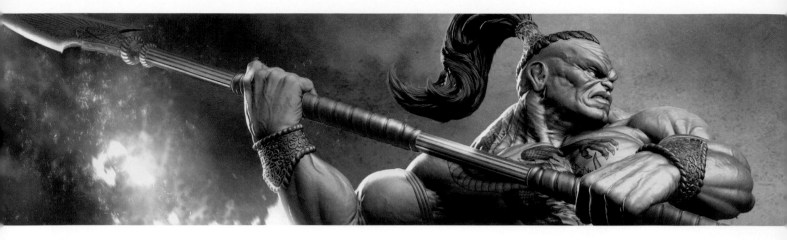

Fire, Heat Haze and Smoke
By Richard Tilbury

Introduction

This tutorial explores how Photoshop can be used to add effects and features to a 3D render in a quick and efficient way that would not be possible inside your 3D software. We will begin with a base 3D render, which in this case is a scene created by **Christopher Tackett** for a Pixologic challenge. We will transform the scene by adding some fire and smoke into the background and then apply some heat haze to the foreground.

Fig.01 shows the base render by Christopher, which portrays a warrior amid a barren wasteland. The color scheme and environment are perfect for a transformation into a heat-ravaged landscape of fire and smoke. I decided to have some fire emerging from behind him on the left of the picture and so the first port of call was to create this effect. As this is to be a still we can add the fire in 2D, which can work really well and save time adjusting parameters and doing intensive render tests.

Adding any visual effect does involve having an artistic eye to some degree, but hopefully these techniques will be useful to artists who

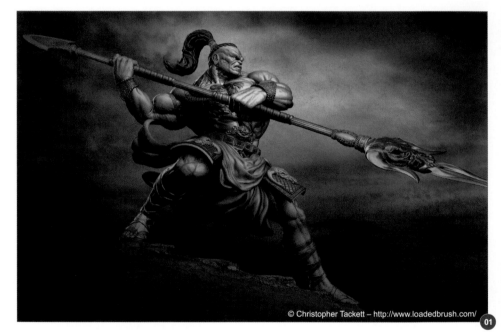

© Christopher Tackett – http://www.loadedbrush.com/

01

are not proficient in painting and permit them to apply the methods on offer and enhance their own workflow and post-work. In order to avoid a purely manual approach I have opted to use existing maps and images to build the components. With regards to the fire, I have chosen to utilise a dirt map, which can be seen in **Fig.02**.

I searched through a library until I found a pattern that most resembled flames. This particular map shows peeling paint, but the areas in black bore a resemblance to flame shapes. I selected these areas (Select > Color Range) and then copied and pasted them into the render. It is far easier in any post-production if your render is divided into separate layers so that you can quickly paste selections into different regions and still have the freedom to move things around. In this case the character was also supplied as an alpha channel and so I could paste the Dirt map in behind him with ease. I selected the area behind him and then pasted the Dirt map into this selection area (Shift+Ctrl+V). I then moved the different areas around to create the pattern visible in **Fig.03**.

02

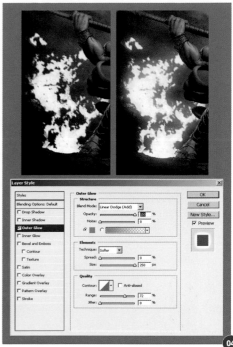

The flames are essentially the black areas from **Fig.02**, which have been rearranged into a different configuration using the Transform tools and the Eraser. Once happy with the general shape, I locked the transparent pixels on this layer (small checkbox above the layers palette) and then filled it with a lemon yellow. Then, using a pure white, I painted in a rough area in the center of the largest shapes. As this was meant to depict fire it needed some blurring courtesy of Filter > Blur > Motion Blur with an angle that tilted along a diagonal (see inset). To create a more intense light and heat, I applied

a glow effect by way of Layer > Layer Style > Outer Glow, using the settings shown in **Fig.04**.

With the flames established I needed to add some smoke and further effects to better integrate it into the scene. The first step was to add smoke, which I did by using a photo of clouds from the free reference library at: http://freetextures.3dtotal.com. I made a selection area around the clouds and then pasted it into the render. It was then color corrected by way of Image > Adjustments > Color Balance and the brightness reduced so that it matched the

scene. As with any section of an image it is often necessary to use a soft edged eraser to blend it in (**Fig.05**).

By using a few selection areas I built up a denser volume of smoke around the fire (**Fig.06**). It is always useful to keep everything on separate layers. In this case using separate layers meant I was able to manipulate and move the different smoke components individually in order to experiment with the composition.

The next phase concerns the creation of a softer, transitional edge around the flames and making a glow that blends them with the smoke. To do this, I again used another Dirt map and selected just one aspect using Select > Color Range. I then copied and pasted the white regions into the scene and made them bright orange (**Fig.07**). As with the flames I added some blurring, but this time just using Gaussian Blur. It looks a little patchy here, but when the flames are superimposed it will make more sense (**Fig.08**).

Perhaps the last aspect to add is some evidence of sparks, which were also derived from a dirt map. **Fig.09** shows the map used, which in this instance only involved the white areas. Once these were integrated, I duplicated the layer and added some Gaussian Blur in order to give them a slight glow and reduce the sharpness.

The next phase involves adding smoke to the right-hand side of the background. I find the best way of doing this is to use photos of clouds. Again I sourced a photo from the library and chose a suitable cloud formation that could represent a thick plume of smoke (**Fig.10**). This type of cumulous cloud is perfect, but in order to fade the smoke out you could either use a soft eraser or alternatively select a more wispy

cirrus cloud and blend the two together. Once your cloud has been copied in the first thing to do is adjust the brightness and contrast using a combination of Curves, Levels and Brightness/ Contrast. When satisfied you can then color correct it using Image > Adjustments > Color Balance and Hue/Saturation. The technique is identical to that shown in **Fig.05**.

With this done it is time to add further smoke into the background. **Fig.11** shows the addition of an extra section of smoke, which has been used to fade out the main plume nearest the viewer, along with some extra plumes throughout the distance.

To maintain a fiery and heat-ravaged theme throughout the picture I thought it would be good to transform the landscape into a scorched wasteland. To do this I used a dirt map once again, which can be seen on the left in **Fig.12**. I selected the white areas only and then pasted these into the scene before scaling them down along the vertical axis to match the perspective. Using an eraser I then deleted sections to form the patches you can see in the render. To get the correct color I locked the pixels (see **Fig.03**) and then, using the Eyedropper tool as a guide, chose lighter versions of the scene colors. I then went to Layer > Layer Style > Outer Glow and applied the settings shown in **Fig.13** to add a sense of heat. To enhance the effect further I then duplicated the layer along with the layer style and erased everything except a few choice areas in the center of some of the larger

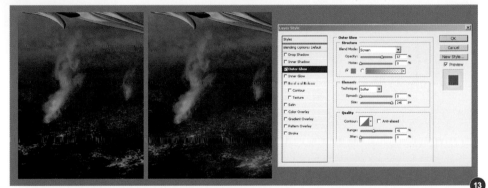

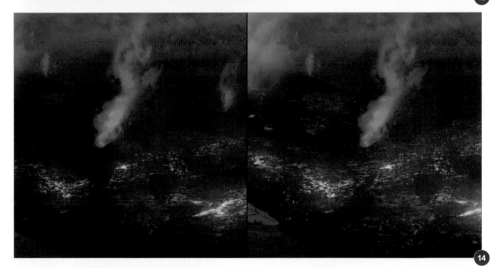

patches. To complete the effect I made these remaining areas bright yellow. **Fig.14** shows the before and after effects of the secondary glow.

This completes the background section of the scene, but because we have added an extra source of light via the fire we should reflect this in our character by way of some rim lighting. A quick and easy way to do this is to first select

just the character and then, on a new layer, fill the selection area with a suitable color (in this case a yellow to mirror the fire – see upper image in **Fig.15**). Then go to Select > Modify > Contract and add a value that creates an appropriate boundary within the outline of the character. Next go to Select > Modify > Feather and enter a value between 10 and 20, depending on the size of your image. Hitting

delete will reveal a soft edged border around
the character, as seen in the lower image.
Now change the blending mode to Soft Light
and then duplicate the layer to exaggerate the
effect.

To add a sharper edge of light, I repeated the
above steps and tried reducing the number
of pixels when modifying the selection area
whilst ignoring any feathering. **Fig.16** shows
such a layer which, when combined with a few
feathered layers, adds stronger highlights along
the extreme edge of our warrior. You will notice
that sections of the edge have been erased
where there would be less light so be mindful of
this when using this technique.

Fig.17 shows the cumulative effect, which
involves a few layers incorporating different
selection settings. There is no formula to
creating the perfect effect, but with some
experimenting and some considered use of the
Eraser we can quickly achieve a satisfactory
result without the need for manual brushwork.

The last aspect that will help enhance the fiery
environment is some evidence of heat haze,
which can be done using a combination of
two filters. The first step is to flatten the image
and then duplicate it. Once done, select the
new layer and go to Filter > Distort > Glass.
The settings will vary according to your scene,
but these are the ones I applied in this case
(**Fig.18**). The Frosted texture is the best option,
but the Scaling will wholly depend on the scene.

Obviously we cannot have heat haze across the
entire image as it would look unrealistic, so we
will focus it along the foreground. I duplicated

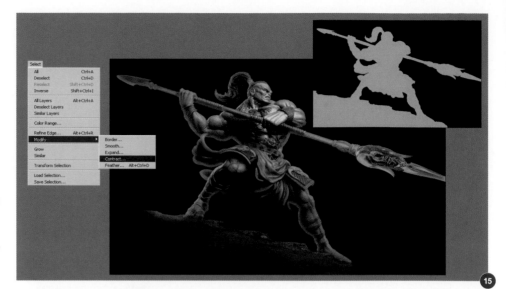

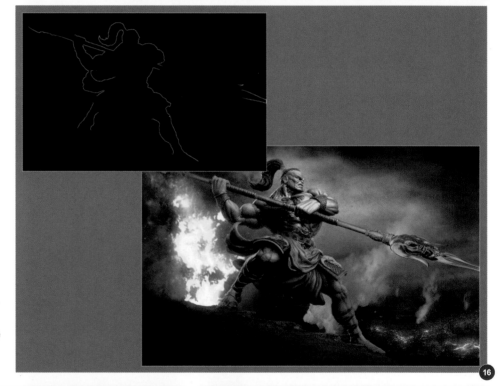

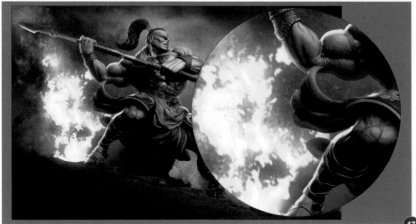

the distorted layer and then in Quick Mask mode, selected a Foreground to Transparent Radial Gradient and dragged a circle around the base of the right foot, as shown in **Fig.19**. Switching to Standard mode, I then deleted the area around the foot and repeated this on the duplicate layer for the area around the left foot. After this the two layers were merged. The before and after effects of this distortion can be seen in **Fig.20**.

One final filter that will complete the effect is a Wave, which is also found under the Distort menu. Again the settings for this are entirely dependent on the scene and image size; however these are roughly the ones I used in this instance (**Fig.21**). Again to limit this filter to a specific region I duplicated the flattened layer and then applied the Wave to this. I wanted

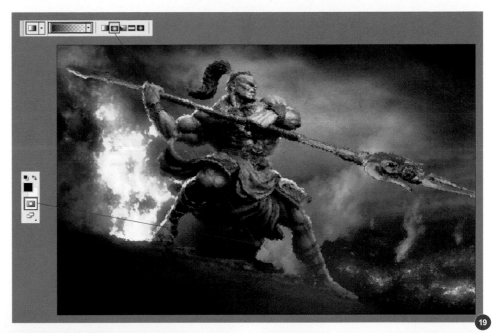

19

21

to restrict it to the extreme foreground and so, using Quick Mask mode, I dragged a Linear Gradient from the bottom of the canvas up to the knee region at an angle that matched the ground (**Fig.22**). Back in Standard mode I then deleted the upper section and merged this layer with the Glass distortion. I then applied a little Gaussian Blur to the distortion and flattened the PSD file, resulting in the final version (**Fig.23**).

I hope that this tutorial has offered some useful tips on creating complex particle effects in Photoshop and shown that post-work can prove a viable alternative to 3D. I would also like to extend my thanks to **Christopher Tackett** for allowing the use of his great artwork for this project.

22

The Breakdown Gallery

This part of the book showcases a collection of finished artwork by a number of notable artists working in the industry today. Each author will present their finished render which will be accompanied by a visual compendium, summarising some of the key passes and layers that contribute towards the finished image. Throughout the following pages we shall be treated to an insight into the process and reveal some of the current techniques used in the industry today.

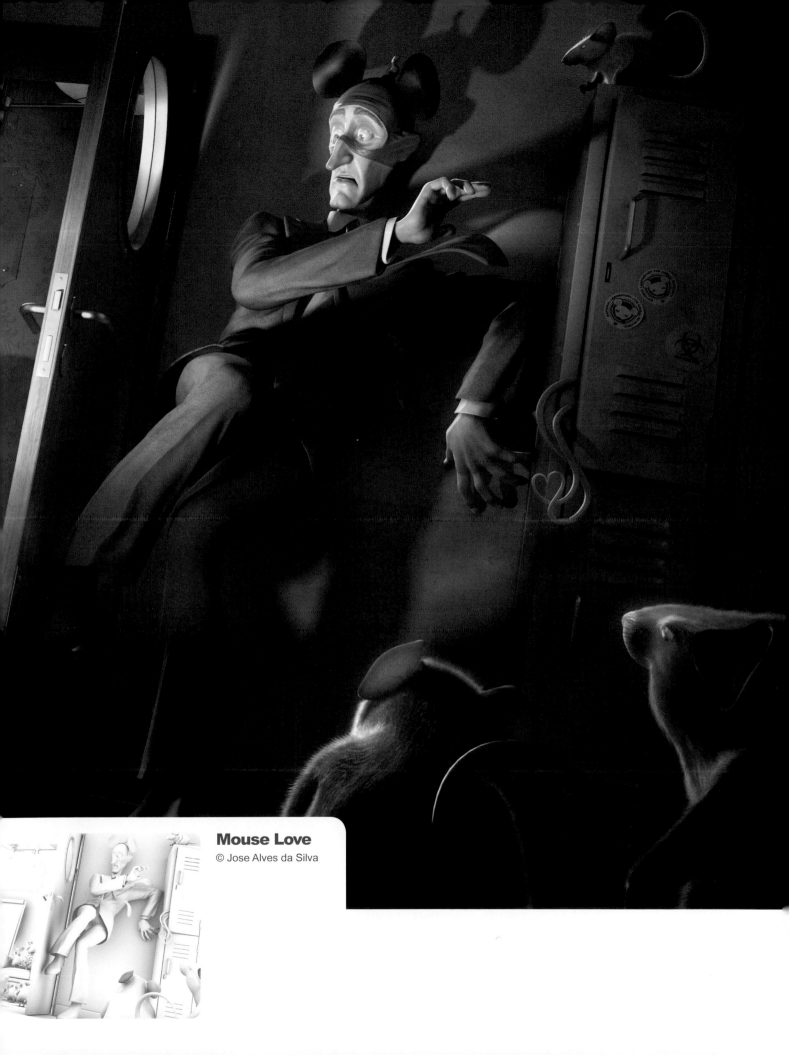

Mouse Love
© Jose Alves da Silva

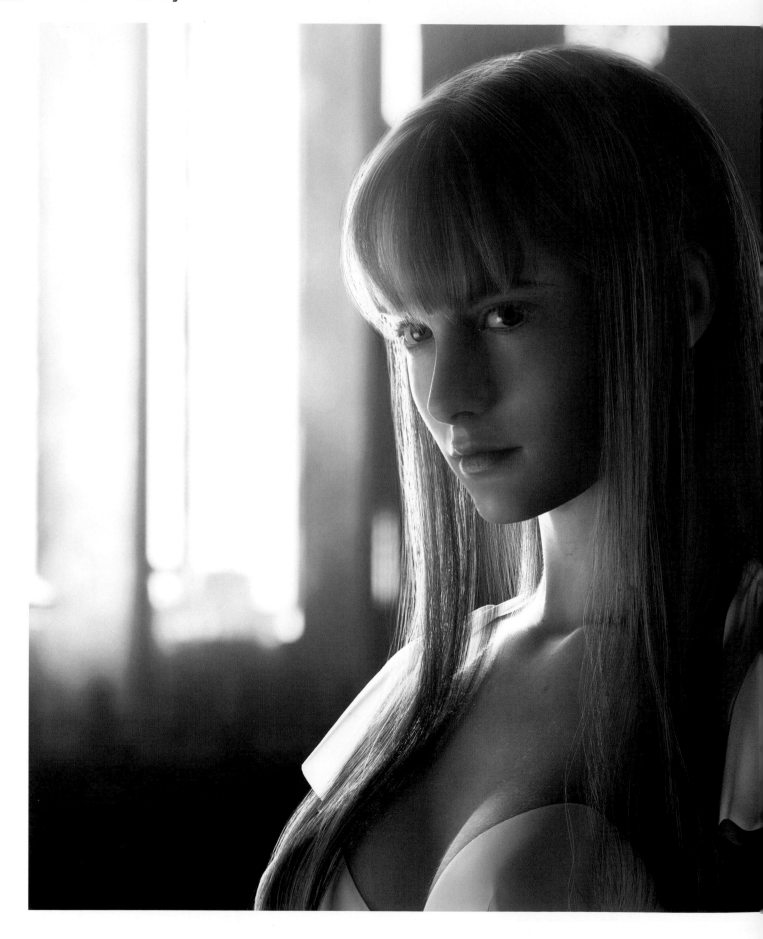

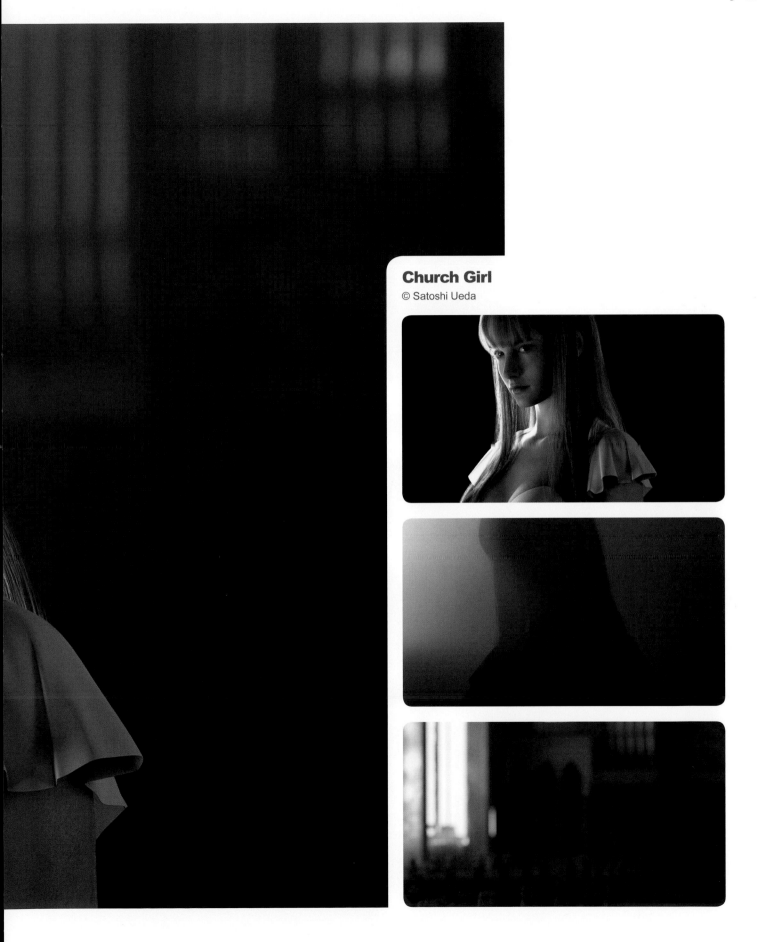

Church Girl
© Satoshi Ueda

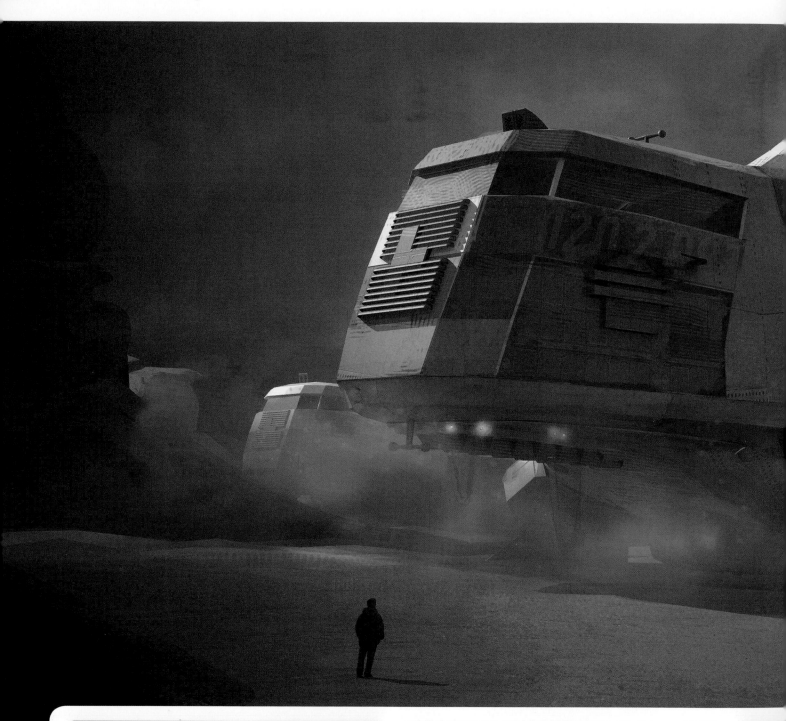

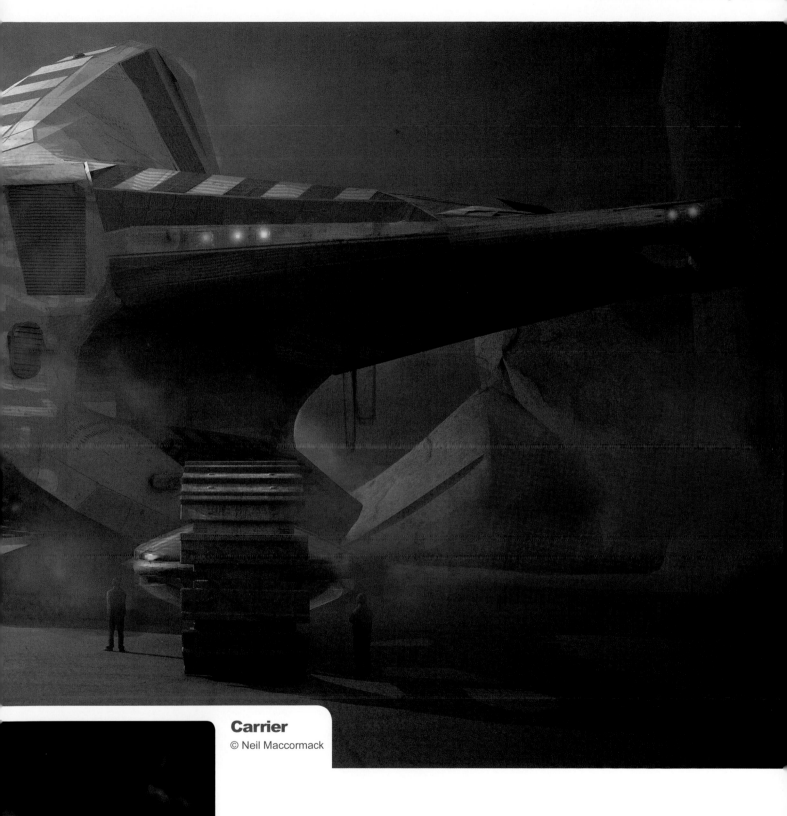

Carrier
© Neil Maccormack

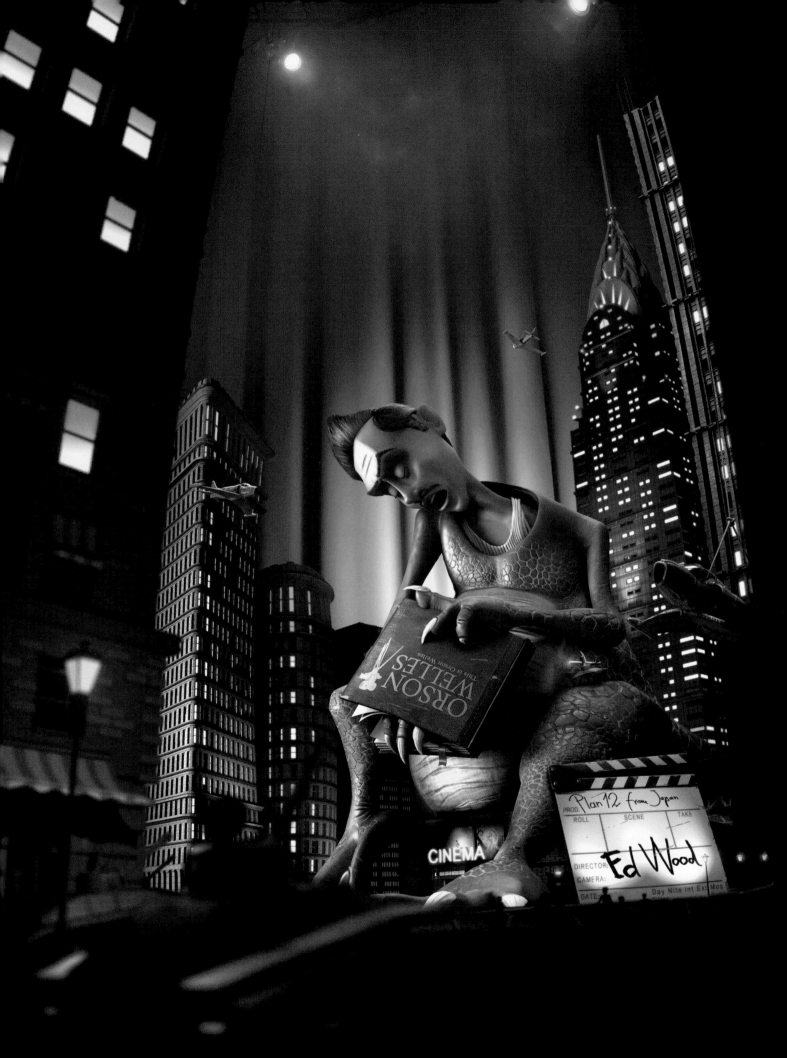

Plan 12
© Mathias Herbster

Le Bain

© Eve Berthelette

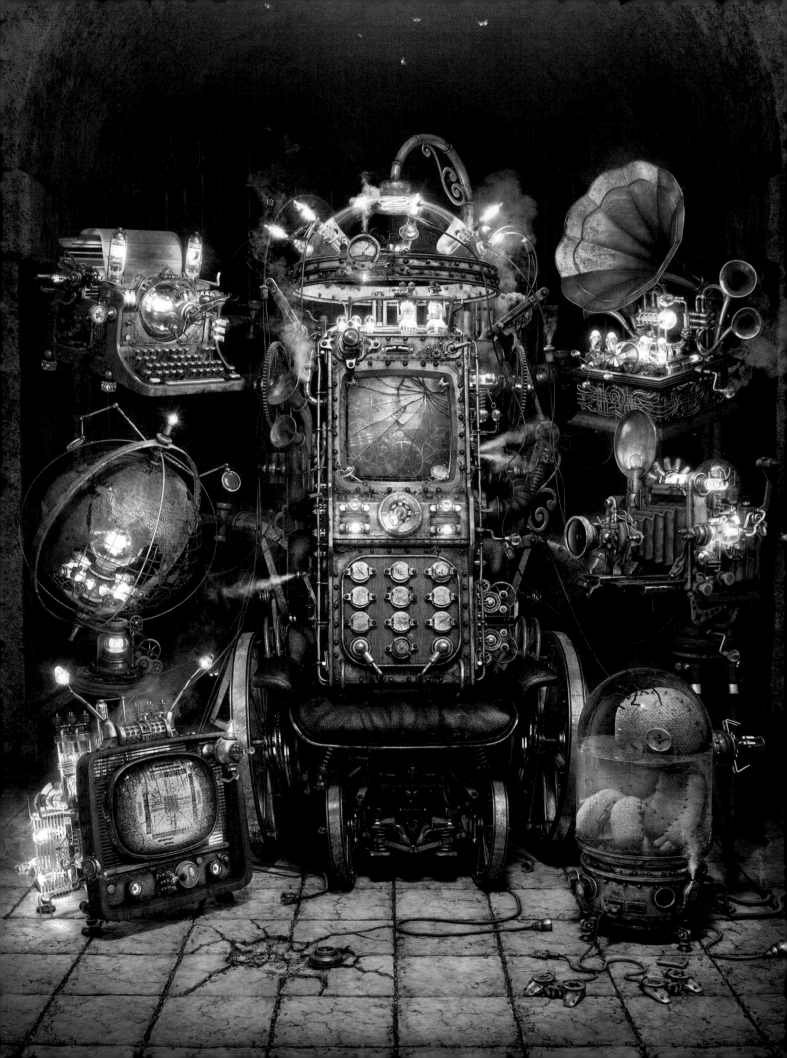

ShokeR
© Aleksandr Kuskov

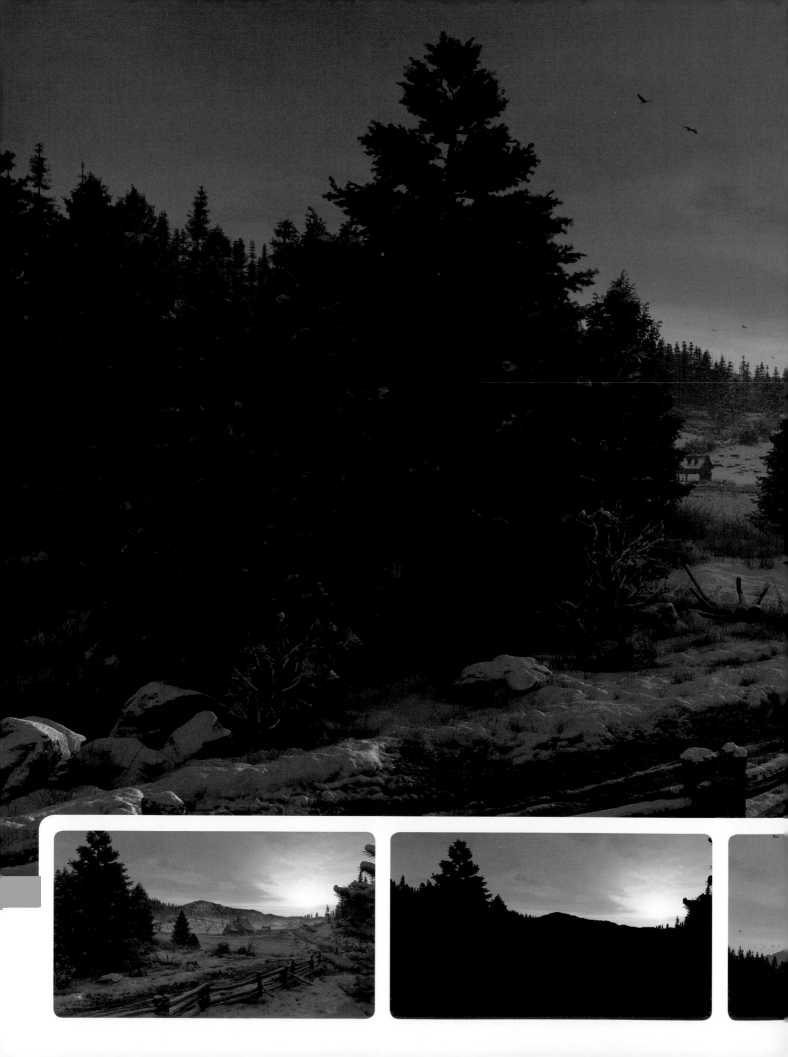

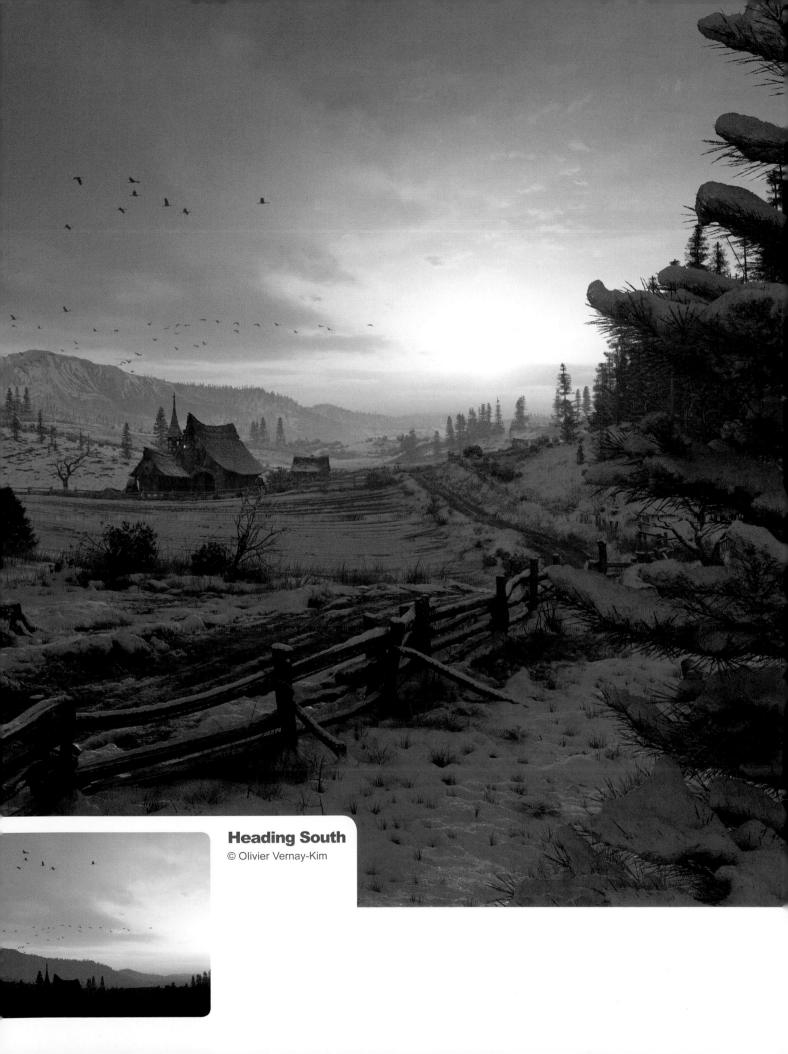

Heading South
© Olivier Vernay-Kim

Hausnummer 42

© Fredi Voss

The Next Level – 3D Paintovers

This chapter, above all others, takes the notion of post-production to its furthest conclusion and to the point where almost all of the 3D foundations are concealed. The tutorials can be compared to the initial Spaceship Concepts article by Mike Hill, in which geometry forms the backbone of the design with all the refinements and detailing limited to Photoshop. The following tutorials are somewhat akin to the type of work a concept artist may produce in the form of "3D paintovers" and are particularly appropriate for artists who are interested in both digital painting and 3D.

Google SketchUp is used to demonstrate the workflow, although all 3D packages are equally appropriate with the principles being universal across the board. Despite the option of being able to purchase a more comprehensive version, SketchUp is available as a free download and therefore has a non-exclusivity which makes it the obvious choice. It has gained huge popularity as an intuitive "all-round" 3D package and has been designed with ease-of-use being at the forefront of the interface and toolset, making it a favorite of many artists who do not specialize in 3D. A brief overview of the interface and toolsets has been included for those unacquainted readers.

For those who wish to take their 3D renders into a more painterly realm, but perhaps do not possess the traditional skills relating to perspective and so on, this chapter should prove particularly relevant. As well as expanding on the approaches mentioned in the Previsualization chapter, it demonstrates the value of paintovers with regard to swiftly producing texture variations, changes in mood and lighting, and adding superficial differences without the need for adjusting textures and re-rendering.

In a way, this chapter is at odds with the rest of the book due mainly to the fact that the example tutorials culminate in a 2D image that begins life within a 3D environment. As such, the format is presented somewhat in reverse compared to the other chapters; however it does demonstrate another cross-pollination between 3D and 2D, providing an informative and useful approach for those artists that work across both disciplines.

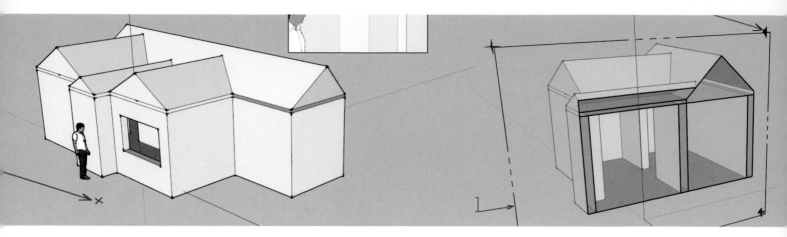

Introduction to Google SketchUp
By Richard Tilbury

Why use SketchUp?

Google SketchUp is a free programme that enables users to quickly and effectively build 3D environments using a number of intuitive tools. Unlike most 3D packages it is very easy to learn and does not require hours of training before decent results are achievable. It is very versatile and, with regards to digital painting, can prove an invaluable tool in swiftly establishing a correct perspective, as well as offering a moveable camera in order to experiment with alternative viewpoints and compositions.

An object can be made and then duplicated any number of times, so if a structural element is repeated throughout your concept then this package can quickly and accurately create such arrays. It also has a simple lighting system that enables the placement of the sun according to the month and time of day by way of slider bars, thus determining physically correct shadows

that can be turned on or off at the click of a button. These functions mean that as an artist wishing to draw detailed or tricky scenes, one can use SketchUp as a valuable starting point to establish a "guide template" on which to paint over.

Installation

In order to install SketchUp, visit: **http://sketchup.google.com** and go to Downloads

on the left hand menu. Select the free version, choose your operating system and then follow the instructions (**Fig.01**).

Once installed, click on the application shortcut and you will be prompted with a dialog box in which you are asked to choose a template (**Fig.02**). The scale and type of your scene will determine which you choose, but for the purposes of this tutorial we will select Architectural Design > Feet and Inches.

Toolbars and Menus

When SketchUp starts you will see a screen resembling **Fig.03**. From the main menu click on View > Toolbars > Large Tool Set; this will access more tools which will appear down the left margin. To change the display mode of the objects in the scene click on View > Face Style; this will show a number of options, as seen in **Fig.04**.

If you also check "Views" under View > Toolbars you will see six small house icons appear below your toolbar (**Fig.05**). These will provide

quick access to orthographic views, as well as isometric. You will notice that I have also checked "Face Style" in the list (highlighted in green), which has added some cube icons to represent the display modes.

This is basically where you can customize your workspace and add toolsets to speed up your workflow. For additional help go to Window > Instructor; this will open a window providing useful information on whichever tool you have currently selected.

Basic Navigation

The key orientation tools you will use to navigate in your scene are Orbit, Pan and Zoom, which you will find on the top toolbar and whose shortcut keys are represented by O (Orbit), H (Pan) and Z (zoom). These can be seen in **Fig.06**.

The main tools used to directly manipulate your objects are Move (M), Rotate (Q) and Scale (S). The Scale tool appears on the left-hand toolbar, which you will see highlighted if you press S on your keyboard.

Drawing Shapes

One way of using SketchUp is to create two-dimensional shapes from which you can extrude three-dimensional objects. Select the top view and then the Line tool (**Fig.07**) and left-click in the viewport to begin drawing. You will notice that as you do so, the points will snap to the green and red axes, thus easily enabling the creation of right-angled structures.

When you finally close the shape by clicking on the initial point you will notice the shape turns blue, indicating a surface has been made; once

a shape has become closed you can still edit it. Using the Line tool, add an internal rectangle (see the top diagram in **Fig.08**). To now make this edge become part of the exterior shape, click on the Eraser tool and then on the outside edge shown in red.

You can continue to cut into your shape or alternatively extend it outwards and then erase the necessary lines by using the Line tool (**Fig.09**). Here I have added a walkway and also a curved section using the Arc tool. You can also draw more organic shapes using the Freehand tool (**Fig.10**).

One other useful function, especially for architectural structures, is the Offset tool. This is situated next to the Rotate tool and enables a shape to be duplicated in order to create depth – perfect for drawing walls in a building, for example (**Fig.11**).

With an exterior wall depth, click on the internal shape using the Select tool (black arrow on the toolbar) and hit "Delete". You can then select the Push/Pull tool and click on the wall and raise it vertically (**Fig.12**). You will notice I have edited the section where the walkway adjoins the building using the Line and Eraser tools so that this was not raised along with the outer wall.

Three Dimensions

When a shape has been converted into 3D it can be edited further by using a combination of the Line and Push/Pull tools. If you move the Line tool along an edge it will snap to the midpoint between opposing edges (**Fig.13**). You can then make equally spaced cuts, as shown. These new shapes can be pushed inward or pulled outward, or alternatively a new shape can be drawn and this can then be manipulated.

In **Fig.14** I have used the Offset tool to create a window shape in the far left rectangle. To create the same proportioned window in the other sections simply select the Offset tool and double-click in each rectangle. To create the arches use the Arc tool and then erase the horizontal join shown by the dotted line. To create windows use the Push/Pull tool to move the shapes inwards beyond the inner wall surface or until they disappear.

Using a combination of the tools mentioned so far you will have the means through which to create and edit a wide range of forms and design detailed scenes.

Atmospherics and Lighting

You can add atmospheric perspective in the form of fog to your scene. Go to View and check "Fog", as seen in **Fig.15**. You will notice that the edges on my building have also been switched off, which you can control in the menu under Edge Style > Display Edges.

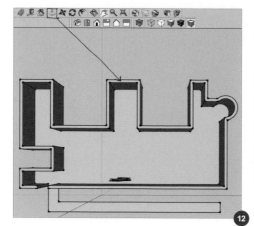

To add lighting effects, check "Shadows", which is above the Fog label, and to get more control over this function go to View > Toolbars > Shadows. This will place two slider bars on your toolbar, which denote the month and time of day. By adjusting these you can

control the position of the sun and direction of the shadows (**Fig.16**). There is a little icon to switch the lighting on or off, and besides this there is another icon which opens up some extra parameters that alter the tonal range of the shading. You can also control whether this affects just the object itself or the ground along with it and vice versa.

Additional Tools

A few other useful tools worth mentioning are the Tape Measure, Protractor and Dimension. The Tape Measure is used to draw guidelines that can then be traced over with the Line tool. In **Fig.17** you can see that the tape measure has created the dotted lines, which can be used as a guide to draw the windows an equal distance from the top and bottom of the block. To delete the lines simply use the Eraser tool. The Protractor is used to create accurate angles. Move the tool to the point at which you wish to start the angle and you will see how it snaps to the three axes. Click to establish the correct plane and then click to begin the angle along the appropriate edge. Now you can set

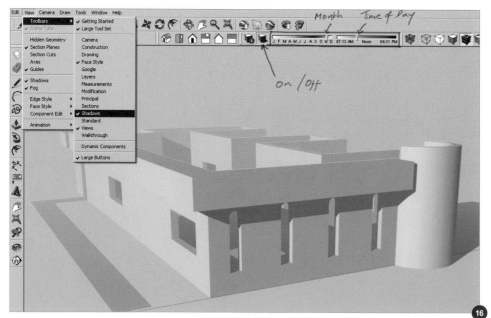

the angle using the guideline. In **Fig.18** I have used the near corner as the starting point, which I will mirror on the opposite corner.

Once the guidelines are drawn, trace them using the Line tool, as with the Tape Measure. In **Fig.19** you can see that the two angles have been drawn and the Push/Pull tool has been used to extrude a roof shape across the base block.

The Dimension tool simply adds a label to your scene, showing the distance between two points. Click and drag from A to B and then drag up or down to set your dimensions, once again using the Eraser tool to delete when necessary (**Fig.20**).

Cameras

The camera in SketchUp is initially placed at an average eye-level height, so when you click on the Position Camera tool, for example, it will zoom in and appear around head height from the ground. In this sense scale is an important factor in your scene.

In **Fig.21** you can see a cross where I intend to position the camera, after which the viewpoint will resemble the inset image. The character has been placed in the scene to demonstrate the relationship between the scale of a character and the initial camera height. To

adjust your camera, use the Look Around tool represented by the eye icon.

One final tool that may prove useful is the Section Plane tool, which allows a view of a cross-section of your object. To use this click on the tool and then align the green icon to the corresponding plane or angle you wish to view. Then select the Move tool, click on one of the corner arrows and drag in the relevant direction (**Fig.22**).

This concludes our overview, which I hope has at least introduced the main tools and their functions. There are, of course, further lessons to learn along with other tools and techniques – such as applying materials – but the main aim here is to introduce the interface and value of the software in terms of building a simple 3D environment that can then be used in digital painting.

Alley Garage
By Alex Broeckel

Introduction

In this tutorial I'm going to talk you through the process of creating a rough 3D mesh in Google SketchUp for use as the base of a moody environment painting in Photoshop.

Step 01

Fig.01 shows the mesh I am going to use as the base for my painting. It's basically just a few rectangular and circular shapes extruded to form a building with one open side. SketchUp is ideal for creating quick base meshes in perfect three-point perspective. You can even define some camera parameters, like Field of View, to get different types of perspective. In my case, I adjusted the Field of View by going into Zoom mode and typing 40mm into the input field in the lower right. Now the scene looks like it was shot with a 40mm lens!

Step 02

To prepare the scene for some over-painting in Photoshop, I don't prepare any mask renders.

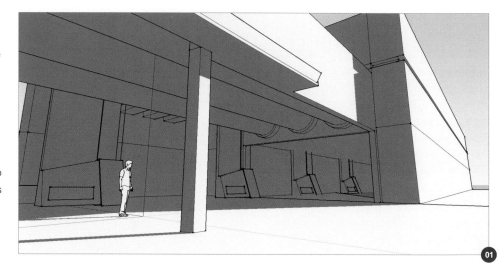

I prefer to do a high resolution line rendering of the scene so that I can make quick selections using Photoshop's great Magic Wand tool. To do this, I open the Styles dialog window from the Windows menu, and there I switch off all of the extras to get rid of everything else apart from the pure black lines. I also set the background color to white and switch off the sky color (**Fig.02**).

Step 03

To render the selected view, I choose Export > 2D Graphic from the File menu and adjust the settings in the dialog to high resolution values, like those shown in **Fig.03**. This method generates a clean line rendering of the scene, which I will import into Photoshop now. Because it's black and white I can put it on a new layer and set its mode to Multiply. I'll also lock the layer completely because I don't want to accidently paint into it later.

Step 04

Now that everything is prepared we can start with the painting. From here on it's a normal painting process, with one little difference being that I can use the line rendering to select large areas very quickly. To do this I select the locked line rendering layer and use the Magic Wand tool to select the first areas I want to fill with color. For this image I have a dark, rainy scene in mind, so I fill the background layer with a grayish blue color as a starting point (**Fig.04**).

Step 05

The next steps are pretty repetitive: I select areas with the Magic Wand tool and paint in the basic lighting of how I imagine this place to be lit. I start by defining the darkest areas first, and adding brighter areas throughout the process. I tend to paint these values low in contrast. It's much easier to increase contrast later than to reduce it. **Fig.05** shows how the image looks after five minutes of painting.

The whole selection process is very fast because of the line rendering layer, so I am able to define my light and shadowed areas in a comfortable way without being slowed down by

needing to use the Lasso tool too often. I also separate layers of darkness and light so I can make adjustments more easily. Of course, you could do it all in one layer, but it doesn't hurt to have multiple layers. They might help you later on if you want to repaint parts of your image.

Step 06

Because I think it is OK as it is at this stage, I am using the Image > Adjustment > Levels

to increase the contrast a little before I start to fill the scene with the details I want. Since there are none of these details in my 3D base geometry, I'll be painting them without the 3D rendered guides, so I'm starting here by drawing some lines onto a separate layer to define a denser perspective grid (based on the original geometry rendering). I can then start painting in details loosely, following the guides I have just added (**Fig.06**).

Step 07

While painting the details, I am still refining the lighting of the scene by defining more and more areas with the help of my line rendering as a guide. Until now I've almost exclusively used Photoshop standard brushes. This is because, until now, it has been more important to me to have the right colors and lighting than to use any fancy brushes.

I'm painting in some details on the ground now to give the viewer a better understanding of the size and perspective of the scene. And since light reflections on water always look nice, I've decided to paint in a puddle of water that will also help to draw attention to the bright lights inside the building (**Fig.07**).

Step 08

Because I think that the whole image could use some more "visual noise" here, I create a new layer on top of all the others and fill it with a concrete texture from my texture library. Texture libraries for 3D programs are a great resource for such textures. I set the layer mode to Soft Light and adjust the layer's opacity a little to blend the texture nicely into the background. But this doesn't quite work without also erasing large parts of the texture. Without erasing them, the viewer's eye would easily recognize the overlay as a single texture. After erasing, the texture layer alone looks like what can be seen in **Fig.08**.

Step 09

I adjust the levels again here for the whole image to give it stronger highlights and darker

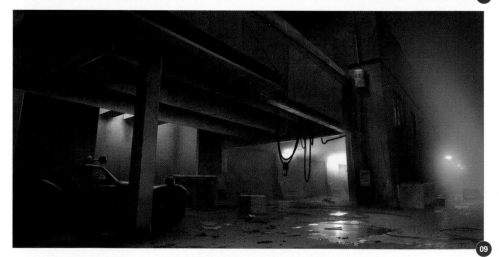

shadowed areas because I've decided just now that I want to make the scene darker still. I don't know why but concept artists seem to love dark paintings. Maybe it's because they are easier to paint? By that I mean that you can hide a lot in the dark! To darken the image, I place another

layer over my background image and set it to Multiply once again, painting in some darker areas with a dark, desaturated blue color. The new dark areas work like a frame for the parts of the image where I want the viewer to focus their attention (**Fig.09**).

Step 10

It's now time to add some rain – on a separate layer – to emphasize the dark and depressing mood of painting a bit more! For the rain I choose a color slightly brighter than the ground, and an almost white shade for the areas where the lights in the background lighten up the raindrops (**Fig.10**).

Step 11 – Final

As the final step I decide that some sharpening will help the image in certain areas, so I flatten the whole image, duplicate the resulting layer, and apply an Unsharp Mask filter with very low values to the new layer (**Fig.11**). Because I don't want the image to be sharpened completely, I take a large soft round brush and erase out the parts of the mask where I want the image to be less important.

And with this final step done, I feel I can finally call the image complete (**Fig.12**). I hope this process has been helpful and that you've learned a little something. Thank you for reading this tutorial.

You can download the base renders that accompany this tutorial from: **www.3dtotal.com/ p3dresources**.

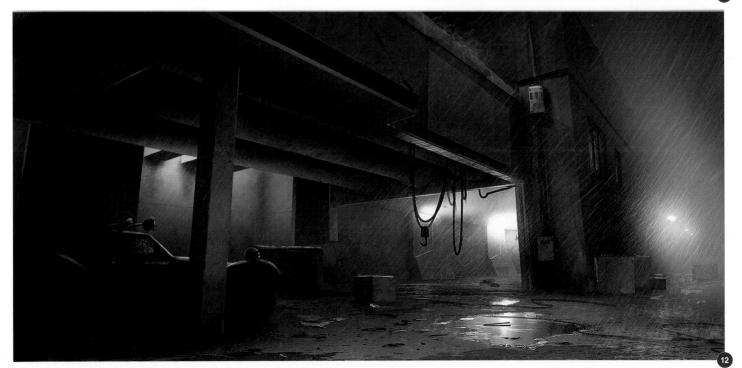

Alley Garage

Futuristic Center
By Richard Tilbury

Introduction

The painting that forms the core of this tutorial will begin its life as a 3D environment within the free version of Google SketchUp. This programme is a very intuitive and simple 3D modeling package that uses a limited number of practical tools.

The 3D scene will then be used as a template within Photoshop to create the final image. As such the scene will already integrate accurate perspective and also enable the addition of lighting effects, which can prove useful when using complex forms.

The final image will culminate in a digital painting, but will retain the above aspects as part of its structure and hence show how simple 3D can be incorporated into a 2D process.

Concept

The first stage involves conceiving an idea behind the image and establishing a composition. Because we are using a 3D scene, we have the advantage of a camera and this means that a final composition does not necessarily need to be decided early on. Once the scene is built the camera can be moved in order to experiment with the most suitable vantage point.

For this concept I want to create a scene on a large scale, utilizing atmospheric perspective with repeatable shapes and thus help emphasize the value of using 3D. I pictured a vast chamber or hangar of some kind in

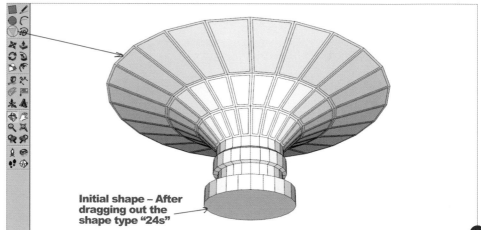

Initial shape – After dragging out the shape type "24s"

which large scale structures would sit and form congregational areas. I imagined them as either assembly points or maybe even areas to set up market stalls, akin to a futuristic bazaar.

Google SketchUp

With a vague notion in mind I begin drawing shapes and pulling out forms in SketchUp. Because the software enables a quick and

effective way of modeling it is perfect for experimenting with simple forms. I build the main chamber using boxes and then use the Circle tool to create a cylinder. Using the Select tool I highlight certain edges and then, by holding down Ctrl with the Move tool, I add new lines/subdivisions. I then scale these to form the umbrella shape seen in **Fig.01**.

I decide to include some elevated walkways, which will span the chamber at intervals. These are initially made using the Rectangle tool and then I use the Line tool snapped to midpoints to divide the shape evenly (red arrow **Fig.02**). The windows are created by way of the Offset tool (blue arrow) and to ensure each are exactly the same proportion I simply double-click in the next section after creating the initial offset. I then use the Push/Pull tool to inset them by using the same method of double-clicking to maintain consistency.

To create an "umbrella" that I can manipulate means re-building it using the Polygon tool, as SketchUp does not allow the pushing/pulling of smoothed or curved surfaces. I need a shape with 24 segments and to do this I type the number of sides followed by the letter S after dragging out the initial shape (**Fig.03**).

To add some interesting shadows and also accentuate the perspective I suspend a grid above the scene to resemble the framework of a yet unfinished structure (**Fig.04**). To create an evenly spaced network I make the first box and duplicate it (hold down Ctrl + Move/Copy tool); once copied I type in a distance. You can repeat this process to add further pieces.

Using a combination of the Line and Push/Pull tools I add some detail and balconies to the main wall (**Fig.05**).

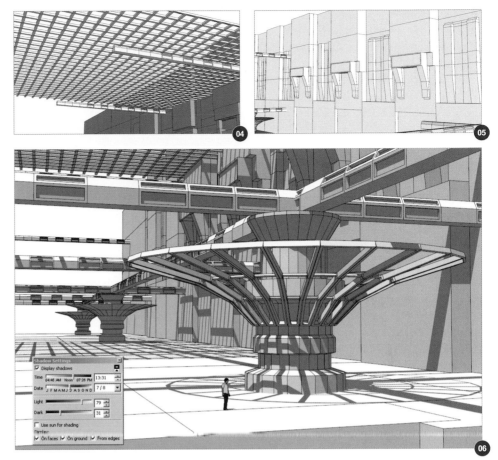

Fig.06 shows the final scene with the inclusion of shading. The umbrella frame was made using the Offset tool, as done with the walkways, and then deleting the inner polygons before pulling out the framework. The dialog box for the lighting (inset) shows the four slider bars which correspond to the month, time of day and tonal range of the lighting.

Painting

Once your scene is complete and you have the camera in the desired position, screen-grab

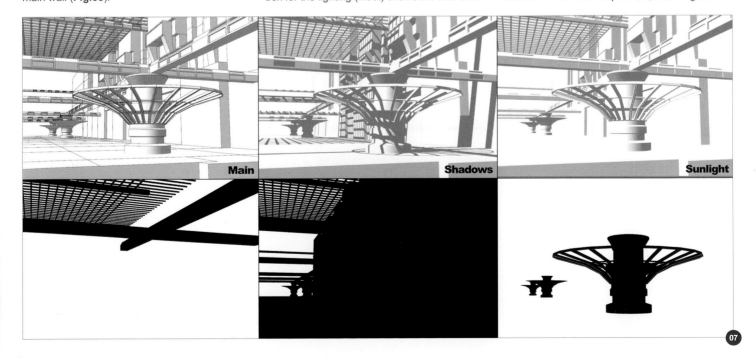

Main

Shadows

Sunlight

your image and then open it in Photoshop. Here you will need to re-size it according to your needs before beginning any of the painting.

I alter the lighting settings in order to save out the shadows as a separate render (**Fig.07**). By applying a black color to the geometry and hiding certain elements it is also possible to save out masks, as seen in the right column.

With the numerous renders saved, I begin by adding in some brushwork and color overlay to try and establish the overall lighting and mood (**Fig.08**). You can see here that the main scene is overlaid across the image to act as a guide.

I organise the file in a way that enables me to easily edit it and make changes later on using certain layers set at specific blending modes (**Fig.09**). This way I can distinguish the color from the lighting and allow it to be altered independently with ease.

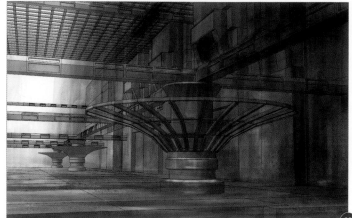

Fig.10 shows the image with the shadow and sunlight layers visible. I also add some sunlight streaming in above the framework by using a layer style.

I decide to add some lights along the underside of the umbrella which are placed on a new layer at the top of my file. I then add an Outer Glow,

as with the sky light, and duplicate the layer, making sure to remove the copied glow first and instead apply some Gaussian Blur to enhance the glow even more (**Fig.11**).

To reflect this I paint in a pool of light on the ground below, which I blur and set to Overlay. To create some variation across the floor and

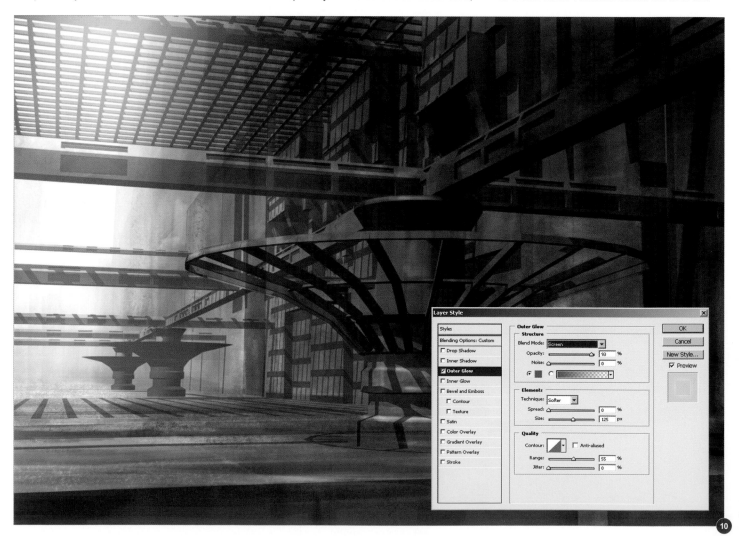

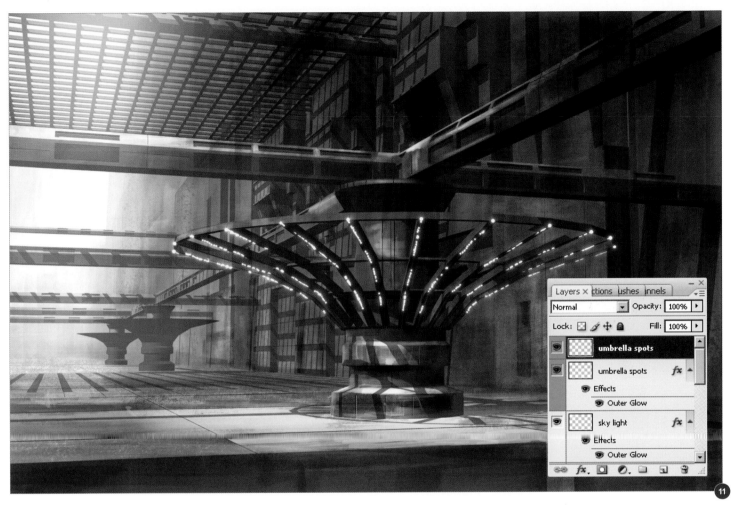

wall I create a small image of randomly sized rectangles in slightly different colors. To align those with the perspective I use the Vanishing Point filter (**Fig.12**). Once pasted in they can be moved, scaled and duplicated as needs be.

In **Fig.13** you can see the subtle patchwork that extends along the wall and which helps break

up the surface somewhat. I have also placed some illuminated windows in the scene using the same technique.

The same panels can be used on the main stem of the umbrella; however, they will need to be skewed to fit with the perspective. This can be done by going to Edit > Transform

> Warp. In **Fig.14** you can see the grid that appears, along with the Bezier handles used to manipulate the image.

The glow at the foot of the umbrella certainly helps, but the lights themselves do not seem intense enough to throw out such a pool, so in order to fix the problem I add a new layer

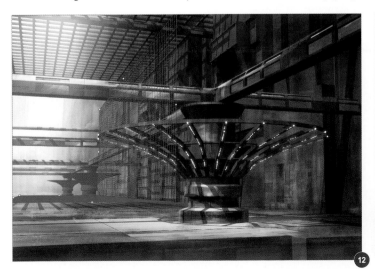

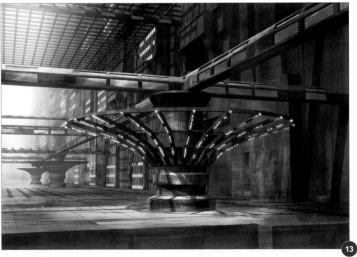

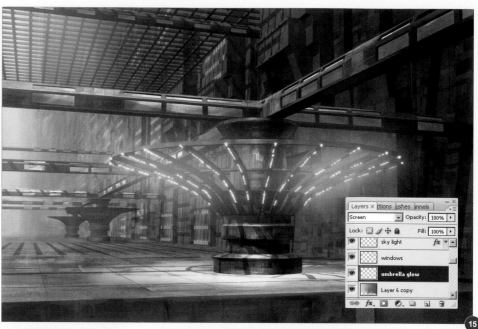

and paint in a soft green area surrounding the bulbs (**Fig.15**). Once blurred and set to Screen blending mode it makes a big difference, and to further the cause I also add a Gradient layer below this, set to Multiply at 60% opacity. This blended from a cool foreground green to a warm off-white in the distance. Not only does this intensify the umbrella lights, but it also serves to separate the foreground and distance.

The foreground looks sufficiently detailed at the moment but the background umbrellas still lack a little definition. On a further layer I add in some subtle variations and a few lights (**Fig.16**).

Adding Characters and Textural Detail

The repetition of the umbrella helps convey a sense of perspective, but to really give the scene scale we can use a common device – the inclusion of figures. In **Fig.17** I have added a crowd of characters spanning from the foreground through to the background to serve as a measuring stick.

To help define the foreground a little more we can use photographs to add detail and suggest an architectural style. It is a question of sifting through reference images to find the most suitable types of imagery. Once pasted into your picture any images will need to be correctly aligned either by hand or by way of the Vanishing Point filter, and normally it is necessary to color correct them too. In **Fig.18** you can see where the two photos have been positioned and adjusted to fit in with the scene. Either desaturate the photos and then select Overlay or Soft Light as the blending mode, or use a combination of Curves and image adjustments to blend them in and leave on

Normal mode, as I have done in this case. It is a good rule of thumb to reserve this type of detail to the most prominent areas only – the near section of wall in this instance.

We can apply this principle to the characters and add detail to the nearest few – albeit with brushwork, but nevertheless continuing this treatment of having more detail in the foreground (**Fig.19**). I also decide on some railings along the near side which echo the elevated framework and help balance the top of the image with the base.

Final Refinements

The painting is at a stage where it can almost be called complete, aside from a few minor tweaks that will further enhance it. One area that will benefit from some extra treatment is the background section where the ground plane meets the horizon line. As the chamber is brightly lit at one end it follows that the light will bleach out the most distant figures and also be reflected some way along the floor. **Fig.20** shows the before and after stage which uses a soft, blurred pale green layer set to Hard Light to create this extra depth, and which also helps the far umbrella recede a little more.

If we look back at **Fig.07** you will notice the flaws apparent in the shadows layer, which does not take into account atmospheric perspective. It is possible to switch on Fog in SketchUp, but this is best achieved in Photoshop for more accurate results and emphasizes why the 3D renders should, in this case, only be considered a guide.

I also add a new skylight using an orange Outer Glow as part of the Layer Style, as I feel that the blue color jarred too much with the scene as a whole and neither created a warm or intense enough light that seemed to reflect the overall mood (**Fig.21**).

It is good practice to work on multiple layers during the painting process so that changes can be made easily at any point and certain details such as the crowd can be hidden or even duplicated if needs be. When you feel confident that you do not need to make any more changes then you can flatten all, or at least a selection, of your layers.

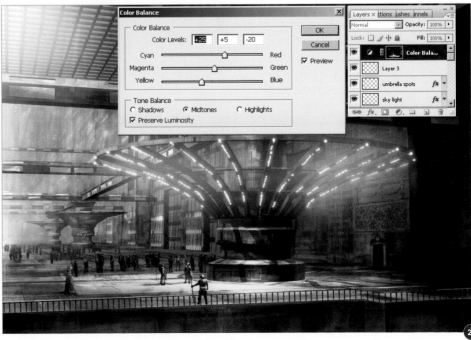

The last stage that I often employ is an Adjustment Layer of some sort, as this enables further alterations to the painting such as color scheme, contrast and lighting. The great part of this function is that it offers the use of a mask to localize the effects and also means that it can be reversed or even discarded if needs be.

In **Fig.22** you will notice a Color Balance adjustment layer at the top of the layers palette in which I have moved the sliders towards a warmer color (red and yellow). The small white areas evident in the mask reveal these warmer values which are seen beneath the umbrella, whereas the black acts as a mask hiding this color adjustment.

And this last modification marks the end of the painting, the final version of which can be seen in **Fig.23**.

Conclusion

If we view digital painting as an accepted practice within certain sectors of the modern, commercial art industry, which I believe is inarguable, then surely 3D is but another yarn in this weave we know as "digital art". After all, can we not regard 3D as the carefully lit life models set up by the Old Masters, or a substitute for the camera used by so many painters over the last century?

Programmes such as Google SketchUp allow artists to quickly and easily explore and experiment with ideas that relate to form and composition, and in so doing inform their work and lend it a believability. More importantly it can save time in the long run, which is an important factor in today's climate.

I hope that this tutorial has validated in some way the inclusion of 3D in a 2D world and 2D in a 3D world, but it is worth remembering that there is no real substitute for traditional art skills – all software, no matter how sophisticated, is useless without a puppeteer!

You can download the base renders that accompany this tutorial from: **www.3dtotal.com/ p3dresources**.

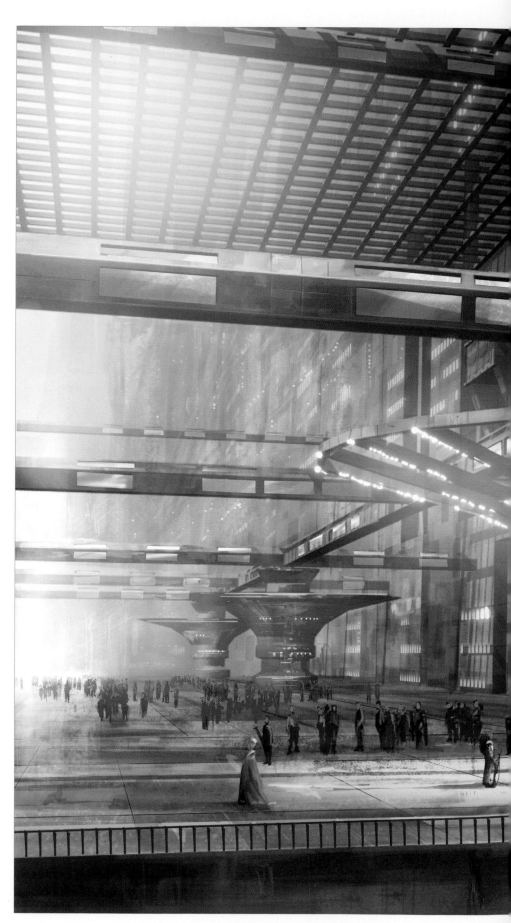

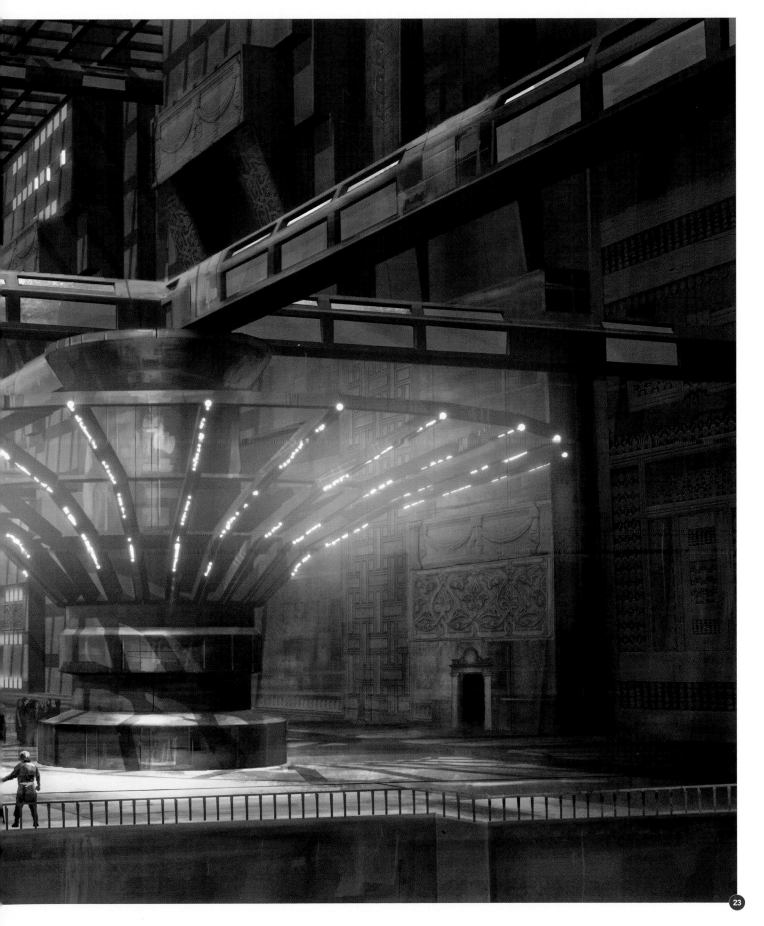

Complete Projects

As the title suggests, this part of the book offers an insight into the process behind a finished piece by focusing on the techniques used throughout the project. We shall be afforded a look into how the various components are assembled in the post-production phase and the impact these have on the original render passes. Two separate projects will be outlined, including a walkthrough of some of the principal 3D attributes and a discussion of how these are refined in Photoshop to produce a final render.

Fantasy Scene – Concept
By Richard Tilbury

Introduction

Using 3ds Max and Photoshop, this tutorial
will teach you how to create a fantasy scene
inspired by real-world architecture, and how to
correctly and effectively use reference photos
of your chosen source of inspiration to get
stunning effects quickly and easily!

During the course of this tutorial we will build a
fictional scene inspired by an existing location
– in this case a cathedral. The building itself will
dictate the style of architecture used throughout
and will essentially be reorganized into a
different structure altogether.

All of the architectural forms and details will be
extracted from the cathedral itself, and after
being deconstructed shall be reassembled to
assume a new design – rather like building
with Lego, if you like. The building will then be
placed into an imaginary environment and will
start its life cycle as a 3D model built inside 3ds
Max. Our 3D package will be used to create the
lighting and perspective, as well as setting the
camera position/viewing angle.

Photographs taken of the site will then be used
to create rudimentary textures used to map the
building. 3DTotal's free Texture & Reference
Image Library (**http://freetextures.3dtotal.
com/**) will be used to construct the scenery in a
way akin to matte painting, as well as add finer
details to the building model.

The final stage of the tutorial process will
involve revisiting the location in order to

01a

01b

photograph certain parts of the cathedral from specific angles to match the perspective in our scene.

Photography

The first stage of the exercise involves taking a camera to the actual location and photographing as many aspects of the building

as possible. From these we can begin to design our building along with its environment and get an idea about the concept.

In **Fig.01a** you can see a handful of photos that were taken of various features of a cathedral. It is good practice to take as many as you can at this stage, because even the most incidental details can become significant during the concept phase and you can always choose to reject those that are inadequate. The idea at this stage is to simply catalogue as much information as possible so that you can sift through the library back in the studio and therefore increase your options.

A good rule of thumb is to try and take photos on an overcast day where there are no strong shadows, but rather a general ambient light. Good examples are the two photos seen in **Fig.01b** where there is a soft light above the scene and no stark shadows.

It's a good idea to start with a blank canvas, as it were, without the need to first correct any strong lighting effects, as they will rarely match

your scene. Sometimes a directional light can prove useful, but overall aim for a soft light. An example of some pictures that may prove difficult to work with can be seen in **Fig.01c**.

Once you've had a chance to look though everything and digest the reference images, you can begin work on your concept. I decided that, because of the stonework in the building and its sense of mass and weight, a scene set in the mountains might prove sympathetic. Also, there are some dramatic photos in 3DTotal's Texture & Reference Image Library.

To create a sense of scale and depth I've opted to have something in the extreme foreground in the form of a small doorway that could perhaps be a secret entrance to the bridge.

Concept

I often like to start an image with some abstract marks and shapes to help suggest forms and an initial direction. In this case I began by adding a doorway set into a rock face in the foreground and then roughed in a background (**Fig.02**).

I imagined the large mass on the left as the side of a mountain, but some of the marks in the center of the image suggest the underside of a bridge spanning the chasm from right to left. The notion of a building set into the side of the left mountain and connecting to the opposite side of the canvas via a bridge felt as though it would make an interesting composition. So with the decision made, I began building the architecture from the library of photographs taken on location (**Fig.03**).

I blocked in the main forms, focusing on the perspective and overall shapes apparent in the structure. Whilst standing beside the cathedral you get a feeling of how the heavy stone work appears to emerge from the ground and vault towards the heavens, and so I wanted to echo this sense of verticality in my concept. I therefore used two huge columns as my key structural devices to help create the height.

In **Fig.04** you can see how the architecture in the concept has been derived from certain features on the cathedral. The columns have been directly copied from those in photo 6, but will be mirrored eventually so that from the top they look like a cross.

03

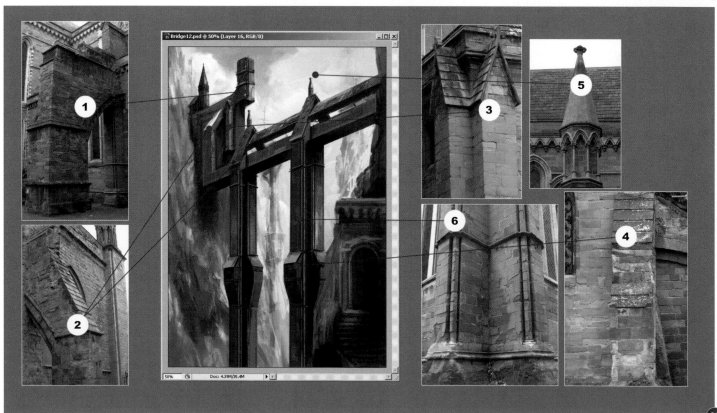

04

To add some interest I added in photo 4, which will use the tiled roof and be flipped 180 degrees to then form the lower half. The main upright on the left side incorporates the arch in photo 1, which has also been flipped upside down and back to front with the arch now on the upper side. The column in photo 2 has been added onto the near side and the tiled roof mimicked above the two main bridge supports.

You can see how each of the main components have been extracted from the photographs and rearranged to create a different building. The world around you is a great source of inspiration and can stimulate the imagination.

In terms of the foreground I've decided to use the door seen in **Fig.05** as it suits the theme. I could include the stonework around it and even incorporate the top of the wall. I thought a little decoration would make it more interesting and so considered the series of small arches in the upper photograph, which I've pasted into the concept.

You may have noticed the changes between this version of the painting and the previous

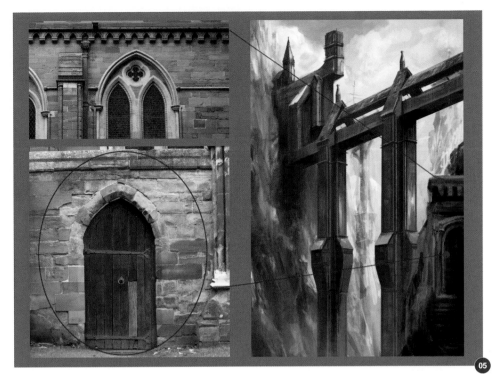

one. I have added in some atmospheric perspective on a new layer set to Hard Light, using a blue/gray (R156, G181, B188) at 25% opacity (**Fig.06**).

To emphasize the scene's altitude I've painted in some mist along the bottom of the picture, which also serves to help separate the bridge from the foreground (**Fig.07**). I felt that the shadows and overall tonal range needed more

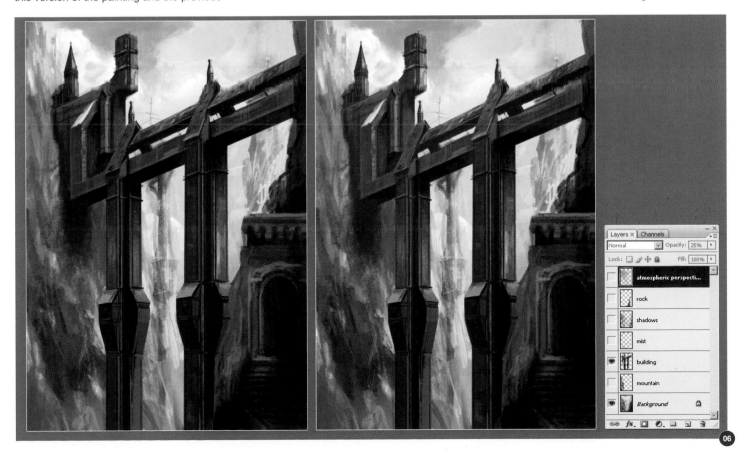

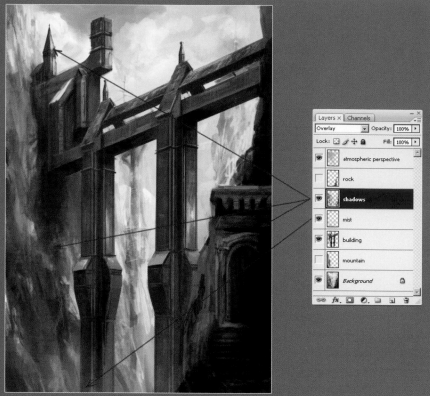

07

contrast, and so I added a new layer set to Overlay and painted in some extra shadows and highlights.

As this is not an exercise in concept painting I've chosen not to refine the painting too much – just enough to give me a reasonable idea about where to start once inside 3ds Max.

Using Photography to Add Texture

One last stage that helps add some textural detail is the inclusion of photographs into the painting process. Once you paste in your photographs you will need to adjust the color and contrast to suit the lighting and tonal range within your scene. You can either set the blending mode of the photos to Overlay or Soft Light, but quite often I prefer to color adjust them using Curves, Levels and Hue/Saturation, keeping the blending mode at Normal.

Here is an example: in **Fig.08** (you can find this photo in 3DTotal's Texture & Reference Image Library), you can see that a section of the left rock face in the upper left photo has been copied and pasted into the concept under the building layer. At the moment it is entirely

08

09

the wrong color and doesn't match, so the first port of call will be to go to Image > Adjustments > Curves and alter the values, as shown in **Fig.09**. You can see the eventual rock texture below this, but you get an idea about how it better matches the lighting now.

The next step is to alter the color and reduce the warm tones, which we do via Image > Adjustments > Hue/Saturation. In **Fig.10** you can see how the middle slider has been moved to -41, which is essentially desaturating it. Now all you need to do is use the Eraser tool

to blend in the edges with the background (**Fig.11**). You will notice the example rock has been pasted over the original layer in the layers palette.

These techniques will prove valuable when it comes to adding in the backplate, as all the photography will generally require color correcting in order to work together in the scene.

I didn't want to spend too long refining the painting at this stage as it is simply a means to an end and just a way of generating a starting point for the modeling phase. Here is the final version with a little perspective correction (**Fig.12**).

In the next section we will look at a general overview of modeling the basic elements that make up the scene, and see how 3D packages can be used to build the main volumes, establish both the perspective and camera angle, as well as provide a light source.

10

11

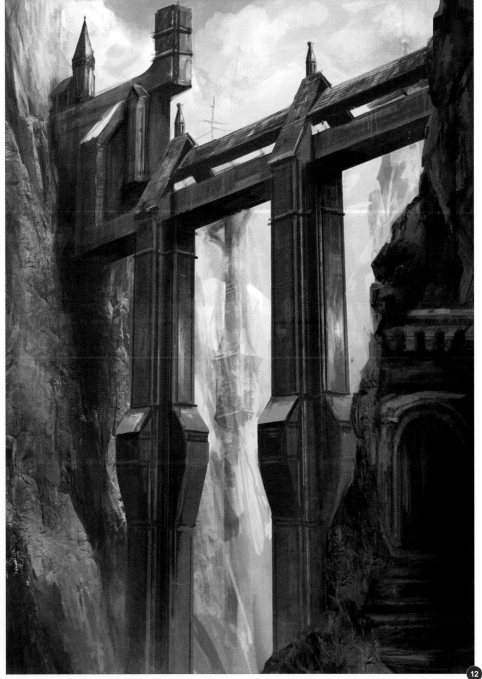

12

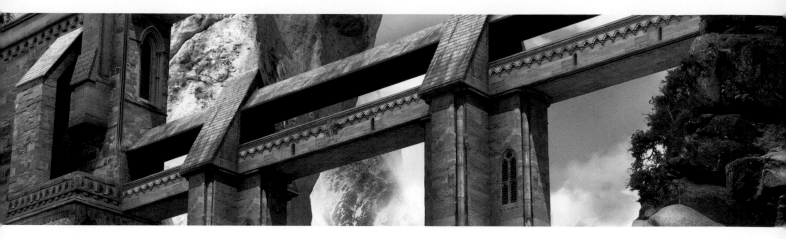

Fantasy Scene – Basic Modeling and Lighting
By Richard Tilbury

Introduction

This chapter presents an overview of the modeling phase of the tutorial and will concern the general principles that are common to most 3D packages. It shall feature 3ds Max as the example software, but rather than detailing a step-by-step approach, we will focus on an overall approach using techniques that are equally applicable within other packages.

The first stage involves looking at the concept and trying to break it down into its key components. In **Fig.01** you can see I have drawn over the top of the image to show how some of the components can be reduced to simple geometric forms. This process of interpreting the scene is quite straightforward as the design is already very simple.

The main building is essentially a rectangular shape with a simple box and triangle used to form the bridge and canopy. The rock face appears to be possibly the most complex aspect, but this can be reduced to an angled plane with some small adjustments. Once a part of the scene is built we can establish a

camera position and then reproduce a similar perspective and eye level in the 3D scene as this will form the basis of our composition and final render.

In **Fig.02** you can see that the bridge itself has been made from a box and the rock face from a plane, as indicated in red in the panel. This plane was then converted into an Editable Poly, subdivided and manipulated to resemble a more natural surface.

Apart from perhaps the building set into this rock face, the main 3D components will be the

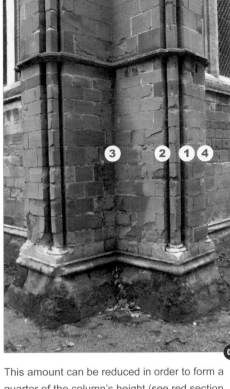

two supporting columns and so it makes sense to create these in order to help establish the eye level and camera angle. These are made up of four identical sections that form a cross shape when seen in plan and so we can make a single section that can then be duplicated three times to form the entire cross section. The best way to do this is by using Splines.

In an Orthographic view I started by creating a shape seen on the left in **Fig.03** – the yellow vertex being the first one in the sequence. It is helpful to use Snaps in order to keep the points aligned whilst doing this. Once done I then selected the vertices highlighted in red and applied a Chamfer, highlighted in the right panel. This added a new vertex beside those selected and resulted in a smoother transition through the six corners.

The four numbered corners correspond to those indicated in **Fig.04** on the section of the cathedral column photo. This quarter of the column can then be duplicated three times and then each of the four pieces can be attached to form the entire shape as seen on the right in **Fig.05**.

The next step is to apply an Extrude modifier and create a three dimensional object from the Spline shape (**Fig.06**).

This amount can be reduced in order to form a quarter of the column's height (see red section in **Fig.07**). The reason for doing this is that we can then map a small section of the entire object. This section can then be duplicated and therefore minimizes the amount of texture space necessary as each part will occupy the same UVW coordinates.

On the right you can see the piece has been multiplied to form the four modular sections.

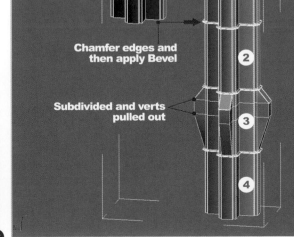

The bottom row of edges can be Chamfered and then the extra group of polys Beveled to form the cross sections that join each piece. Two subdivisions have been added to piece 3 and then the verts pulled out to mimic the concept sketch. Once done this column can be copied to create the second one and then both placed below the bridge. With these two elements now in place we can add a camera and roughly match the angle in the concept.

In **Fig.08** you can see the position of the camera relative to the geometry (1) and the eventual camera view in the far right image (2).

The main building can be started from a box and then, once converted into an Editable Poly, subdivided and then the verts moved and polygons extruded to form the various components (**Fig.09**). The section shown in blue was modeled as a separate mesh and then attached to the main building.

To create the arched feature that extends from the highlighted poly it is possible to create a curved Spline (one quarter of a circle in this case) and then use the Extrude Along Spline function.

The Spline is placed in front of the appropriate face and then once the arch is extruded you can align the outer edge of verts/faces in order to create a 90 degree angle, thus resembling the structure seen in the photograph (**Fig.10**).

The concept sketch shows a doorway set into the side of a rock face in the foreground and after looking through the photos I decided to use the door seen in **Fig.11**.

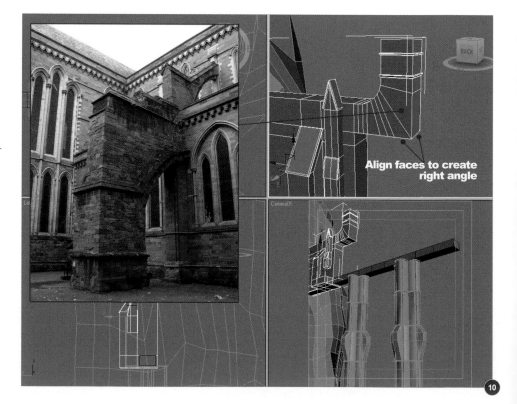

Align faces to create right angle

When you find a perfect image/texture this can be the driving force behind the geometry and in this case I modeled the door based upon the photo (inset). I decided it was a little slim and so exaggerated the width slightly, but still within the limitations of the photo.

The best way to create this is to start with a simple box that will be used to model one half of the doorway, as see in **Fig.12** (a). I then selected the outer edge of all of the polys except those on the extreme right and extruded them (b). The extra polys were then aligned to create a right angled shape (c). The edges highlighted in red were then chamfered to create the door surround. The geometry can then be mirrored to form the complete door as seen on the far left.

When it comes to the mapping I can simply project this image onto the geometry and with a small amount of scaling it will fit accurately.

Even though the rock faces will probably be composed within Photoshop using photos, it is useful to model a rudimentary version to help get an idea about their formation and how light may react with them. As a provisional solution I modeled three separate sections of rock using

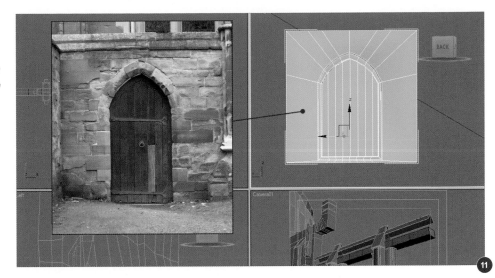

a plane as a starting point (**Fig.13**). I applied a Noise modifier to rupture their uniformity and create some randomness and then manipulated the verts to refine the shape.

These three meshes are crude but will give me a good idea about how the rock formations will look and therefore act as a guide when choosing the photos.

The Background
The scene is coming together now but one of the key aspects which is yet to be resolved

is the background. As this is far from the camera, the best approach will be to find suitable backdrops, in this case using the free library of photos available at 3DTotal (**http://freetextures.3dtotal.com**), and then simply map these onto a flat plane positioned behind the scene.

In **Fig.14** you can see two large planes that correspond to the city and mountain range that will eventually appear in the distance behind the rock faces.

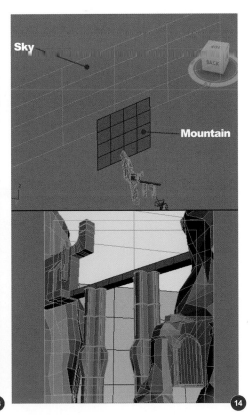

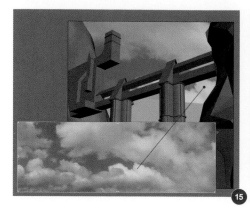

For the sky I decided upon the following image from the free library, which can be seen mapped onto the distant plane in **Fig.15**. If you wish to brighten the image you can make the material self-illuminated or alternatively alter the values in Photoshop using Curves, Brightness/Contrast etc.

The sky can be mapped onto the plane using only the Diffuse map channel, but the mountain range that is in front of this will require an opacity map. If we look at an example image in **Fig.16** we can see that the mountain itself is OK, but we can make out the top edge of the plane which looks wholly inappropriate.

We need an image with an alpha channel whereby white represents an opaque or visible region of the map and black determines a transparent area (**Fig.17**).

In **Fig.18** you will notice in the Material Editor that the JPEG in the upper left of **Fig.17** has been assigned as the Diffuse map and the TGA file that carries the alpha channel has been assigned to the Opacity slot.

When the scene is rendered we now see that the alpha channel disguises the sky and reveals only the mountain, making the background look far more authentic (**Fig.19**).

Lighting

So far we have focused purely on the modeling phase of the scene, but one very helpful aspect of working in 3D is the inclusion of lights. The main light source in the concept piece is somewhere in the upper right of the picture behind the buildings so I initially placed a Directional Light with Ray Traced Shadows in a similar position (**Fig.20**).

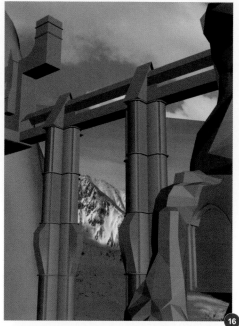

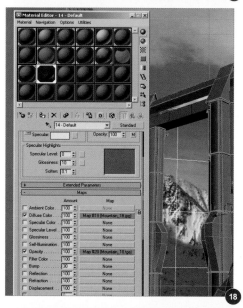

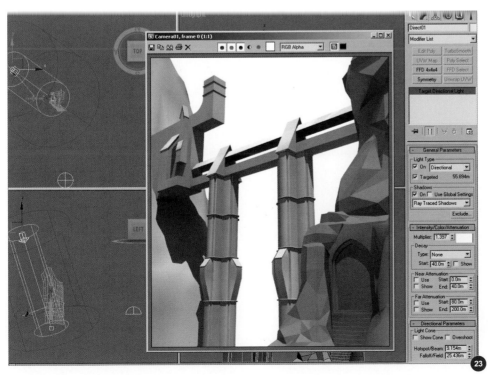

When the scene was rendered out it looked like **Fig.21**. As you can see, the Ray Traced Shadows react accurately to the scene, but overall everything looks very dark, with the near doorway hidden in silhouette. To help add some ambient light into the shadows I added a Skylight, which softens the scene and also adds some much global illumination in the shaded areas, especially the foreground (**Fig.22**).

The render looks far more like the concept now, but the nearside of the building is exclusively in shadow and the direction of the light does not really do this or the columns justice. As an alternative I moved the light to the opposite side of the scene (**Fig.23**).

This rendered the foreground somewhat lighter than I desired, but as much of this would be built from photos it was not a problem as the values could be controlled in Photoshop.

When compositing an image together in Photoshop based upon a 3D scene it is helpful to have numerous passes in order to have more control. As this scene will partly be built from photographs there is no real need for the common number of 3D passes, but one that will prove useful is Ambient Occlusion.

Fig.24 shows this pass, which emulates global illumination and calculates which areas would receive less light. This render pass can be placed over the final textured scene and help add some soft shadows and depth to the scene.

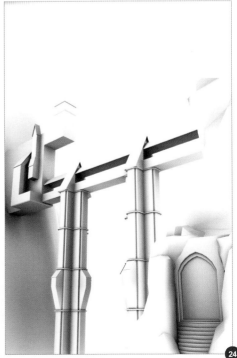

Fantasy Scene – Creating Textures From Photographs
By Richard Tilbury

Introduction

During this section we will look at how to use our location photos to extract and create textures for our 3D scene, which will form the base layer for compositing in further detail later in the tutorial.

We will begin with the columns as these are one of the principal 3D elements. In **Fig.01** you can see the unwrapped geometry in the bottom right corner, which represents the two columns in an exported wireframe template (top group is column A and lower part is column B).

As you may remember, only one section of the column was made and mapped initially. This was then duplicated to create the four sections that make up the whole piece. Therefore the green rectangular area (1) corresponds to the three sections in the 3D render and whatever texture is placed here will appear on each of these sections. This saves texture space and because this scene will utilize post-production techniques we can use Photoshop to add variation later on the render itself.

Having sifted through the photos I decided that the two on the left were the most suitable for texturing the columns. These photos are available in 3DTotal's free texture library.

The first step is to make a selection around the area you wish to use and then copy this into your PSD file, using your wireframe template as a guide. Scale and position it accordingly and then duplicate it to fill in the desired part of the

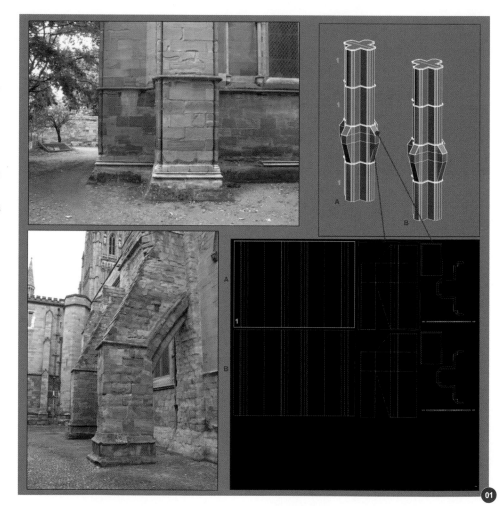

template. This will obviously not yet be tileable but there are two ways to solve the problem.

Making these cropped sections tileable is not wholly necessary given that much of the refinement will be done during post-production and hence can be fixed in Photoshop, but it is

useful to be aware of the procedure as it can prove valuable and is always worth knowing.

1. Flatten the duplicated stone into one layer and then use the Clone Stamp and Healing Brush tools to hide the seams.
2. Use the Offset filter on the original

cropped section of stone to make it tileable and then copy this into our template.

Offsetting

In **Fig.02** you can see the cropped section of the wall from the photo in **Fig.01**. The width and height measure 810 x 1374 and so to make it tileable go to Filter > Other > Offset and enter half these values in the corresponding boxes (see right dialog box).

This flips the outer edges into the center and shows the consequent seam that would appear when tiling the image as it stands.

Use the Clone Stamp and Healing Brush tools to conceal these central joins, but making sure to leave the edges intact. **Fig.03** shows the corrected texture which no longer has an obvious seam through the central axes.

To return the texture to its original format, simply apply the Offset once again and the image will flip back to its original format, with the central axes now forming the outer edges (**Fig.04**).

In **Fig.05** you can see the two approaches used to texture the two column sections. The upper section represents method 1 and the lower takes advantage of the Offset filter. Any texture, unless completely uniform and symmetrical, will create a tileable pattern to some extent, but you can see how the Offset method at least removes the seams. It is up to you which approach you take, but remember

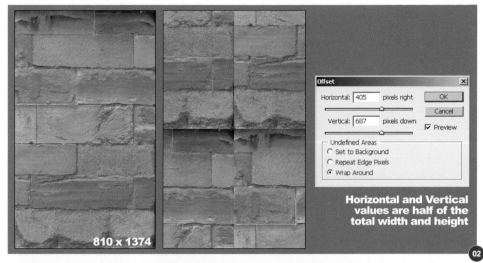

Horizontal and Vertical values are half of the total width and height

that even if you clone out any symmetry here it will appear on the actual geometry as this section is mapped to the four modular pieces of the mesh. Whatever you do now will minimize the work later during post-production, but either technique is ultimately valid.

For my base layer I chose to blend areas from two principal images as shown in **Fig.06**. Evidently the stone work is a different color in each photo and so they need to be made consistent. I did this by going to Image > Adjustments and then using a combination of

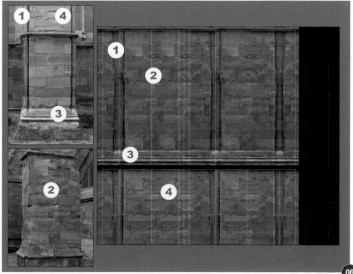

Curves and Brightness/Contrast to align the tonal values, followed by Color Balance and Hue/Saturation to match the color scheme. These were not made tileable beforehand, but rather were cloned in the template, similar to method 1 above. The numbers highlight some of the photo details evident in the texture.

The bottom section of the column uses the base of the pillar in the upper photo and the corners of the 3D column correspond to the upright sections numbered 1. To keep the texture consistent I copied sections of this stone to fill in the other areas. I used the upper photo in **Fig.07** to create some variation and weathering, and the tiles from the lower image to detail the small roof.

The top group of textures corresponds to the left column in **Fig.08** and the lower set to the right-hand one. You can see how by sharing mapping coordinates each section of the column is identical, but this is a good enough base for the 3D render and, as previously mentioned, we can refine this and add variation later in Photoshop.

Cropping and Tiling

With regards to the foreground door, you may recall the design was modeled on a photo and so the texturing here was very straightforward. I grabbed an area of the photo and simply pasted it into my wireframe template (**Fig.09**).

I scaled and positioned it accordingly and then applied it to the scene (**Fig.10**).

In the case of the bridge section, which was made up of a simple box, all I needed really was a tileable texture of some stonework. As this 3D element occupied a small proportion of the final render it did not require much detail as this could be added later. I selected a suitable image of a wall and then cropped it to include just the relevant area. I rotated and skewed the new image to make the stonework and edging parallel by going to Edit > Transform > Skew/Rotate/Distort etc.

Once this was done I applied the Offset filter to make the image tileable (**Fig.11**) and cloned out the dark colored stone which would look too conspicuous.

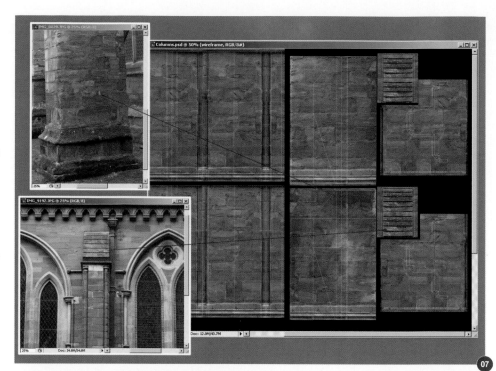

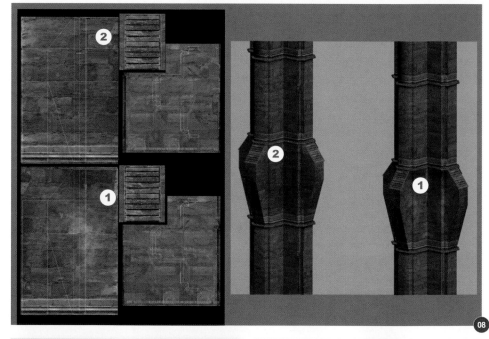

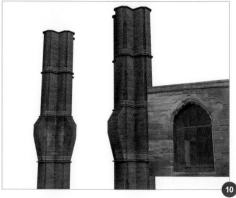

Once done I applied this map to the bridge section, making sure to tick the Tile boxes to texture the entire surface. You will notice that I have altered the V Offset value, which has moved the lower edging to the top edge (**Fig.12**).

I used the same technique on the roof above the bridge. This time I cropped and transformed the roof tiles from the photo (inset **Fig.13**) into the texture seen below. This was then tiled according to the values seen on the left in the material editor.

Main Building

The building on the far left is composed of a few elements and so needed to be unwrapped. To texture this I selected a number of the photos and grabbed various sections to add variety across the surface. In **Fig.14** you can see the middle section of the pillar has been used to texture part of the left edge. I selected two more photos and repeated this procedure to fill in the rest of this building section (see **Fig.15 – 16**).

You may have noticed also that the areas labeled 1 have been extracted from the wall under the right-hand window in **Fig.14**.

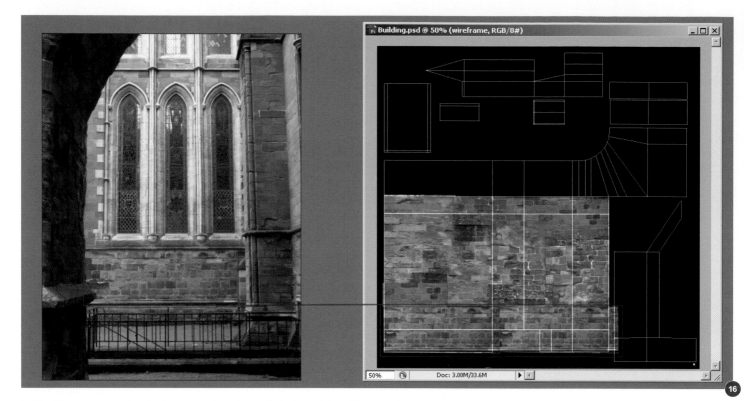

In **Fig.17** you can see two further examples of how the roof tiles have been taken from two separate photos and transformed to fit our template.

This part of the scene was built up in the same manner as the columns, using a collage of different references that were then color corrected. Seams and edges were then disguised and blended once each of these component sections had been merged into a single layer. You will notice that some of the stonework has not been merged together; this is because these edges are hidden in the final camera render. No need to spend time on areas that will be hidden so be sure to make render tests as you work in order to focus on the crucial parts.

In **Fig.18** you can see how the underside of the building has not been mapped and therefore does not occupy any significant part of the template. The reason for this is because in the final scene this will be hidden from view by the rock face it sits against.

Rock Face

To create a good starting point and base texture for the rock it is a case of first of all adding a planar map to the geometry. Because this is not flat it will require you to align your mapping Gizmo to the general angle of the mesh. If the mesh curves away from the camera, focus

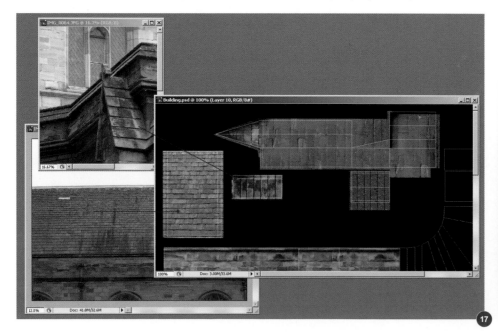

19

on the section that will be most apparent. As this will use a single image projected onto the surface, I opted to add smoothing to the mesh to prevent any harsh shadows caused by the geometry conflicting with the actual texture.

In **Fig.19** you can see the mapping Gizmo in the form of a yellow rectangle with one green side. Notice in the viewports how the angle is aligned with those faces that are visible to the camera. The faces furthest away will show distortion but this is not important; in fact some of these could in fact be deleted. I chose an image of rock from the resource library at 3DTotal and then altered the mapping coordinates so that I could position certain details in specific areas.

The texture can be seen in the scene in **Fig.20**, with two seams caused by manipulating the Tiling coordinates (highlighted in red). This is not a problem because, as we have emphasized earlier, these issues can be resolved in Photoshop.

The near rock face will be built up using photos within Photoshop and so will not require any mapping or textures.

You can see, however, that very quickly we have a good base of textures to work

with, providing a sufficient foundation upon which to improve and refine the detail. The main objective during this phase is not to produce finished results, but instead to create a framework or structure that will form the backbone of the final image.

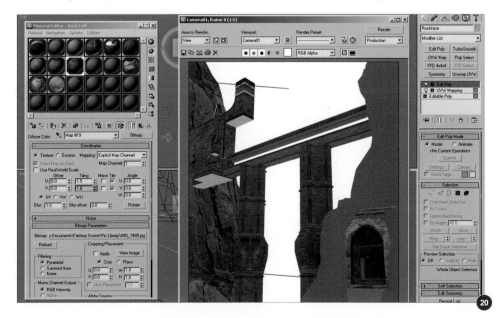

20

Fantasy Scene – Adding the Sky and Scenery
By Richard Tilbury

Introduction

You may remember in an earlier section that we looked at the use of 3D planes and alpha channels to put in some background scenery. **Fig.01** shows the stage the scene is currently at with a provisional rock texture mapped to both the main sections of geometry either side of the bridge. The texture used on the right is temporary and used as a provisional guide. It will be replaced with a series of photos later in this tutorial and built up in Photoshop.

For now, let's introduce some extra elements to the background. I would like to add a rock formation between the building and the distant mountain using an image I found on the 3DTotal texture site.

This image had a good shape and so I started by adding a new plane into the 3D scene onto which the image would be projected just as I had done previously with the background mountain. To match the scene it needed some

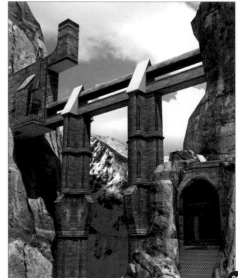

color correction which was done in the following order using image adjustments:

1. I altered the Color Balance to add some warmer hues (**Fig.02a**).
2. I altered the Levels to lighten the shadows and reduce the overall tonal range (**Fig.02b**).
3. I modified the Hue/Saturation, as shown in **Fig.02c**.

After making these changes I crudely extended the rock using the Clone Stamp and Healing Brush tools so that it fitted the dimensions of the plane to which it was going to be mapped in 3ds Max. Once done I made an accompanying alpha channel to hide the sky and shrubs (**Fig.02d**). It was then saved out as a TGA file, which carries the alpha channel, and then

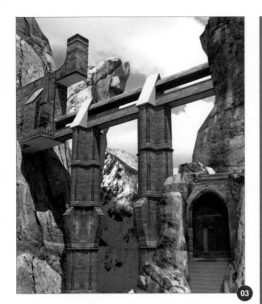

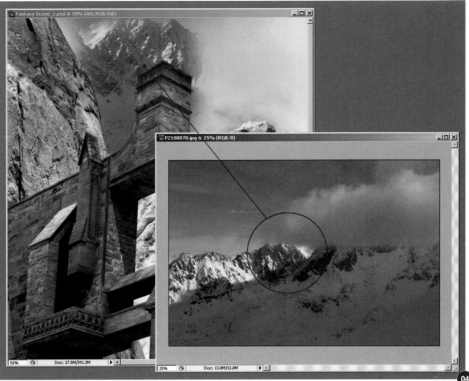

copied into the Diffuse and Opacity slots in
Max. The plane was then positioned in the
scene behind the building, the result of which
can be seen in **Fig.03**.

This concluded the use of actual geometry in
the scene in order to construct the background
and from now on I will use Photoshop entirely.
I wanted to add some even higher mountains
behind the building and so I once again trawled
the library of free textures available at 3DTotal
and came across an image.

I copied a section from the original image
(ringed red in Fig.01) and pasted it into a new
layer behind my building render. I then went to
Image > Adjustments > Curves and reduced
the contrast to create some atmospheric

perspective. You can also see that I flipped
the mountains horizontally in order to keep
the lighting consistent, which in this case
comes from the left. It is worth noting that for
this kind of work, which that involves a lot of
post-production, it is good practice to keep as
many components as possible separate within

your PSD so that you may make changes more
easily as you go along and be able to isolate
specific areas quickly.

For example, here in **Fig.05** I have a mask that
I can use to quickly separate the building from
the background if I wish to crop any photos

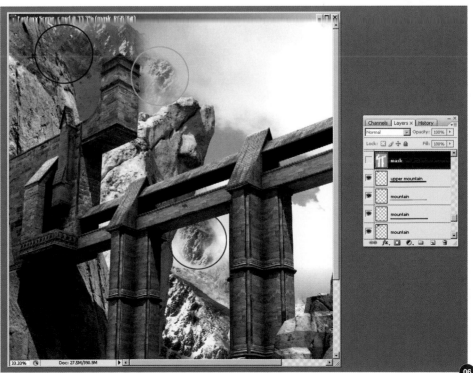

that are pasted in or if I wish to make any color corrections to just the building and bridge. I simply applied a white material to the relevant geometry and then rendered it out on a different colored backdrop within the Environment parameters.

I continued to sift through the library of mountain images and cropped and pasted in sections that fitted in with what I had so far. In **Fig.06** you can see the file structure on the right in the layers palette with the three extra mountain regions that have been used to elaborate the background. The colored rings correspond to the areas that have been added into the PSD file and once the contrast was adjusted using Image > Adjustments > Curves I used the Eraser tool (with a soft brush) to create the impression of cloud and help blend the sections together.

The upper part of the background is looking more interesting, but the bottom section could do with some refinement so that the snow does not come down quite as low as it does. I looked through the library and found another useful photo. Using the mask shown in **Fig.05** as a guide, I pasted the image into my PSD and scaled it accordingly. The area in red can be seen next to the right column. Once done I used the Eraser tool to soften the top edge and blend it with the snowy mountain using a soft round brush (**Fig.07**).

I reviewed the sky and thought that it looked a little uniform and so found a good photo to help add some interest. You can see the photo that

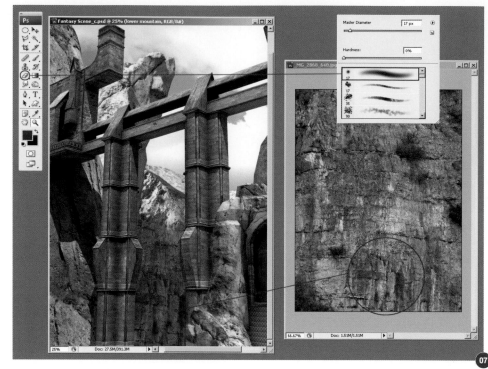

I chose from the 3DTotal free texture library in the left image of **Fig.08**. The black area in the this image shows where the sky has been used and blended with the original that is mapped onto the back plate. To create a clean edge that corresponds to the foreground rock face you can render out this section of geometry in a flat color, as we did with the bridge in **Fig.05**. You can also see that I have added some trees between the columns and an extra section of mountain (compare to **Fig.06**). Whenever you paste in sections of different photos it is important that you color correct them by way of Image > Adjustments, which was touched upon in the previous section. My normal procedure is

to start with Curves and adjust the tonal range and contrast to match the host image, followed by Brightness/Contrast if necessary and then I either use Color Balance or Hue/Saturation to correct the color. The key modifications are all found under Image > Adjustments and I usually use a combination of these depending on the context:

- Curves
- Levels
- Brightness/Contrast
- Color Balance
- Hue/Saturation

Foreground

As mentioned earlier, the foreground rock face will be built up in Photoshop and was started by using further images from the 3DTotal library.

> **Quick Tip:** It is important that you consider the lighting and choose source material that is either neutral (for example, photographed under a diffuse light with no harsh shadows), or ones that already demonstrate lighting conditions that closely match the original plate.

In this case the rocks are shaded by a canopy of trees and as such just display a general ambient light being cast from above. I selected an area highlighted in **Fig.09** and pasted this in beside the door and then used Image > Adjustments > Color Balance to increase the red hue and reduce the greens. I rotated it to more closely match the geometry and then used the Eraser tool to trim the edges. The main shadow is evident under the uppermost block of rock, which fits in with the scene.

The second image I used to create the stone section above the door. In **Fig.10** you can see another example of how a section of the right image has been blended into the scene. It is best to paste in a roughly accurate selection area into your main plate, and then blend it into the actual scene using the Eraser tool. Again this was color corrected slightly to add a warmer hue using Color Balance.

I took a rough crop approximating the area on the right and then flipped it horizontally and

placed it in the mid section (**Fig.11**). You can see that I have utilized the shaded area at the top of the cropped section to create a natural crevice in the scene.

The remaining upper section still requires some work and in this case I used an image from the Matte painting category of the 3DTotal library. All of the images here carry a black and white mask making it easy to isolate the most prominent components; in this case the edge of mountain pass.

In **Fig.12** you can see how I have used the accompanying mask to quickly isolate the shrub and rock, which have then been copied into the scene and flipped horizontally. You will notice that I have decided to leave part of the temporary rock texture that was projected onto the geometry as it seemed to work quite well. This was not intentional but rather a happy accident, but it is always worth taking advantage of these opportunities.

Once each of the component photos are in place and have been color corrected it is often

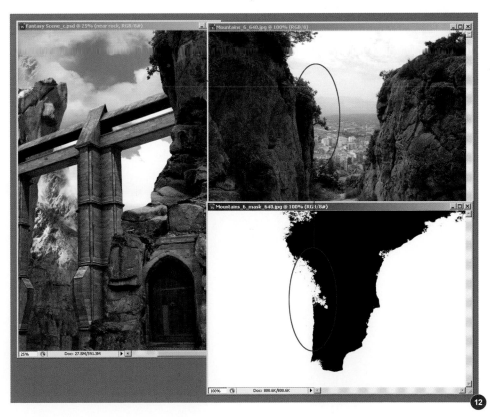

necessary to use the Clone Stamp and Healing Brush tools to blend them together and conceal any obvious seams, as we did in the earlier Basic Modeling and Lighting section of this tutorial.

Another detail which I added to the foreground to create some interest was the decorative carving above the door, which was taken again from a 3DTotal reference image. It was first scaled and skewed to match the perspective (Edit > Transform) and then color corrected (Image > Adjustments > Color Balance) (**Fig.13**).

The last remaining area that needs obvious attention is the staircase. This can be done in one of two ways. A stone texture can be pasted in from a photo and then the shadow from the

Ambient Occlusion map used to create the volume (left in **Fig.14**) or alternatively a stone texture can be projected onto the geometry in the 3D scene (right in **Fig.14**) and the light rig used to generate the shadows. Either way will work and in fact there is no reason why you cannot combine the two approaches by first mapping the geometry and then enhancing the shadows by overlaying the AO map. Here is the result of mapping a stone texture roughly onto the steps and then overlaying the AO map, which is set to Multiply at around 68% opacity (**Fig.15**).

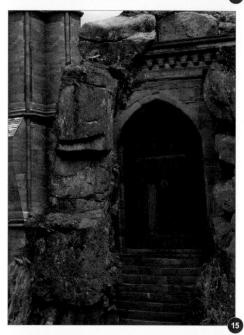

We have now built up most of the background and foreground scenery, but one area that needs addressing is the shadow below the building. It would look better if the building were supported by a rock outcrop as it looks a little

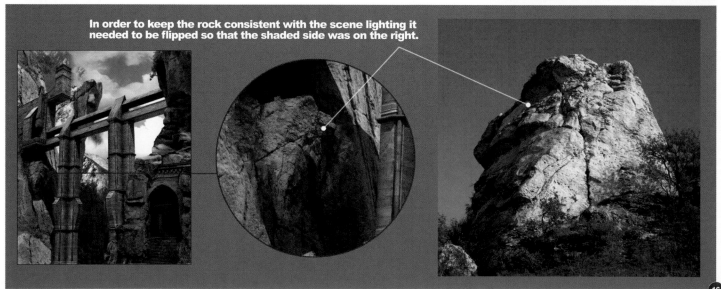

In order to keep the rock consistent with the scene lighting it needed to be flipped so that the shaded side was on the right.

precarious. I scoured the library once again and found an appropriate image.

I chose this particular image because it suited the scene's geography. The rock was shaded on one side and showed a natural angle that I could exploit effectively. In **Fig.16** you can see the process used to blend the rock, which involved flipping it horizontally in order to match the lighting.

To link this new outcrop to the building I opted to use a photo I took at the location of the cathedral. These arches were almost photographed at the right angle and so needed only a minimal amount of skewing to fit. Once correctly scaled and in position, I reduced the brightness and contrast levels (**Fig.17**).

This added a structural support to the base of the building and helped bind it more successfully to the rock face, but there was now a noticeable hole along the side. To fix this I selected a photo of an arch (**Fig.18**) and then went to Edit > Transform > Skew and fitted it in with the scene perspective. I then reduced the brightness and contrast and blended it in with the Clone Stamp tool.

This concludes this section, where we have looked at how we can use Photoshop and a careful selection of photos to build much of the eventual scenery in both the foreground and background.

17

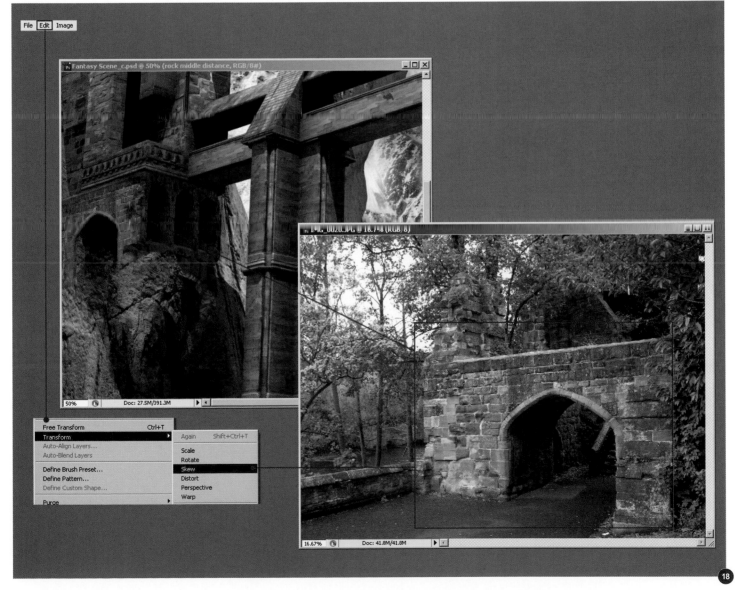

18

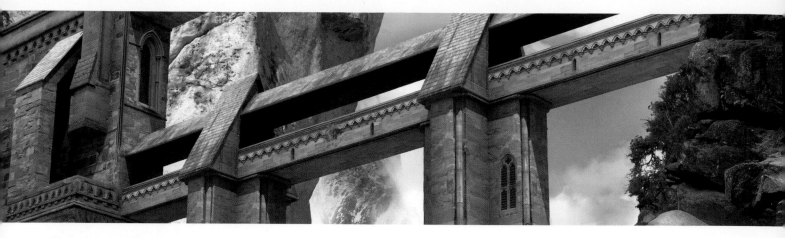

Fantasy Scene – Post-production
By Richard Tilbury

Adding Some Detail

Fig.01 shows the stage we had reached at the end of the last section. We now have all of the main components in place with the foreground and background composited in around the 3D elements. The next stage involves adding some details to the scene and, in particular, the buildings, which will help make them more interesting and give the viewer more to look at.

Once this is done we will add in some more architectural aspects that will further enhance the building and be photographed on location

to closely match the perspective in the scene. Once these aspects have been added we will conclude with some image adjustments in Photoshop to bring everything together.

To start with I chose a section from one of the photos to enhance the left part of the building (**Fig.02**). I copied and pasted the section highlighted in red and then went to Edit > Transform > Skew and aligned it with the building. I followed the same procedure for a section along the top edge of the bridge, as seen in **Fig.03**. I scanned through the library

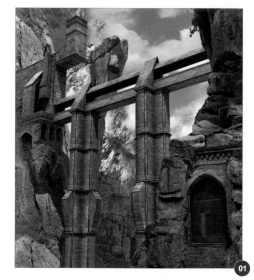

01

of photos to find some other suitable details and **Fig.04** shows some of these once they have been applied. The approach is the same each time, which first of all requires everything being scaled and then skewed/transformed to match the perspective. Once this is done you can begin making the appropriate image adjustments, e.g: Color Balance, Brightness/Contrast etc. Notice that I have chosen photos that have details similar to the perspective in the scene.

The columns, bridge and building now look a bit more interesting, with the windows adding some sense of scale as well as helping break up the uniformity. I added the smaller brickwork on the left column to disguise the symmetry and perhaps suggest some repair work. You may also notice that the decoration along the bridge has some damage in the middle section. All of

02

these details and imperfections are small, but collectively they help make the overall scene a little more realistic.

To suggest that the bridge is a link to some sort of mountain outpost, I opted to add another building in the upper right. **Fig.05** shows how, from a single photo, the new section of architecture is transformed to match the perspective. This is one of the photos I took after re-visiting the site for specific perspective shots but proved to be more useful than I had anticipated! I made a selection area around the parts highlighted in red and then pasted these into my scene. Using a combination of Rotate, Distort and Skew (Edit > Transform) these were then assembled. As this only occupied a small region of the image I didn't worry too much about the seam matching perfectly. The main thing to focus on was the tonal range and color and so using a combination of Brightness/Contrast, Curves and Color Balance proved to be very useful.

At this moment the building is not integrated with the rock face and so will need some attention. The first step involves adding a shadow to the right, but in this case I added some more rock from a different photo that was darkened (the middle image in **Fig.06**). To help support the architecture I then pasted in some rock from a different reference.

I chose this picture because as you can see in the right image in **Fig.06**, it had a natural ledge with shadows that I could exploit. It was flipped in order to get the light on the opposite side, but it fitted in nicely.

Photos to Match the Scene

You may recall that a few of the details, such as the arched window below the main tower and the carved decoration along the top of the bridge, almost matched the perspective of the scene. These photos were taken especially for the render once I knew where the camera would be placed. Even if you are not able to take specific photos it is always a good idea to try and find images that match as closely as possible. This is not vital, but it does reduce the amount of skewing and distortion needed. After looking at the scene I decided it would be good to add something above the right column as well as on the rock in the middle distance as this looked like a natural lookout post. I also thought that the "L-shaped" tower needed to be more interesting. I therefore picked up the camera and went back to the cathedral to look for some suitable subject matter.

Fig.07 shows the photo I took after looking around the cathedral for a suitable section of architecture. I photographed this with the scene in mind as I wanted to use the spire. You can see that it was easy to mask and once pasted and scaled it was almost perfect. I used Curves to brighten it up and made sure it was similar in color to the roof. This spire didn't have any strong shadows on it, which is ideal for this type of exercise, but I saw it could benefit from some subtle shading on the left. To do this I first duplicated the layer and then darkened it slightly. Then I clicked on the "Add Layer Mask" icon at the base of the layers palette (small white circle in a gray rectangle). Using a pure black I then painted along the left edge inside

the mask to reveal a shadow (inset in **Fig.07**). This is a good technique as it is fully reversible. For the large outcrop I photographed a turret next to the cathedral, making sure to roughly mimic the correct perspective. This was then copied into the scene and a darker duplicate layer was made to represent the shadows.

Fig.08 shows the result, which has been color corrected and the corresponding Layer Mask used to reveal the shadow along the left-hand side. One could argue that given the position of the sun there would be very little shadow on the visible side of each of these components, but a subtle hint can sometimes help to create a bit of volume. It was now time to deal with the

"L-shaped" tower, which needed a focal point. I looked around the cathedral and then my eye caught the statues outside the entrance which looked perfect. Remembering the camera angle in the scene, I took a photo that I then used to add another area of interest (**Fig.09**).

Final Adjustments

At this stage everything of significance was in place and I had an even spread of detail from the background through to the foreground. Numerous refinements had been made to the 3D components to add interest, as well as the inclusion of some specific details such as the statue. It is worth keeping a set of masks for your work so that at this stage you can

quickly isolate and change certain sections quickly. Either this or simply keep everything on separate layers, although this can often result in a very intensive and complicated file.

Before completing the image with some additional painting and extra components, I made some changes at this point using only what was apparent so far. **Fig.10** shows the "before and after" versions, with the former on the left. The key changes are as follows:

1. Upper left building and rock face were made lighter and the contrast reduced using Image > Adjustments > Curves. I then tinted it blue (Image > Adjustments > Color Balance).
2. I repeated this process for the outcrop of rock so that these sections receded further.
3. I darkened the lower section of the mountain to add depth and suggest it was shadowed by the foreground mountain (Image > Adjustments > Brightness/Contrast).
4. By duplicating this upper section and then applying a layer mask, I lightened the near face to add volume and made the outer leaves more translucent to reflect the bright sky behind them (Image > Adjustments > Curves).
5. To better integrate the door with the mountainside I tinted it towards green to match the surrounding rocks (Image > Adjustments > Color Balance).

After this initial phase of color and tonal adjustments, I flattened the PSD. I decided that the 3D elements were a little too dark and didn't really look like they were built from the mountains surrounding them. I used a mask that corresponded to just this section so that I could isolate and duplicate just the 3D parts. I then applied an adjustment layer (Layer > New Adjustment Layer > Levels) and moved the sliders to lighten the stone work (**Fig.11**).

I duplicated the buildings purely because I didn't want the adjustment layer to affect the entire image. I then added a Color Balance adjustment layer and a very small amount of green and red, as shown in **Fig.12**, so that the buildings had a very subtle hint of green to balance them with the rock.

I added a new layer called "refinements" and on this I started to paint out some of the problem areas. Because the 3D scene was very basic it meant that sections like the intersecting roof canopies did not cast a shadow. On the left in **Fig.13** are two details of the scene before I painted in the corrections, which are highlighted by the red dots. You can see that generally the edges are a bit sharp and have an outline that needs to be addressed. These are only small touches, but they really help to improve the scene greatly.

The next thing I added were some plants to soften the edge of the foreground rocks. I did this because it helped reduce the "cutout" effect and gave it a more natural feel. I used one of the free images at the following location as it already had a mask which meant I could select just the shrubs and copy them in swiftly.

Once in position, I color corrected them to make them a little more green and lush. **Fig.14** shows the extra plants that were added (left image) and two sections from the reference photo that I used. To blend them in and generate more growth, I used the Clone Stamp and Eraser tools to manually place them around the rocks in a natural way.

At this point the image is almost complete but after taking a break from looking at the scene I decided that the foreground was a little too warm and did not seem fully part of the environment. I therefore duplicated this section and then went to Image > Adjustments > Color Balance and tinted it towards a cooler value by increasing the blue.

One final touch was the addition of some mist, which was done on a new layer. I used a soft round airbrush set to a low opacity, and with a pure white I painted in a few strokes that were then blurred (Filter > Blur > Gaussian Blur).

Here is the final image (**Fig.15**).

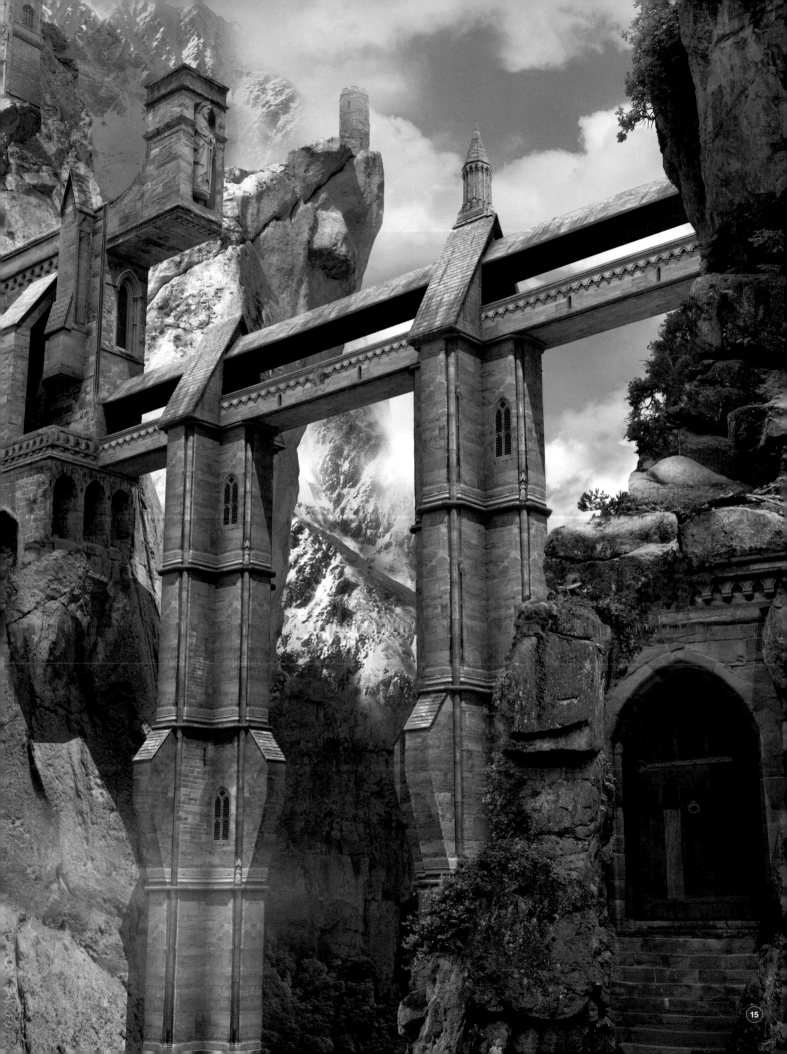

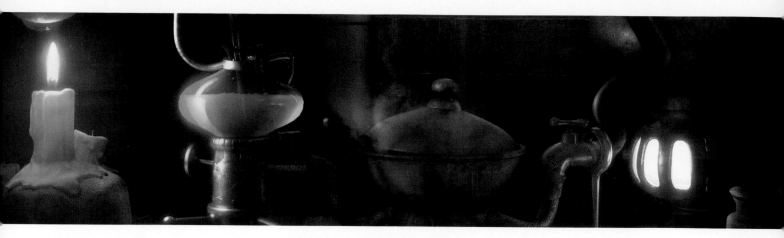

Alchemist's Chamber – Texturing and Lighting
By Aleksander Jovanovic

Introduction

In this tutorial I will be guiding you through the process of enhancing your still frame images with the help of Photoshop and various 2D techniques. I won't be using any type of plugins, and I'm going to show one way you can create your fine looking images very quickly, and very efficiently, with enormous freedom. Once you master the techniques I'm about to demonstrate it will mean that in very short periods of time you can produce production-ready concept art, or even final still frame images.

Of course this only applies to inanimate pictures, but can be a great foundation for some large texturing processes in animation production. When you define the look you're

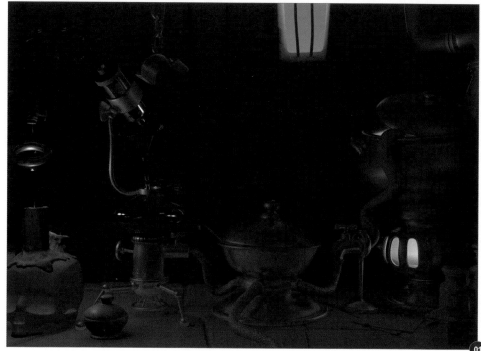

after, it's just a matter of trying to reproduce this same effect in a 3D scene without losing long hours to experimentation. Another way to do this could be to use camera map techniques. With this little trick you project the final image through the camera onto the geometry and use it as matte painting etc.

My scene for this project is fairly simple, with some basic shaders. It is rendered with mental ray, so for the glass and metal I used its native "mia_material", and for everything else I just used the default Lambert shader without changing any of the specific properties. This doesn't really matter that much because you

can work the same way with any render engine around. I decided to work like this just to show how much you can achieve with what is a rather empty scene.

One more thing that's defined and is included within the render is the lighting, which is achieved with a few light sources and is really nothing fancy. Since it's set to be a night interior scene we have lights that mimic moonlight, candle light and some additional light coming from some sort of oven. To create them I used point and area lights. I rendered out Beauty, Ambient Occlusion (AO) and Selection passes, which I created for the sake of fast selection,

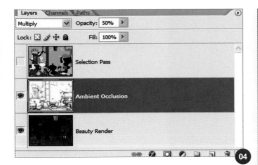

and that's about it. It's up to the artist how many passes he needs, but I chose those three (**Fig.01 – 03**).

The first thing I like to do is to color correct my image by adjusting levels, and to set some general tone for the image, or to be more precise, define a mood. Textures and paint-over's I will add later; first it is time for lightning. The Ambient Occlusion pass will introduce some very fine details. It is useful to mimic contact shadows. I put this layer on top of my image. I will even put all of my later textures below it. It is important to set the blending mode to Multiply, even if you paint your own AO layer. When I paint my own Ambient Occlusion pass I usually have two layers. In one of them I have harsh contact shadows and in the second one I have very soft shadows with falloff.

Later in the process I will mask out parts of AO layer that are directly lit with a light source, since there will be no shadows in those areas. Feel free to adjust the visibility of the AO layer because sometimes you'll need to combine more of them, but in this particular case I was satisfied with 50% visibility. There have been cases when I had to blur the AO pass for a much more compelling result (**Fig.04 – 05**), but not on this occasion.

Since our image is still washed out we'll do some color correction next, using Primary Adjustment layers.

Quick Tip: I try not to damage the original render, in any way and so I have everything saved in different layers with masks for a better control. That way I can go back at any time and change whatever I like.

When it comes to color correction I don't have a precise recipe, so just use your judgement instead. As for myself, I like to use levels and color balance most of the time. With levels I will adjust the contrast of the overall image and with color balance I will tone it nicely. In this case I used some warm colors. In other words, I introduced some red and some blue tones. One very nice thing about the Color Balance tool is that you can tone shadows, midtones and highlights independently. Color correct

layers will stay on top of the other layers. At the very end I might come back and introduce some other tools (**Fig.06**). This is it. We might come back and do some extra correction later, but for now we'll concentrate on the lighting and background plate seen from the chamber window.

2D Lighting

I painted in some light effects using a very basic soft brush, varying its hardness and opacity according to the situation. In my experience the best way to do something like that for this kind of night scene is to use a bright orange color, and to set the blending mode of the layer to Color Dodge. This also applies to daylight scenes, when you need some bloom effect from the sunlight. You can see how I used a harder brush on the metal pillar and a much softer one on the other parts, especially on those that are further away (**Fig.07**).

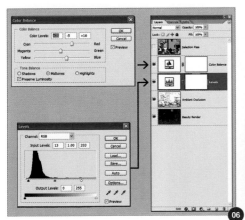

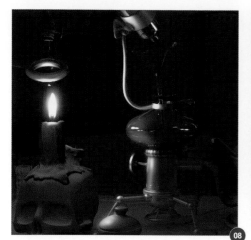

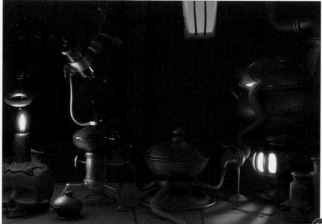

I tried to imagine the way the light would travel and bounce around the table and surrounding elements. The Selection pass helped me a lot here, otherwise I would have had to use various selection tools, and spend some time doing it. This is also a part when you have to use your own judgment and logic or some artistic preference. For the candle flame I used a simple photo reference, and masked out areas outside of the flame. The only thing I left was a bit of the candle top, including wax (**Fig.08**).

With a hard brush with a small diameter, I painted small sparkles of dust illuminated by the flame, just to introduce some more details. To give more of a sense of depth I erased some

of them, but I set the Eraser tool to a fairly low opacity. That way they fade out, but they do not disappear completely. The ones I did not touch with the Eraser remain very bright, and these variations will make it more believable. Finally I masked out parts of the Ambient Occlusion pass where I don't have shadows. Those areas are the ones that are directly illuminated by light sources (**Fig.09 – 10**).

Around the candle I added one layer of very soft glow, to accentuate the hot air around it. One more detail I painted in is a layer with red values just around hot areas of the image. I wasn't trying to be very precise here so I used a very soft brush and the same color value as

for the light layer, which is orange. The blending mode was set to Color Burn. Finally I added some vignetting around the corners of the image (**Fig.11**).

At this point I was satisfied with the atmosphere, but what I realized was that certain parts of the image disappeared into the darkness. Not completely, but some very nice rim lights would help to separate them from the background. I used a dark cyan color for this effect. The layer's blending mode is set to Linear Dodge, but there are other combinations as well. This effect is subtle, but it can really help a lot. Later we can always come back and change the hue, saturation, lightness etc.,

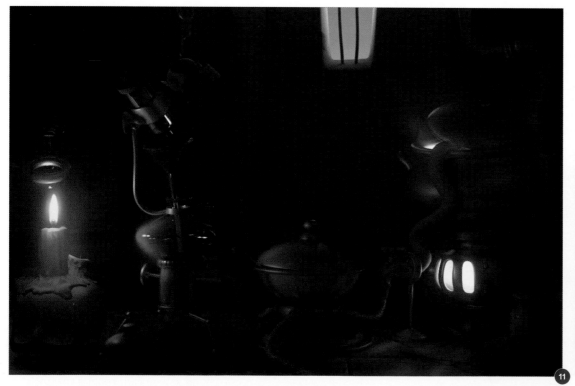

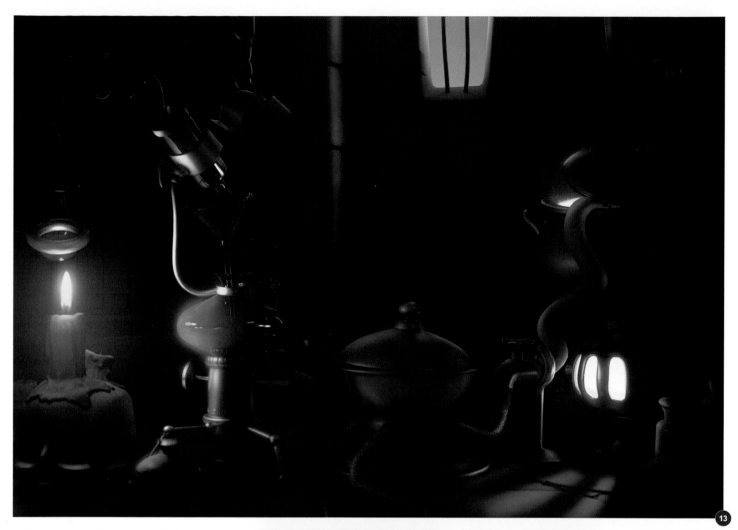

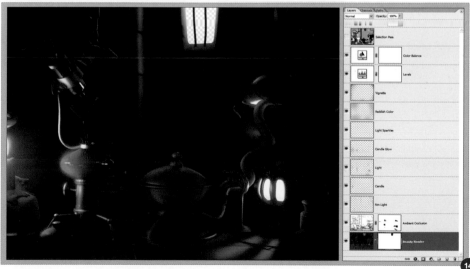

as because everything is saved in layers we have enormous freedom. In this situation the Selection pass I mentioned at the beginning helped me a lot, especially on the edges, but either way all you need is a trained and steady arm (**Fig.12 – 13**).

The next step will be to create moonlight and stars for the background. I will also create volumetric light that will come through the window. Since I have an alpha channel I will

use it to create a mask for my beauty render. Sky, moon and stars will be placed in the bottom layer (**Fig.14**).

For the sky I chose a dark blue background. The moon and stars are fairly simple, I created

a slightly cartoon version by hand, but photo references are also useful when trying to create a realistic effect. My moon is a simple circle filled with a yellow color, with one circular part deleted. Finally I blurred it a bit and added some outer glow (**Fig.15**).

The next step, and a very nice detail, was the volumetric light coming from the window. With a simple Polygonal Lasso tool, I created the basic shape of the moonlight, and I filled it with a bluish color. Just as I did for the rim light, I set the blending mode to Linear Dodge (**Fig.16**).

Now I will soften the look and harsh edges with a Blur filter and adjust its opacity. If necessary there is always the option of painting some more rays, or even erasing some, but it's really the artist's choice (**Fig.17**).

To start with the beam of light seemed fairly uniform and synthetic. What I decided to go was break it up with a pattern overlay effect. For the pattern I chose clouds, with the largest scale option and small opacity, and the blending mode set to Multiply (**Fig.18 – 19**).

To achieve the effect of light decay on the volumetric light I will duplicate the volume light layer, desaturate it and erase all the areas that are far away from the window. The other way

would be to paint a mask, or to use some photo references; in that case you'll need a black and white image (**Fig.20**).

One final thing to consider about the lighting at this point is the candle light. Wax is naturally a translucent material that dissipates light through the surface. The easiest way to cheat this phenomenon will be to gradually paint light or to use a mask to make it appear like that (**Fig.21**).

I used a soft brush to paint one translucent layer and a specular layer on top of the candles. Specular is much stronger and more prominent, but the translucent effect is actually the one that's more important here and will help sell the illusion. With this step I finalized the lighting part of the image. I can always come back and change whatever I like, from intensity, to hue, to influence etc, and I probably will be revisiting these layers at the very end. To make it more organized and clean I group all of these layers under a new group named "Lighting" and then moved on to the next section, where we will look at the texturing process (**Fig.22 – 23**).

2D Texturing

Textures are a vital part of any picture, and they play a very important role in our perception of the artwork. In combination with the lighting they define the quality of the surfaces and their properties. Usually in 3D, artists un-wrap UVs or use projections to place textures for diffuse,

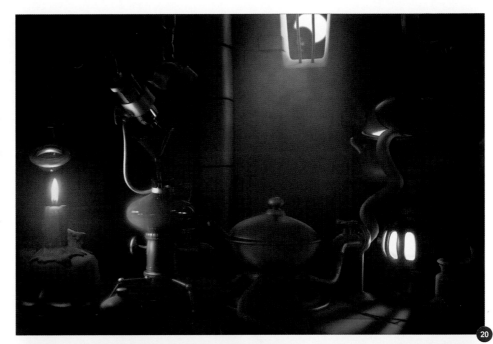

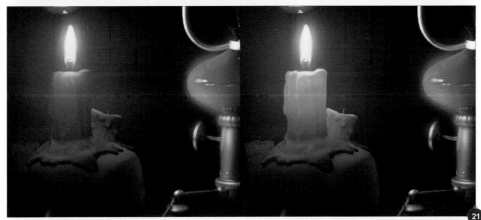

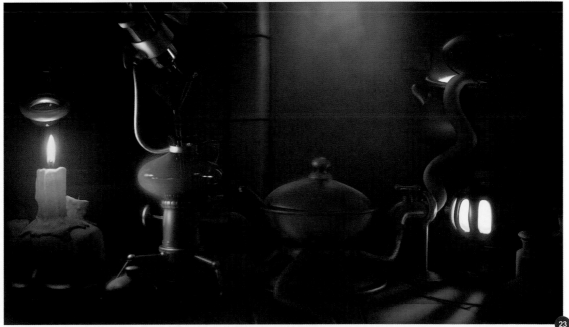

bump, specular displacement etc. As mentioned before, this scene has no textures at all. What we are about to do is texture an entire scene in 2D and fake most of the attributes. For the most part I will use different types of 2D textures already prepared, cleaned and ready to use in any kind of 3D application, but I will also use some reference photos I shot or found online. Just like in the case of the lighting I will use masks, transform tools and various brushes.

First of all I created a rust effect on various metal pieces in the front, using one of my favorite libraries from 3DTotal's Total Textures V2:R2 – Aged and Stressed DVD. Here's the image that I used (**Fig.24**).

As you can see there are plenty of fine details here, but I decided to combine it with other images from the same collection. I put it under the Ambient Occlusion layer defined the blending mode as Overlay. With a very soft brush and opacity I painted in parts that I needed to be seen. This means that I set the mask as completely black and, with a white color, I revealed just certain portions – this technique is my personal choice. Since the final resolution was quite large (it's 4K) I planned to duplicate the image several times for different

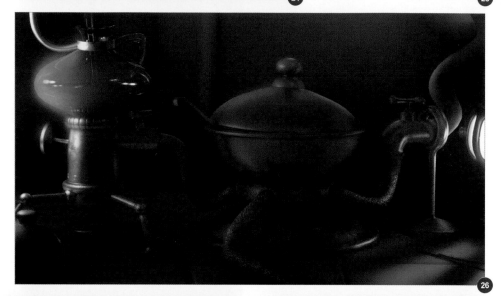

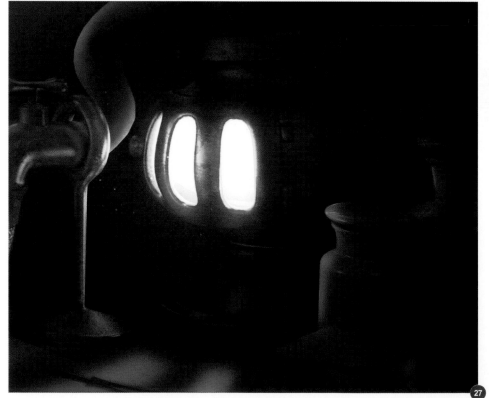

parts, and rotate and scale it accordingly. It was important to imagine how the image would look at the end and to invest some time in telling the story of the image, like there are some parts where some liquid leaked, which has created rust etc. Here is the example of how I duplicated and masked different parts of the image and the final result (**Fig.25 – 26**).

I continued to paint this first layer of rust over all the metal parts. Don't forget that here I was just painting a mask of the texture I used for the metal (**Fig.27 – 28**).

As you may have noticed, some nice color variations have been achieved on the surface, but some new layers need to be introduced in order to introduce natural variations and imperfections of different materials. This is a great piece of metal that came from the same library (**Fig.29**).

Here you can see that I even painted some texture over the glass just to eliminate the sterile, clean look of its surface (**Fig.30**).

Finally I added some small marks with this texture (**Fig.31**). For the blending mode I used Vivid Light, but as I said don't forgot to experiment with different modes as this is just an example not a rule. This created the very subtle effect of cracks and marks on the metal surface. I gently placed it over different parts of the image. You can see some beautiful details here. It doesn't look as synthetic anymore (**Fig.32 – 33**).

To accentuate rusty edges and bumpy surfaces and to give my textures some depth I painted light strokes on the edges of parts where the surface would not be entirely smooth, like the cracks for example. I used a brush with a very small diameter and just followed the path of my lights. I only painted the sides that are directly lit. You can see how much this improves the overall quality. Of course you can improvise when doing this as long as what you end up with looks good (**Fig.34 – 35**).

Also I added some extra layers of texture, but I used just some portions of it. The purpose of these textures was to introduce some more details. You can never get enough of details, especially in computer graphics (**Fig.36 – 37**).

The more layers we introduce, the more details we will achieve. Of course the artist should find the right balance. Here is the example of one more layer above all of the others, and the painted specular on top of it. By this point I had three different textures above each other (**Fig.38**). What's more important is that with every new texture I introduced, I was constantly painting in the specular layer.

For the cauldron in the middle I found a very neat texture that helped me to sell the illusion that some sort of matter used to drip out of it. The funny thing is that this specific texture came from the stone collection, and I just used one portion of it (**Fig.39**).

Here you can see how I just masked that specific part of the texture and I used Warp Transformation to deform it accordingly (**Fig.40**). To keep everything organized I grouped all of these textures under a new group that referred to metal textures on the table.

The next step was to texture the table top, which is made from stone pieces. I used this texture for the first layer (**Fig.41**). Gradually I added more. Like the layers used on the metal I set the blending mode to Overlay and used a low level of opacity.

I wanted to add some noise here, so I used Gaussian Blur with minimum strength to soften it a bit, and later I used the Blur tool to soften

specific areas. I masked out areas I didn't need with a soft brush. I added to the other stone texture with this one (**Fig.42**).

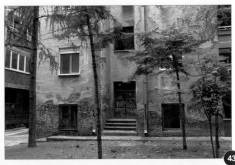

The one thing we should not forget are the specular details that I put around the corners of the table blocks. Of course there is no perfectly clean desk in the world, especially if it belongs to an alchemist and is situated down in the cellar. Here, for those details and especially dirt I used a photo I took recently. I used ground details such as leaves and small stones. When you work on some sort of a street scene you can use these kinds of pictures to put leaves and other dirt in the corners and it will look very convincing (**Fig.43**).

I put this layer at the top and masked out a lot. I just left what I found interesting. Here is the final look of the table top; it's all mixed and you cannot really tell that I used one specific texture to accomplish this task (**Fig.44**).

The skull is textured using the same procedure. For the texture I used this one from the stones collection (**Fig.45**).

Now for the bottles on the table. They don't have any specific color information, or texture. First I painted in some color, with the blending mode set to Color. To avoid a uniform color feel I always erase some areas, but for that I use a very soft brush with a very low level of opacity. Finally if the color is too intensive, I use the

Sponge tool and saturate it. You could also use a Hue/Saturation window to control the overall level of saturation with the sliders.

Now I have some papers in front of the oven; they are some sort of alchemist formula. To

make it a bit interesting I found this image in an architecture book. These marks were found on some ancient bricks and they looked kind of interesting. I retouched the image and put it on top of the paper. Using the Distort Transform tool I adjusted its shape to match the papers (**Fig.46**).

To accentuate the marks I painted specular strokes on top of it, and some dirt with a simple black color set to a low opacity. I used the same method for the big hose coming from the big cauldron. It consists of several layers for basic color, two mixed textures, and specular (**Fig.47**).

By this point I was almost finished with the front layer of the image. The final touch was to add liquid to the bottles. I painted them just like the other parts, but you could always shoot a real photograph and combine it with your render.

The first thing would be to give it some color, and I chose a light green. I didn't change the blending mode here; instead I left it as it was.

Here I painted several layers with one being a sold liquid layer with some bubbles and splashes on top of it. I used a variation of the same color from light to dark. The next one had a lower opacity, but the same color, with small drops and traces of the fluid that is moving within the bottle. On the specular layer I painted a specular reflection for the bubbles and for the candle light. I used the same color for the specular as for the liquid, so that it's not white but green. Finally I introduced some reflections on the glass surface, mainly for the candle and a flame. You can see the progress here (**Fig.48**).

The same principle was applied for the left bottle with the red liquid in it (**Fig.49**).

With this step I finished the front layer of the image, and I will finish the background using the same methods. The background has fewer elements and will consume less time. At the end I'll re-examine the entire image and redo the parts that need correction.

I started with the door. Doors are mostly made of wood, but they have some metal parts on them as well. For the wooden planks I used one of the textures from the wood collection that I

retouched so it didn't have visible plank edges, and it looked seamless. I did this because my model already has modeled planks (**Fig.50**). I used this same texture for the horizontal and vertical parts, just rotating it accordingly.

For the metal parts I used this texture, but slightly desaturated (**Fig.51**).

Finally my door looked like this. I masked out everything I didn't need (**Fig.52**).

For the large column next to the window I decided to use a marble texture. So I didn't combine it with any other image as it looked just fine the way it was. I also painted some specular light around the cracks to mimic a bump effect. The wall, on the other hand, was quite large and needed some extra work. For the basic texture I used this one, with the blending mode set as Overlay (**Fig.53**). I duplicated it until it covered the entire back wall.

To mimic the decreasing intensity of the light as it moves away from the window, and in order to achieve some darker parts in the image, I used one layer style in an extra layer. I used a Gradient Overlay with default black and white colors and Multiply as the blending mode. I also put a completely black layer set to Multiply mode with a very low level of opacity on top. After that I masked out areas that were not dark. With this effect I faked light falloff coming from the window.

We are now almost about to finish the texturing process of the alchemist chamber. Just like all the other parts in the image, I textured the remaining parts, such as the bricks and the staircase in the lower right corner. In order to keep everything organized and clean I grouped all of these textures under a new group and I named it accordingly. It is much easier to keep everything organized from the beginning because it can get messy very quickly. This

way anyone can troubleshoot what you did, and also you can navigate much faster through sometimes thousands of layers.

Painting Over Details

With the image almost finished, it was time to paint over some of the fine details, like the spider-webs or smoke coming out of the cauldron. Considering spider-webs, I usually paint several layers. The first layer represents the overall design of the spider web. I will paint it with a harder brush in order to visualize how it looks. But keep in mind to never use a brush that is too hard, because it's a bit tricky to control, especially on high res images. After this step, I will soften it with a very soft brush, and also lower the layer's opacity. Often I paint more details after this step over the top. Finally I add one more layer with very fine strands, and I also add some very nice specular highlights on the web. As I mentioned before if you have a real-life image then don't be afraid to use it; I chose to paint it in order to show a technique and also because I enjoy drawing. Here is the web I drew around the window. I also did several of them in other parts of the room (**Fig.51**).

Concerning the smoke coming out of the cauldrons, I painted some parts, and for the others I used images that I found from a reference library online. When I paint smoke I usually use very soft brushes. For the volumetric shadow I usually use the Burn tool

as well as Dodge tool for the highlights. For a photo reference I deliberately chose a smoke shot in front of a black background. When the background is black, and the smoke is white, we can set the layer mode to Screen and only the smoke part will remain. Then I can easily mask its falloff and it will look perfect.

All that remained was some fine-tuning, including effects like depth of field and glow etc., and the image was complete (**Fig.55**).

We've come a long way with the image, but you can always refine more and more and introduce new layers as well. Just let your imagination and inspiration guide you. Never be afraid to experiment and try out different things; the more you practice, the more you will discover.

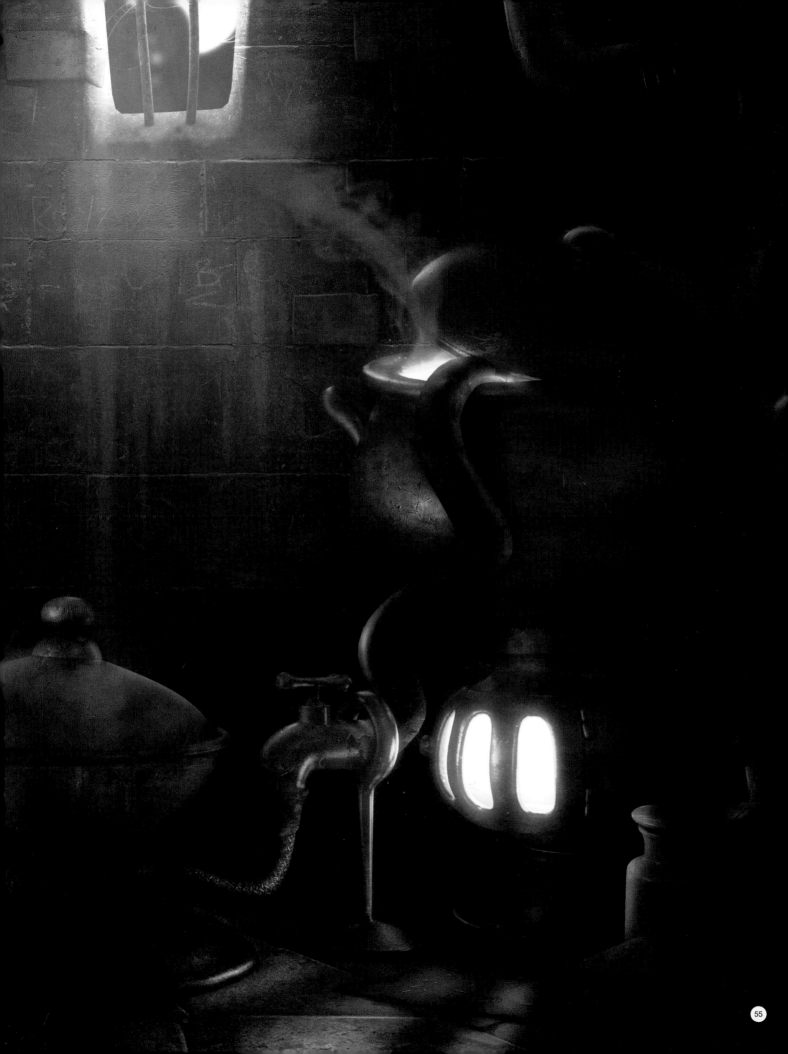

Aleksander Jovanovic

jovanovic.cg@gmail.com

http://www.inbitwin.com/

Aleksandr Kuskov

natikks@gmail.com

http://alekscg.daportfolio.com/

Alex Broeckel

raybender@me.com

http://www.alexbroeckel.com

Andrzej Sykut

eltazaar@gmail.com

http://azazel.carbonmade.com/

Branko Bistrovic

bisvic@gmail.com

http://www.brushdreams.com/brankosfurnace.swf

Darren Yeow

darren@stylus-monkey.com

http://www.stylus-monkey.com/

Eve Berthelette

berthelette@hotmail.com

http://muskol.cgsociety.org/gallery/

Fábio M. Ragonha

fabioragonha@yahoo.com.br

http://www.fabiomr.com/

Fredi Voss

vuuxx@gmx.de

http://www.fredivoss.de

Jama Jurabaev

jama_art@tag.tj

http://jamajurabaev.daportfolio.com/

Jose Alves da Silva

joalvessilva@netcabo.pt

http://zeoyn.cgsociety.org/gallery/

Mathias Herbster

MathesHerbster@gmx.de

http://deadpixel.tk/

Mike Hill

mhill@karakterconcept.com

http://www.freefallgraphics.com/

Neil Maccormack

Neil.Maccormack@mccann.ch

http://www.bearfootfilms.com/

Olivier Vernay - Kim

kive7701@yahoo.fr

http://oli.vernay.free.fr/

Richard Tilbury

ibex80@hotmail.com

http://richardtilburyart.com

Satoshi Ueda

satoshi@akatuki.biz

http://www.akatuki.biz/

Zoltan Korcsok

zoltankorcsok@gmail.com

http://www.zkorcsok.hu